HORSES

HISTORY ✦ MYTH ✦ ART

HORSES
HISTORY ◆ MYTH ◆ ART

CATHERINE JOHNS

Harvard University Press
Cambridge, Massachusetts
2006

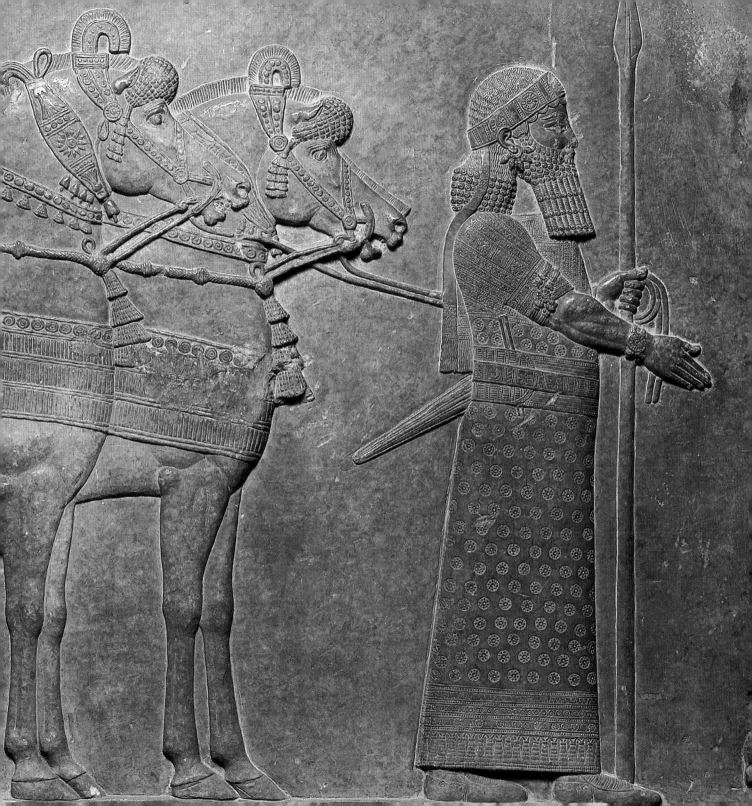

First published in 2006 by The British Museum Press

Library of Congress Cataloging-in-Publication Data

Johns, Catherine
 Horses : history, myth, art / Catherine Johns
 p. cm.
 Includes bibliographical references (p.).
 ISBN-13: 978-0-674-02323-9
 ISBN-10: 0-674-02323-4
 1. Horses in art. 2. Horses–History.
 3. Horses–Mythology. I. Title

 N7660.J64 2006
 704.9'43296655–dc22
 2006043677

HALF-TITLE PAGE
Ivory *netsuke* of a horse in a stable. Japanese,
19th century AD, signed by Kaigyokudo.

TITLE PAGE
Alabaster relief from Nineveh depicting King
Ashurbanipal and two of his horses. Assyrian,
645–635 BC (see pp. 104–5).

OPPOSITE
Sidney Nolan (1917–92):
The bushranger Ned Kelly charging on his horse.
Fibre-tipped pen on paper, 1954.

CONTENTS

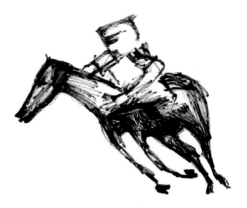

FOREWORD AND
ACKNOWLEDGEMENTS

THIS book aims to build up a multi-layered visual impression of the ways in which horses have been perceived and depicted as servants, companions, symbols and artistic inspiration, based on art and artefacts in the incomparable collections of the British Museum. It is not a formal history of the domestic horse in human culture.

My original idea for a picture-book focusing on horses in the British Museum's collections goes back nearly twenty-five years. More recently, in the late 1990s, a British Museum exhibition was proposed on the horse in human culture; the work of the planning committee revealed that many other curators in the institution shared my keen interest in, and enthusiasm for, the story of the ancient association between horses and humans, and the way in which it has been celebrated in art and in everyday objects throughout the ages. In the event, the exhibition itself did not take place, but the lively discussions between curators and the identification of relevant themes and objects have done much to shape the concept of this book.

I am not a practical horsewoman, though I have been able to ask the advice of friends who are, and my academic expertise as an archaeologist centres on the Roman world, so I have been wholly dependent on the help of colleagues for the selection and explanation of material from all other periods and cultures, help which they have given most readily and generously. Nevertheless, the reader will notice that Graeco-Roman material is particularly well represented in the picture section of the book. This may be partly the result of my own bias, but it is also the case that horses are depicted in Classical art with great frequency and great beauty. In fact, it would not be difficult to produce a whole book on horses in Greek and Roman art from the British Museum collections. At the same time, whole books could focus on the

enchanting horses that curvet and gallop through countless gorgeous Persian and Mughal paintings; on the innumerable horses, both aristocratic and common, that appear in the drawings, engravings and prints of post-medieval Western artists, or those that are so stylishly and vividly depicted in the arts of China and Japan. I have tried to make a balanced selection between numerous themes, cultures, areas, dates, materials and object-types, and to highlight cross-cultural comparisons by juxtaposing images of different dates and from different areas. Where I have failed, I am myself to blame, but where I have succeeded, my generous and knowledgeable colleagues must bear much of the credit.

I should like to thank the following colleagues and friends most warmly and sincerely for their help:

Don Bailey, Richard Blurton, Anne Braude, Sheila Canby, Isabelle Causse, Dominique Collon, Barrie Cook, Jill Cook, Stephen Crummy, Angela Evans, Sally Fletcher, Joanne Freeman, Sue Hardman, Karen Hughes, Jayne Krentz, Marcel Maree, Carol Michaelson, Sheila O'Connell, Mavis Pilbeam, Jenny Price, James Robinson, Judy Rudoe, Judith Swaddling and Hilary Williams, together with all those colleagues in the curatorial departments of the Museum who arranged for the photography of objects, and the British Museum photographers who have actually taken the pictures. The Suffolk County Council Archaeological Service were especially helpful with the picture on page 23. I am also most grateful to the designers, Price Watkins, for their work, and to my colleagues in the British Museum Press.

Catherine Johns

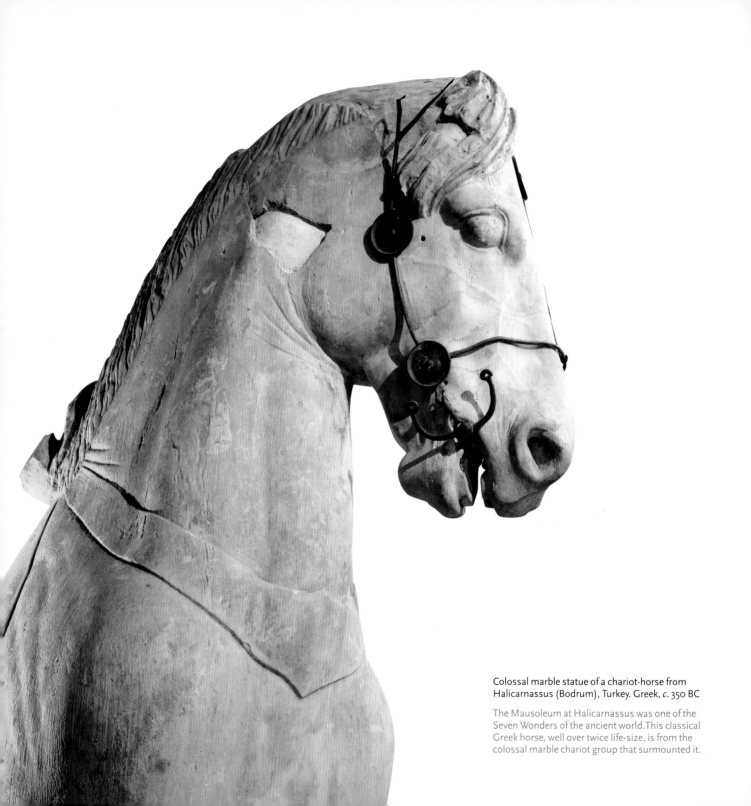

Colossal marble statue of a chariot-horse from
Halicarnassus (Bodrum), Turkey. Greek, c. 350 BC

The Mausoleum at Halicarnassus was one of the
Seven Wonders of the ancient world. This classical
Greek horse, well over twice life-size, is from the
colossal marble chariot group that surmounted it.

HORSES AND HUMANS

PEOPLE love horses: they have always occupied a special place in human consciousness. They are beautiful creatures whose form and action appeal powerfully to human sensibilities, but these are not the only reasons why they have so frequently been represented in art. The role they have played in human societies since they were domesticated some six thousand years ago has been so crucial that it is no exaggeration to say that the development of nations and cultures would have been quite different had they not existed. This book is an attempt to illustrate the relationship of humans and horses through the ages, using images of the horse in art from prehistory to the present day.

Evolution

The ultimate origin of the horse is chronologically remote. About 60-55 million years ago, in the Eocene epoch of the Tertiary period, long, long before our own earliest hominid ancestors came into existence, a small, dog-like mammal walked the earth on padded paws, browsing on soft foliage and fruit. It had four toes on its front feet and three on its hind feet, and it was no bigger than a fox. This animal is still popularly known by the poetic name bestowed on its fossil remains in the late nineteenth century by the American palaeontologist O.C. Marsh: *Eohippus*, the dawn horse. But it was not yet a horse by any conceivable definition of that word, and was ancestral to other genera of animals, such as present-day tapirs and rhinoceroses, as well as to horses. With the advance of scientific research it transpired that the American *Eohippus* was the same genus as fossil remains that had been noted and described from Eocene deposits in the London area by the British scientist Sir Richard Owen in the 1840s. He had called it *Hyracotherium*, and this, its original scientific name, takes precedence. Its use is preferable to *Eohippus* for reasons other than pure scientific convention. *Eohippus* is too romantic and evocative a word to be entirely forgotten, but it may have contributed to a totally false and oversimplified popular perception of a miniature 'horse' whose direct linear descendants grew steadily larger over the hundreds, thousands and millions of years until they had become large enough for us to recognize them as ponies.

In fact, *Hyracotherium* stood at the beginning, not of a single line of descent but of an extremely complicated evolutionary process that led, over many millions of years, to the modern genus that we call *Equus*, which comprises horses, asses and zebras. The most complete fossil records of this many-branched family tree are from North America, and they reveal not only continual adaptation in response to changing climatic and environmental conditions, but also many side-branches which were evolutionary dead ends.

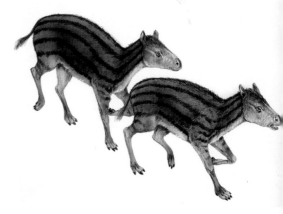

Hyracotherium, the remote ancestor of the horse

An artist's reconstruction suggests the possible appearance of the small animal from which equids and other related species are descended.

Evolution is not a linear progression but a much more intricate system of innovation, adaptation, change and demise, so many fossil groups on that tree have no modern descendants. Equids spread out over the primeval land bridges into the landmasses that eventually became Europe, Asia and Africa, and perhaps by some four million years ago had developed into various types, species and subspecies of the modern genus *Equus*.

By then, they walked and ran, not on multi-toed paws, but on a solid, undivided hoof, the 'fingernail' of the ancestral third toe, and their teeth and digestive systems had altered so that they could eat not only soft vegetable food but hard, fibrous grasses and grains. They became grazers rather than browsers, animals of the open steppes and grasslands rather than lush forests with shrubby undergrowth, able to move fast over long distances. Much later, the arrangement of their highly specialized teeth, with a considerable gap between the incisors and the large grinding molars, was to prove very useful to the enterprising humans who first devised the bridle and the bit.

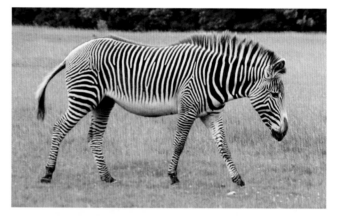

An immensely long period of time was still to pass before the clever and mischievous primate known as *Homo sapiens* made its first appearance, in the Quaternary era around half a million years ago. Populations of wild horses, asses and zebras would have adapted to suit the environments in which they lived, but the attempts that have been made in the past to postulate clear subspecies or types that were directly ancestral to the main groups into which we divide present-day horses are not especially enlightening. In hot, dry climates, animals whose physical features help to keep them cool, such as long, slender limbs, short coats and large ears, survive more easily; in colder, damper areas, heat-conserving characteristics such as heavy and stocky conformation, thick fur and small ears are more advantageous. They may look different but still belong to exactly the same species, self-selected for type simply because the individuals whose bodies are best suited for survival are those that mature and reproduce most successfully and pass on their qualities. Modern breeds of various domestic animals, created through selective breeding under human control, demonstrate the wide variations possible within the same species.

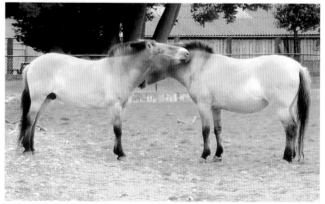

Genuinely wild populations of zebras and of asses, both African and Asian, still exist, though most are under threat, but only one species of true wild horse has survived to the present day, namely *Equus ferus przewalskii*, the Mongolian wild horse discovered in the late nineteenth century. Though this engaging beast followed other wild equids, such as the tarpan (*Equus ferus ferus*), into extinction in the

Wild equids

TOP: Grevy's zebra (*Equus grevyi*).
ABOVE: The Mongolian wild horse (*Equus ferus przewalskii*), rescued from the brink of extinction in the 20th century.

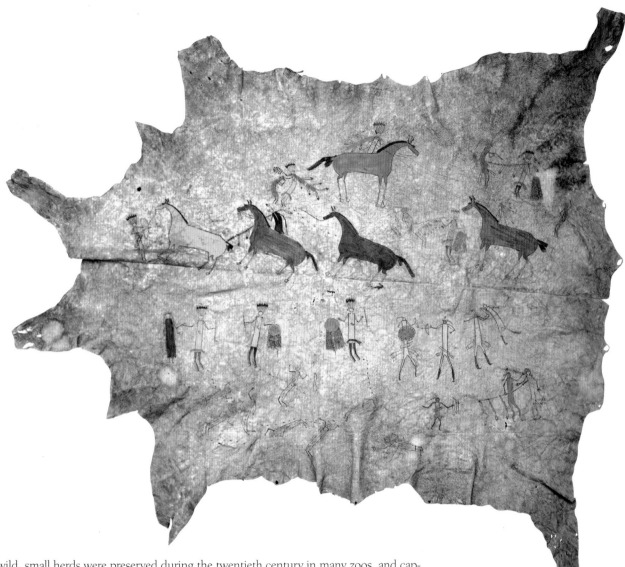

wild, small herds were preserved during the twentieth century in many zoos, and captive breeding has now restored the numbers sufficiently for the species to be cautiously reintroduced, under controlled conditions, into the wild. Przewalski's horse, with 66 chromosomes rather than the 64 possessed by the domestic *Equus caballus*, is probably not a direct ancestor of any modern domestic horse, but a separate, though very closely related, species. Its physical appearance, however, is extremely similar to that of the equines depicted in the earliest art of the Palaeolithic period.

Herds of feral horses and ponies, animals that live in the wild but are descended from domesticated stock, are still found in many parts of the world. An interesting sidelight on the spread and evolution of *Equus* is that the American continent, where

Horses in the New World

A Native American (Blackfoot) buffalo-skin robe, made in the 19th century, is decorated with painted scenes that tell a story. Mounted warriors play a part in the tale.

the earliest fossil traces of equids are so well represented and studied, has no indigenous horses today. Around the end of the last Ice Age at about 10,000 BC (very recently in geological terms), equids and several other large mammals became extinct in the Americas, for reasons which probably involved both climate change and human agency. Horses were not to be seen there again until the early sixteenth century AD, when the *conquistadores* introduced their splendid Spanish horses and their pack-mules and donkeys. All the domesticated breeds and feral herds of North and South American horses, including the hardy mustangs that embody so perfectly our notion of a wild horse, are descended from these animals and from the other European horses imported by successive waves of immigrants to the New World.

Domestication

Men and women – and indeed, children – are frequently able to tame an individual young wild animal, such as a lion or a badger, but the domestication of a whole species is not only a much slower process, but fundamentally different, involving adaptation on both sides, a kind of social co-evolution. Over many generations, domesticated populations come to differ in certain ways from their wild progenitors; their evolution takes a slightly different path, alongside that of the humans who exploit, but also protect, them. Relatively few species have become 'domestic animals', and those that have all exhibit innate social and behavioural patterns that have enabled them to adapt to life with *Homo sapiens*, as well as physical changes as compared with wild populations. Domestication is not simply imposed on other animals by people. Even though humans are the dominant partners, domestication is to some extent a process entered into jointly by two species, to their mutual benefit.

For many millennia of early human prehistory, horses were amongst the wild animals hunted to provide meat and other desirable products for human use, such as bones and skins. The first artists painted and engraved pictures of their prey on bone and stone, not primarily to display their splendid creative skills, but from religious and magical motives. Horses took their place amongst wild cattle, reindeer and other quarry, yet already seem to have been of particular interest and importance. Though the wild horses known to our remote Stone Age ancestors were quite small by our standards, even diminutive ponies are extremely strong and can move very rapidly. To hunt them successfully, Stone Age people, running on their own two feet and equipped only with weapons made from wood and stone, would have needed to understand the animals' behaviour patterns well, and to be able to anticipate their actions. It was this kind of knowledge, based on careful observation, that eventually made possible the domestication of animals, because it enabled people to exploit and modify the natural and instinctive behaviour of other species.

A covered mule-cart engraved on a Roman gemstone

Mule-carts were a common means of transport in the Roman world. This sard gemstone is only 13 mm long, and was made for setting in a piece of jewellery.

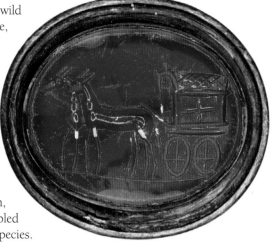

Horses and donkeys were domesticated comparatively late compared with other animals, probably around 4000 BC in Western Asia. By that time, people in many parts of the world were no longer reliant on hunting and gathering their food, but had become nomadic stockbreeders or settled farmers, raising livestock such as cattle, sheep and goats and, in the static communities, growing and harvesting food plants. They still hunted wild game, but could now do so with the assistance of domestic dogs, the close animal companions who also helped them to protect and control their flocks and herds. Their needs for meat, milk, skins and wool were being met, and it may not have been immediately obvious to them that the horse had anything more to offer than the occasional thrill of the chase and a different type of meat.

The horse did have something more to offer. It had the potential to bring about nothing less than a revolution in power and transport, a dramatic development that transformed the ability of humans to wage war, to conquer other groups of men and women, to enlarge their territories, to travel, and thereby to spread their own culture, language and way of life. The horse, its cousin the donkey, and the deliberate human hybridization of those two, the mule, made it possible for people to move further and faster than ever before, carrying their possessions with them and defeating opposition amongst populations that resisted their onslaughts. Horses and donkeys can carry and haul heavy loads as effectively as cattle, and can do so faster and on considerably less fodder and water: horses are also the only animals that are truly comfortable for people to ride bareback, that is, without carefully designed and constructed saddles or seats. Their natural herd mentality and behaviour patterns, when intelligently and sympathetically utilized, make them willing and able to follow instructions and to go in the direction, and at the speed, desired by a human rider or driver. These abilities and characteristics were to become indispensable to humans, and have remained so for thousands of years.

Scholarly research into the process of equine domestication has been a hot topic for generations, and new discoveries and theories continually emerge. In recent years, genetic research based on the analysis of mitochondrial DNA has suggested that domestication was not a single event that took place at one location and one point in time and then radiated outwards. It was more likely a series of episodes in different places and times that resulted in the domestication of horses from a number of separate wild populations, thus providing a wide range of genetic material within the single domestic species, *Equus caballus*. We should always bear in mind, however, that the archaeological and scientific evidence for the earliest phases of taming and domestication can never be complete or unequivocal. We need to remember the old rule that absence of evidence is not the same thing as evidence of absence: not all domesticated animals, let alone individually tamed, semi-domesticated ones, will have left archaeological traces that we can interpret. At the same time, some of the evidence that has been

A Persian riding a donkey, painted by a Greek artist *c.* 470 BC

The vessel is an *oinochoe* (wine-jug), made in the red-figure technique of Greek painted pottery. It was found at Cerveteri, Italy.

used to support the theory of domestication at given sites is not incontrovertible but merely suggestive. There are undoubtedly many discoveries still to be made on this subject.

Much debate has also taken place over the question of whether driving or riding came first. Even if horses were initially being caught and tamed from the wild or captive-bred mainly as providers of milk and meat, the idea of using a docile and biddable equine to carry or pull a load would have been fairly obvious, and the contours of a horse's back, unlike that of an ox, positively invite the idea that a person might be able to sit securely astride it. The courage and confidence required by the first individual to bestride a horse in any given community should not, however, be underestimated. The two ideas, draught and riding, must always have been interconnected, and it is probably futile to try to separate them. By later prehistory in Europe and Asia, in the technological phases we call the Bronze and Iron Ages, we know that horses were being used for both purposes, and the archaeological evidence includes not only equine bones and teeth that show probable signs of domestication, but also artefacts related to the exploitation of the horse, ranging from bridle-bits to representations, in the art of some sophisticated cultures, of horses actually harnessed to chariots or carrying riders.

If a person wishes to control an animal, assuming it is already tame and non-aggressive, he will devise some sort of collar or harness out of rope or leather. The obvious solution is generally a plain collar around the animal's neck and a leash attached to it. But horses, even small ones only 12 or 13 hands high,[1] are too strong and heavy to be controlled with a simple strap around the neck and a lead; if the horse pulls one way and the man the other, the horse is likely to win. A halter or headstall fitting around the head works much better in persuading a horse to go in a specified direction, whether the human is merely walking and leading it or is sitting astride its back and encouraging it to move forward as required.

The evolution of the bridle and the bit, as well as the many different forms of harness for enabling a horse to pull a load, is another tale that can never be told in detail: the earliest phases have left neither written nor material evidence, and a very rare and fortunate concatenation of events would be needed to preserve even a single rope bridle with a wooden or bone bit from prehistoric times. There would surely have been many different occasions on which unknown geniuses came up with the idea of adding a mouthpiece to a headstall,

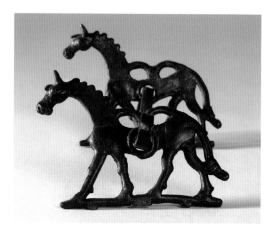

Bronze bridle-bit from Luristan, Iran, *c.* 1400–650 BC

This prehistoric bit has cheekpieces in the form of stylized horses.

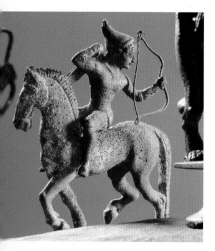

An ancient feat of horsemanship: an Amazon warrior turns to draw her bow to make the Parthian shot

The figure is from a bronze vessel made around 480 BC and found at Capua, Italy. It is of either Greek or Italian manufacture.

a smooth, firm bar resting on the horse's gums in the diastema, that useful toothless gap between its incisors and molars. Even at its simplest, the bit refined the rather crude process of pushing, pulling, driving or goading tame horses into something more complex and precise. Some ancient bits, though happily not all, were cruelly harsh to the horse's mouth, but the combination of bit design and the hands of the horseman (or horsewoman) can effect anything from brutal domination to gentle persuasion. Good horsemanship, an almost symbiotic relationship between horse and human in which small and often subtle signals convey the handler's wishes to the horse, and the horse complies, was present from the very beginning, or horses would never have learnt to serve the purposes of human masters at all.

Most popular books dealing with horses devote much space to the numerous modern breeds, thought to be close to seven hundred at present. Many distinct varieties of horses and ponies are represented in ancient and medieval art, and we can assume that selection for different tasks was always based on attributes such as strength, size, speed, boldness or docility, and even on factors as superficial as colour. Animals that excelled in certain ways would certainly have been selected for breeding, in the hope that they would pass on their virtues. Nevertheless, the strict definition of *breed*, with its implications of stud books, pedigrees and the highly regulated and recorded matings which result in fairly reliable transmission of many required characteristics, is a modern one, going back no further than the late seventeenth century. Although we have not yet learnt nearly all that there is to know about genetics and inheritance, these subjects are far better understood than they were a few centuries ago. It is best to avoid the word 'breed' in connection with ancient domestic animals, and to speak rather of varying *types*, in the way that a modern hunter or cob is a type of horse, rather than a breed.

Warfare

It is easy to list the extensive range of activities in which horses have supported and assisted humans over the ages – transport, draught, warfare, agriculture, industry, hunting, racing, ceremony, display of status – but it is harder to separate those functions clearly, for they tend to blend and overlap. The horse's natural ability to run and jump has been made to serve humankind's love of hunting, entertainment and competition, while the actions of the war-horse, based on fighting, have been further formalized into games and sports, ceremonial display and even the intricate athletics of modern dressage.

Our evidence for the precise ways in which horses were used by different cultures during the first millennium BC is sparse, but warfare and display seem to have been of paramount importance while the species was still too special and expensive

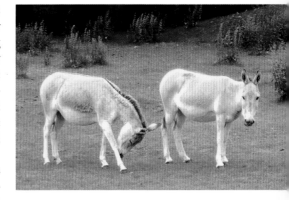

The Asian wild ass, or onager

This species, *Equus hemionus onager*, features in the art of ancient Assyria, where it was hunted and possibly part-domesticated. It is now a rare wild animal.

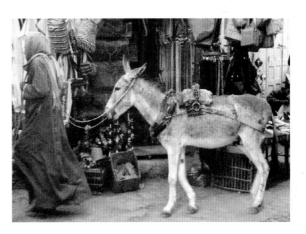

The domestic donkey, *Equus asinus*

The domestic donkey has played a major part in human societies, and continues to do so, as a reliable and inexpensive beast of burden. This individual, harnessed for draught, was photographed in the *souk* at Aswan, Egypt.

to be used for humble everyday purposes. The respective parts played by cattle and by different equine species, namely horses, asses, onagers, and hybrids of all these, therefore remain somewhat hazy. Cattle continue to be used for heavy draught and for agricultural tasks, such as ploughing, up to the present day in many areas. Donkeys and horse/donkey hybrids (mules and hinnies)[2] are generally rather less satisfactory to ride than horses, but have often been preferred as pack- and draught-animals. All domestic donkeys (*Equus asinus*) are descended from the African wild ass (*Equus africanus*), but the onager, or Asian wild ass (*Equus hemionus*), may have been at least partially domesticated in ancient Assyria, and seems sometimes to have been kept in captivity specifically in order to produce donkey/onager hybrids, a kind of mule for which we have no modern word. The social organization of the African wild ass (and of two of the three surviving zebra species, none of which has ever been domesticated) is different from that of horses, and this is why, although donkeys are strong, intelligent and docile creatures, they behave differently from horses and have a reputation for intractability.

Horses appeal far more powerfully to human aesthetic perceptions than donkeys. They can look showy and spirited, especially when decoratively caparisoned in colourful and elaborate harness, and therefore confer great prestige on the person who rides upon or behind them. Fine horses, those that were handsome and well-trained, were valuable luxury possessions, and the ownership and mastery of them became a sign of superior social standing. The mounted man is physically set above those who are on foot, and his ability to control a large, strong (and often male) quadruped symbolized his power. It was probably this symbolic impact, as well as the practical advantages of speed and strength, that made the image of the mounted or chariot-borne warrior such a significant one in prehistoric antiquity. In the Bronze Age art of the Classical world, and in that of ancient Egypt and Assyria, the horse-drawn chariot appears, not as a mundane means of transport, but as a warlike emblem of wealth, strength, power, leadership and royalty.

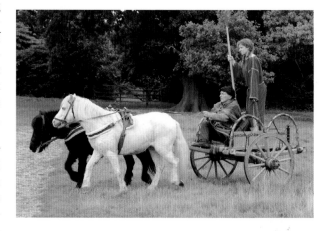

Chariot warfare had died out in the Graeco-Roman world by the fourth century BC, but we know that it was still practised amongst the late Iron Age tribes of Britain at the time of the Roman invasion in the first century AD, and we have both written accounts from Roman sources and archaeological evidence of chariots. Compared with the elegant creatures, with their slender legs and refined, aristocratic heads, that we see harnessed to chariots in the art of the ancient Near East, Egypt and Greece, the diminutive shaggy native ponies of the Iron Age Britons may seem unimposing, but the skill required to manoeuvre such a vehicle in battle, and to hurl weapons accurately while standing in it and moving at speed over uneven

Reconstruction of a British Iron Age war-chariot

This working reconstruction, drawn here by a pair of Welsh ponies, was made in 2002, and was closely based on archaeological evidence from excavated chariot-burials.

ground, must have been extraordinary. Two-wheeled chariots remained in use in the Roman world, but only for ceremonial purposes and for racing rather than battle, another example of the mutation of one tradition into another, of war into a display, game or competition.

The mounted warrior also appears early in the art of the ancient Near East and the Classical world, and the development of riding and chariotry was paralleled much further east, in ancient China and amongst nomadic Asian tribes. Although there are some representations of riders from a period as early as around 2000–1600 BC in Mesopotamia, they show an insecure style of bareback riding, with the rider perched well back towards the animal's rump. By the ninth century BC, however, Assyrian art reveals confident mounted soldiers using very distinctive and elaborate bridles. Even without saddles and girths, skilled riders were already well able to control their mounts and to use weapons effectively from horseback. The iconic images of Alexander the Great in the fourth century BC riding his beloved black stallion Bucephalus ('Ox-head'), one of the most famous horses in history, exemplify the Greek style of riding, completely bareback, or at most with a cloth or pad on the horse's back, and no girth.

It is widely supposed that truly effective cavalry did not, and could not, exist until the invention of the stirrup, which was developed in China and first adopted in the West in the seventh or eighth century AD, because a rider could not wield weapons easily when so insecurely mounted. This is at best a half-truth. There were always skilled horsemen and horsewomen who rode securely and confidently bareback, but in any case, by the time of the Roman Empire, cavalry saddles made on a rigid framework (a saddle tree) had come into use. These were designed with projecting padded 'horns' that partially enclosed the rider's thighs and provided a very secure seat without any need for stirrups. Roman cavalry units were auxiliary troops normally recruited from provinces where there was already a strong native tradition of good horsemanship, and modern research and practical experiments have proved beyond doubt that their equipment worked so well that stirrups, though certainly a very important invention, were not quite the revolutionary improvement that has long been supposed.

By the Middle Ages, war horses were being specially bred for size and strength

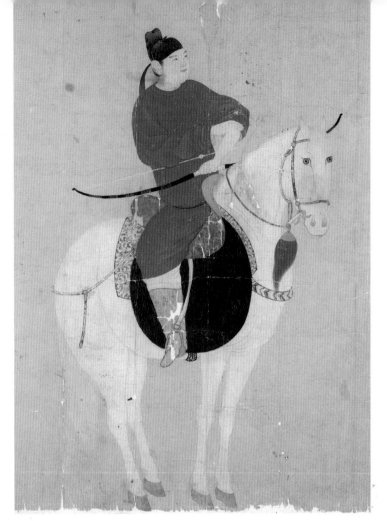

A Chinese nobleman on horseback

Silk handscroll painted by the artist Qian Xuan (c. AD 1235–1300) and dated 1290.

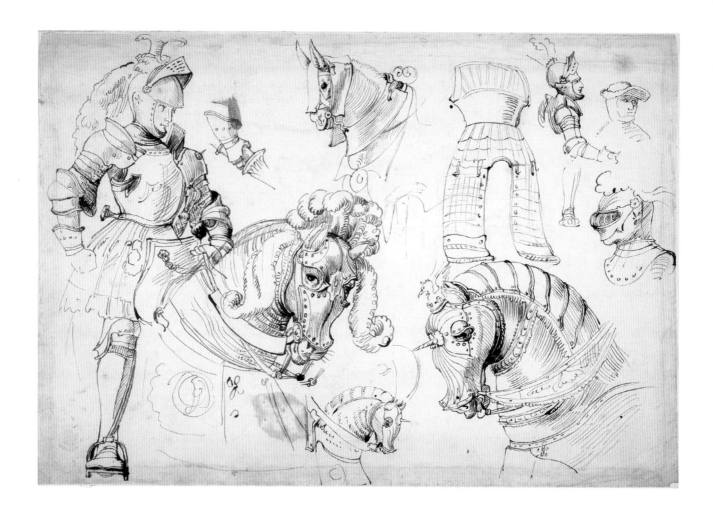

rather than speed and agility, and were clearly differentiated from quality riding horses, common hacks and draught horses: there were many terms in English to describe different kinds of horses, and even now, when the words are no longer in common use, we should be surprised to read of a lady mounted upon a destrier, or a knight riding a palfrey. War-horses needed to carry not only a heavily armed and armoured rider, but also a substantial amount of metal armour of their own, and to be able to withstand the heavy impact of charges with a long lance. Horse-armour was nothing new, but it reached its apogee in the late medieval period both in the Western world and in the East.

People continued to depend upon the horse in warfare right up to the twentieth century, the First World War (1914–1918) being the last major conflict in which regular cavalry played an important part. The immense number of valuable riding horses, humble draught horses, and pack-animals, mostly mules, that died in the service of the universal human lust for power, conquest and new territory is a matter

of sorrow and shame. The equine servants of mankind have paid a heavy price, not only on the field of battle itself, but from the cruel privations of marches with insufficient food and water and on the long sea-transports that took the Spanish conquerors to America or the British troops to the Crimea. On some voyages to the New World in the sixteenth century, up to half of those fine, highly bred and valuable Spanish horses never set foot on the newly discovered continent. They died at sea, and their bodies were thrown overboard. The descendants of those who survived the journey are now the feral horses and the numerous high-quality domestic breeds of North and South America.

Transport

The use of the horse in everyday transport and in agriculture is rather more difficult to trace in the art of the ancient world, because these activities are less commonly represented than the spectacles of battle and ceremony. Horses or donkeys harnessed to four-wheeled carts are depicted very early indeed, for example on the so-called Standard of Ur (c. 2500 BC), but in spite of the unwieldy design of the ancient Sumerian vehicles, the context is war rather than everyday life. Light two-wheeled chariots proved much more practical and manoeuvrable on the battlefield but the development of heavy four-wheeled vehicles continued, and by the Roman period they were in widespread use, drawn by equids as well as by oxen. Provincial Roman relief sculpture sometimes shows heavy covered wagons that would have been used for transporting fairly large loads of people and goods. The iron *hipposandal* and the nailed horseshoe, designed to protect the equine hoof on both hard and waterlogged surfaces, were both invented in the Roman period, but were not in everyday use.

The excellent metalled roads of the Roman Empire were allowed to fall into total disrepair during the rise of the medieval states in Europe in succeeding centuries, and although horses had become common and cheap enough to be used for draught and even agricultural work, there could be no fast horse-drawn traffic over the rough tracks that served as roads throughout the medieval and early modern periods. By the late seventeenth century, however, road networks started to improve, and for around 250 years there was a *floruit* of horse-drawn transport of many kinds, from the showy carriages of the wealthy to the public stage-coaches. This lasted only until horse-power was increasingly displaced by the rise of the railways and then of motor vehicles. By the early nineteenth century, there were dozens of different kinds of horse-drawn vehicles for different uses, even more than the considerable variety that had existed in the Roman world. City streets were thronged with horse-drawn omnibuses and cabs for hire, delivery vehicles, dustcarts and fire-engines, expensive private carriages and light sporting vehicles. Most of the larger and heavier vehicles were drawn by two or more horses, and required complex harnessing and some skill on the part of the driver.

Hunting on horseback

This vignette of an aristocratic huntsman is part of the sumptuous and colourful enamelled and gilded decoration on a glass flask made in Syria in the middle of the 13th century AD.

Crashes and fatal accidents in traffic were a hazard long before the motor-car had been thought of. The traffic may not have moved very fast by our standards, but it could still be dangerous.

Horses remained a fairly familiar sight on urban streets, and a very common one in the countryside, until about the middle of the twentieth century in northern Europe, but both horses and donkeys are still to be seen today alongside urban motor traffic in many other parts of the world. Equine animals still play their age-old part in transporting goods.

Hunting, racing and equestrian sports

Hunting is an essential activity for carnivores, and as we have noted, in remote prehistory horses were the prey rather than the partners of *Homo sapiens* who were searching for meat. As soon as human communities had domestic horses to ride, and domestic dogs to help them chase and catch their prey, they could hunt far more effectively, yet by the time that had happened, they had also learnt how to keep and breed domestic animals such as cattle and sheep, which they could slaughter as required for food. Hunting, at least of larger game, was no longer necessary for survival, but it had become a sport, a test of courage and skill, an opportunity to display superior riding skills and handsome mounts, and thus, a signifier of high social position. It acquired a symbolic significance which it has not completely lost to this day. All ancient and medieval societies were obsessed by the hunt, and there is an unbroken hunting tradition from antiquity through the medieval centuries to the present.

The horse's innate aptitude for running very fast and jumping obstacles was exploited, not only when other swift animals, such as deer, were to be hunted, but also for straightforward racing competitions. Probably all horse-owning societies have con-ducted at least some informal races, because humans cannot resist competition. In the Classical world, it was chariot-racing rather than racing riding-horses that developed as a major leisure industry; the winning horses and charioteers became celebrities, whose names and images featured on popular souvenirs, and the supporters' partisan feelings sometimes erupted in riotous behaviour of the kind familiar amongst some modern football fans. There is plenty of visual evidence for Roman racing, and it was clearly a thrilling but extremely dangerous sport. Controlling a *quadriga*, a team of four horses harnessed side by side, at high speed on a track with very tight turns required a degree of courage and skill even beyond that of modern steeplechase horses and jockeys, and regularly led to fatalities, both equine and human.

The rise of modern horse-racing in the eighteenth century is a long story in itself,

Chariot-racing

The Greek coins of Syracuse (Sicily) are amongst the most beautiful coins from the ancient world. This silver decadrachm of *c.* 413 BC shows a *quadriga* with the goddess Nike (Victory) hovering overhead and extending the victor's wreath to the charioteer.

and is inextricably bound up with the development of the Thoroughbred breed, but harness-racing of a specialized kind still remains very important in some countries, with one American breed, the Standard Bred, dedicated to that purpose. Instead of the flat-out gallop of the Roman chariot-race or the modern flat-race or steeplechase, these animals use more restricted gaits, the trot or the pace, to achieve an equally impressive and competitive contest of speed and agility.

Competitive equestrian sports and games, ranging from show-jumping to dressage competitions and polo, have all developed from the desire to display the skills of horse and rider working as a team and carrying out complex feats of speed, agility and strength. Running fast, leaping over obstacles, manoeuvring deftly in restricted spaces and even displaying, in a controlled form, the aggressive fighting skills of the stallion protecting his mares, have all been woven into formalized games and sports in which the strength and skill of horse and human are integrated.

A game of polo

This Indian painting in Rajasthan style dates from about AD 1750. Traditionally polo was played by both men and women, and the players in this picture are all female. The British first encountered the game in India, and adopted it themselves with enthusiasm.

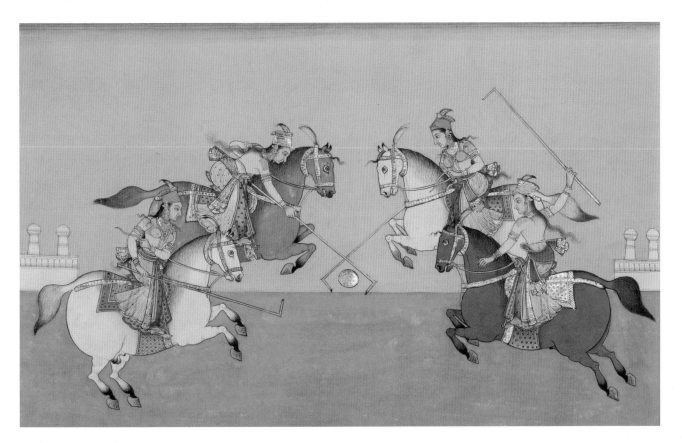

Display and ceremony

The acceptable face of war includes celebratory parades, pageants and military games, blending almost imperceptibly into state, religious and personal ritual marking great occasions, the age-old pomp and circumstance of formal display. From antiquity to the present day, chariots, other horse-drawn vehicles and riders have been vital in such events. Horses lend to the human participants on these occasions a special glamour and dignity, and the very word 'cavalcade' incorporates the idea of horses as a central element in an impressive procession. On modern state occasions, a procession in which the central participants ride in an elaborate antique coach drawn by a team of four or six matched carriage-horses and flanked by mounted outriders, cannot fail to be more memorable than one consisting of a series of motor limousines. In countries where horse-drawn vehicles are no longer used as everyday transport, important human rites of passage such as weddings and funerals are still sometimes graced by the use of the more ancient form of conveyance. A gleaming motor hearse inspires solemn feelings in those who watch it drive by, but the sight of the traditional funerary carriage with its bevelled-glass sides, drawn by proudly stepping black horses wearing black plumes on their heads, is something even more evocative because it embodies such a venerable tradition, the connection between past, present and future that is always brought to mind by the cycle of human life and death. The horses make a fundamental difference, because they are beautiful in themselves and because they have performed these noble tasks for countless generations.

Ancient art is replete with representations that immortalize pageants and processions featuring riders and horse-drawn vehicles. The Panathenaic procession depicted on the Parthenon frieze is one such, and it brings vividly to life a great religious and state festival in ancient Athens. In a Roman triumph, a victorious general was borne on a richly decorated ceremonial chariot when he received the accolades of the people, and in the medieval joust, knights would display their colourful heraldic splendour in ritual fights. Events of this kind lose much of their impact without horses, and some, like jousting, are impossible without them. Equine participation is part of the very fabric of human ceremonial display, because any human, however important, looks more impressive on a horse.

Consequently, the equestrian statue or portrait has been favoured over the ages for honouring men, and occasionally women, of great fame, status and

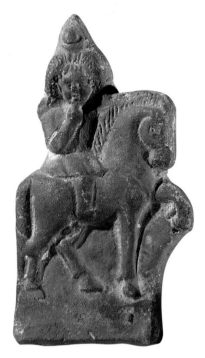

The god Harpocrates riding in a procession

A terracotta figure made in Egypt in the Ptolemaic period, in the 2nd century BC. The ceremonial wreath worn by the rider is of a type worn by those taking part in religious processions, and his gesture, with his finger to his lips, identifies him as Harpocrates.

Copper-alloy statuette from Benin, West Africa

An African dignitary of the 16th century AD displays his power and importance on horseback.

achievement, from mounted Roman emperors to mounted Boer War generals. The status of any hero, whether historical or mythical, is enhanced by a horse, best of all a named, individual horse regarded as the hero's constant partner, as in the cases of Alexander the Great and Bucephalus, or the legendary Persian warrior Rustam and his noble and courageous red horse Rakhsh.

In certain societies, the horses of an important man or woman were sometimes buried with them. Horse-burials are one of the archaeological sources for information about ancient bits, bridles, saddles and other equipment. In China, horses and vehicles were being entombed with rulers as early as the Shang dynasty (1600–1100 BC), but perhaps the most famous examples are the fifth-century BC tombs of Pazyryk in Siberia, where freezing conditions preserved fragile and colourful organic materials such as wood, cloth and felt, and thus revealed the full range of the elaborate and decorative panoply of man, woman and horse in a nomadic, horse-dependent prehistoric society. In Britain, not long before the Roman conquest, some Iron Age tribes still buried leaders (male and female) with their vehicles and the trappings of their ponies, and as late as the early medieval period, the grave of an Anglo-Saxon warrior found in Suffolk followed the same tradition.

Whether the horses themselves were sacrificed to accompany their people to the grave, or whether the horse-related equipment alone was buried, and the lives of the horses themselves spared, the immense symbolic importance of these animals in the life and death of their wealthy and influential owners is clear.

Training and management

Just because horses can survive without human intervention in the wild does not mean that their domestic equivalents can look after themselves: domestic horses require a considerable amount of attention to their health and comfort. As physically specialized animals, their legs and feet in particular are subject to a range of disorders, and failure to prevent or treat these can be disastrous. As soon as horses were domesticated, it must have become obvious that certain people had a natural empathy with them, and were able to take care of them, train them and control them much better than others.

There are occasional representations from antiquity of the everyday care of horses, such as the scene within the camp of the Assyrian army in a ninth-century BC wall relief. However, it is only in comparatively modern times that genre scenes of everyday life, as opposed to the great events of war, state and religion, began to be regarded as appropriate subjects for serious art, so such things are somewhat rare. The earliest, albeit fragmentary, written records of horse management go back to the second millennium BC in Western Asia, but the work of the Athenian general Xenophon, writing in the fourth century BC, is the fullest and most important evidence for ancient attitudes to horse-keeping. His book *Peri hippikes* (*On Horsemanship*) is a detailed manual

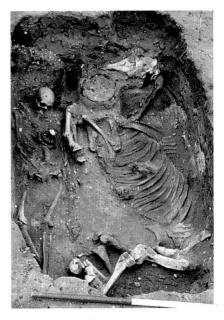

A horse-burial from the 6th century AD

In this early medieval grave excavated at Lakenheath, Suffolk, in the late 1990s, an Anglo-Saxon warrior and his mount were found buried side by side.

on the selection, training and care of the horse, and is no mere curiosity of Classical literature. It has continued in use as a practical guide for some 2,400 years, and many of its recommendations are still endorsed today. His treatises on hunting and on the duties of a cavalry commander also survive.

Specialized medical care for horses, donkeys and mules existed from early times, and used the same mixture of common sense, herbal and other natural remedies, and fanciful superstitious practices that marked the early evolution of medicine for humans. The Roman army employed *veterinarii* and *mulomedici* to see to the health of mounts and pack-animals, and even within the context of modern scientific veterinary practice, the doctoring of equine animals, especially Thoroughbred racehorses, remains a specialist one with its own traditions.

Myth and symbolism

People have always invested nature, including other animals, with symbolic meanings and mystical powers. Humans are the ultimate generalists. Although we can do most of the things that other land animals do, we often cannot do them nearly as well as species that are more specialized. We are not as large, as strong, as swift, as fierce, or even as patient, fertile, silent or cunning as certain other animals, and people have always coveted some of the qualities possessed by the animals they exploit. In religious myth and magical folk-tale, horses take their place as symbols of speed and power, courage and loyalty, beauty and nobility. Horses, often white ones, had mystical associations with gods and heroes in both Europe and Asia, and traces of ancient horse symbolism survive in the medieval literature and the folklore of many countries. It is striking that horses feature even in the folk-tales of some native North American peoples, although those cultures have known the species for a mere five centuries rather than for thousands of years.

To the Greeks, horses were creatures of Poseidon, the god of the sea, who created them as the most beautiful of animals, and there are many named divine horses in Classical Greek literature, such as those who drew the chariot of the sun-god, Helios, across the sky, or the pair that drew the chariot of the hero Achilles – Balios and Xanthos, a grey and a bay sired by Zephyros, the west wind. Many of the horses of Greek mythology were offspring of the winds, a clear allusion to speed as a desirable quality in a horse. Winged horses, and half-horses like centaurs and hippocamps, also had their place in Greek mythology.

The Roman cavalry, made up of men from various provinces of the Empire, looked for a divine guardian not to the Graeco-Roman pantheon, but to the mythology of the Gaulish Celts, where they encountered a goddess, Epona, who was closely associated with horses. Images of this protective and nurturing horse-goddess, and altars dedicated to her, are found along with those to the usual martial deities,

The Buddha on his horse Kanthaka

This brass statuette from Mogok, Burma, 19th century AD, represents the Great Departure of Prince Siddartha. The figures supporting the feet of the Buddha's horse, Kanthaka, are muffling the sound of his hoofbeats as they leave the palace.

Victory, Mars and Minerva, throughout the Empire. In the medieval literatures of both Ireland and Wales, there are indications of an ancient equine goddess who may possibly be linked with the Continental Celtic Epona of late prehistory and the Roman period. In Ireland, the immortal mare-woman was one manifestation of a divine goddess-triad, and was named Macha. In Wales, a medieval tale tells of a beautiful woman named Rhiannon, who was pursued by one of her suitors, Pwyll, king of Dyfed, as she rode an obviously magical steed. Eventually, as his queen, she was falsely accused of the murder of her newborn son, and was forced to do penance by carrying guests and visitors into the court on her back. Her mixed human and equine nature hints at her original status as a pagan horse-goddess.

Horses feature in Hindu mythology, where the sun-god Vivasvat sometimes takes the form of a stallion, and in the Norse sagas, where the great god Odin rode upon an eight-legged horse named Sleipnir, who could fly without wings and move between different states of being, the world of men and that of the immortals. A connection with solar deities is repeated in some of the mythology of the Navajo people. Though even in a moment of triumph and acclaim the central divine figure of Christianity rode upon a humble ass rather than a splendid charger, both the Buddha and the Prophet Mohammed had horses that played a significant part in their lives. The Buddha was carried on his travels, from the moment that he left his princely home, by his horse Kanthaka, no mere beast of burden but a rational individual whose personal thoughts and feelings are recorded in the sacred texts. Horses feature frequently in the tales and traditions of Islam, as might be expected amongst conquering peoples who took pride in the possession of one of the most beautiful breeds of horse, the Arab. The Prophet Mohammed himself ascended to heaven in the year AD 621 on the back of the winged horse Al Burak, who was brought to him by the archangel Gabriel, one of many winged and flying horses in myth and legend.

The Greek Pegasus remains for most of us the very archetype of the flying horse. He was the son of Poseidon and of the Gorgon Medusa; with a blow of his hoof he brought into being the sacred spring Hippocrene, and he carried the thunderbolt of Zeus. The story of Bellerophon, mounted on Pegasus, slaying the monster Chimaera, was one that could be adapted, like so many pagan tales, and given a Christian interpretation, and images of this event from late Antiquity are often to be included in Christian iconography.

The idea of a flying horse is, however, far older and more widespread than its focus in Graeco-Roman culture. A depiction of a horse with huge, feathered wings can look wonderfully plausible, and the idea of flight is no more than an extension of the qualities of speed and grace that are already associated with the species. Winged horses remain popular fantasies, not only

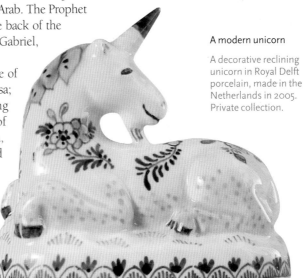

A modern unicorn

A decorative reclining unicorn in Royal Delft porcelain, made in the Netherlands in 2005. Private collection.

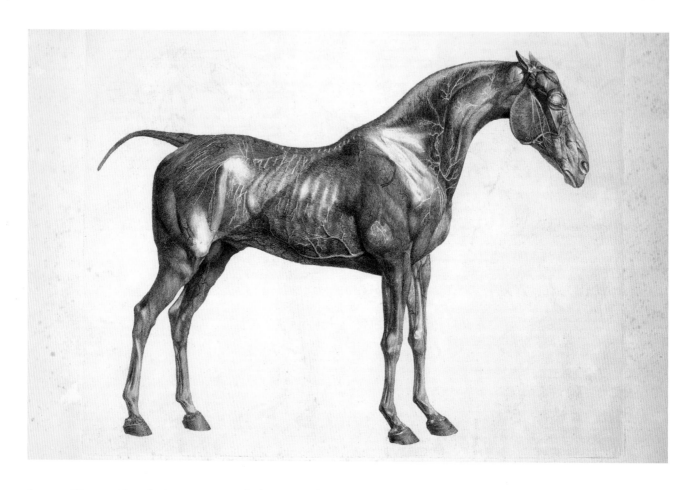

in art and literature but also in commerce and advertising. The winged horse is a super-horse, but remains firmly equine.

The hippocamp, formed of the foreparts of a horse and the tail of a fish, is a less elegant monster but was one of many such beasts combining the realms of land and sea in the world of Classical myth. In late Roman art we find not only fish-tailed horses but marine deer, bulls, dogs and feline animals such as tigers and panthers. The chariot of Poseidon, or Neptune in the Roman pantheon, was drawn by hippocamps, and the creatures were often ridden by Nereids, the sea-nymphs who formed part of the marine section of the entourage of Bacchus. Centaurs, half man and half horse, were also to be found amongst the wine-god's followers. Their standard conformation in Classical art consisted of the torso of a man (or woman, for there were also some female centaurs) rising from the shoulders of a horse, so that all four legs were equine. Like the satyrs (which in older Greek myth also had horses' hoofs and tails, not the goat-like attributes that became usual later), Centaurs epitomized the wild and untrammelled forces of nature, unrestrained by the rational mind, and were given to excessive drunkenness,

The artist as scientist: an engraving from *The Anatomy of the Horse* (1766), by George Stubbs (1724–1806)

This engraving shows the first stage of dissection, a flayed horse with only the skin removed so as to reveal the muscles.

brawling and the sexual molestation of females, vices that are clearly human rather than equine. Yet there were noble centaurs, too, notably Chiron who was famed for his deep wisdom and for his knowledge of healing, music and the arts. He was the teacher of heroes and gods – Achilles, Jason and even Asclepius, the god of medicine himself.

The unicorn, another fantasy horse-hybrid, remains immensely popular. Unicorns are mentioned not only in Classical literature but also in Biblical sources, as though they were an actual living species rather than an imaginary one. We have to remember that it is only in modern times that human knowledge of the world is such that there are few major undiscovered animals left: there were still many natural wonders and unknown mysteries in ancient and medieval times, and the idea of a horned horse may not have seemed too far-fetched. In the medieval period, the 'proof' of the unicorn's existence was provided by the long, straight spiralling tusk of the male narwhal (*Monodon monoceros*), an arctic whale. Such horns were valued trophies credited with many magical powers.

There are Oriental as well as Occidental forms of the unicorn. The *qilin*, or Chinese unicorn, has the body of a deer, the tail of an ox, the hoofs of a horse and a single 'horn' of flesh: it is a gentle, beneficent creature whose appearance foretells the birth of a ruler. More familiar in the West is the medieval, heraldic unicorn – a lightly built white horse, usually with cloven hoofs and a goat-like beard, and with a long, straight, spiralling horn emerging from the centre of the forehead. In medieval times this animal carried a range of symbolism that included purity, chastity and virginity.

Horses depicted in art and objects of use

The beauty of horses has delighted artists at all times and places. Artists who have illustrated historical and mythological events, or who have had the task of portraying and glorifying powerful patrons, have needed, for purely practical reasons, to study horses and to learn to depict them with skill and accuracy, but many have also enjoyed and studied them as a favourite subject in their own right.

Horses appear in art across the ages in many different guises: at a colossal or life-size scale, in marble and bronze sculpture and huge paintings, and at a minuscule size, on coins and gems and jewellery; in minutely detailed and photographically realistic form, or stylized into a few simple, sweeping lines or planes. Representations of horses are not only to be found in what have traditionally been called the fine arts, painting and sculpture: horse imagery has also been used to decorate objects of use and adornment, not only because of the animals' symbolism, but simply because they are so pleasing to the human eye. Horse-shaped or horse-adorned objects have been made in stone and metal, ceramic and glass, wood, bone, ivory and textiles; they are part of the visual and decorative repertoire of most human cultures.

Horses on a pottery container: a Greek *pyxis* made *c.* 760–750 BC

The round ceramic box is decorated in the Greek Geometric style, and four elegantly stylized horses stand on the lid.

The themes touched upon in this brief introduction are examined and illustrated in visual form in the pages that follow. Objects in the collections of the British Museum have been selected to illustrate the range of human perceptions of the horse. These representations come from many different eras of history and prehistory, and from many different parts of the world. All of them demonstrate the fascination with, and admiration for, the horse, a noble and beautiful animal whose contribution to human culture has been profound.

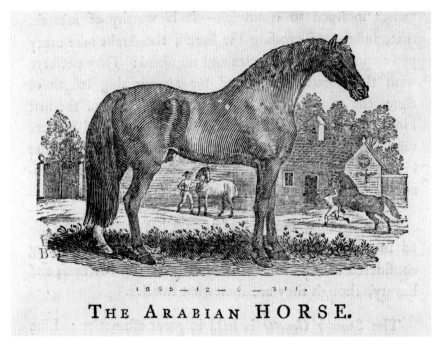

THE ARABIAN HORSE.

The Arabian Horse

A wood engraving by
Thomas Bewick (1753–1828) for
The History of Quadrupeds (1790).

1. The height of a horse is measured at the withers, the slight prominence at the animal's shoulder where the neck flows into the back. The unit of measurement in the English-speaking world is the *hand*, which is 4 inches, or approximately 10 centimetres. Thus, a horse 14.2 hh (hands high) measures 58 inches, or just over 145 centimetres, at the withers. This height is conventionally the dividing line between a horse and a pony, though there are other distinctions.

2. The mule is the offspring of a donkey stallion and a horse mare. Hinnies are sired by a horse stallion on a donkey mare. The two types of hybrid are not identical, and mules have always been more common. Horses and donkeys have different chromosome counts, and mules are therefore nearly always infertile, though very rare exceptions occur.

THE IMAGE OF THE HORSE

THE DAWN OF ART

OUR remote Stone Age ancestors did not domesticate the wild horses who shared their world, but instead hunted, killed and ate them. Horses were one of the prey animals whose meat, fat, skin, hair, hoofs, bones and sinews were used and valued by their human hunters. The vivid and realistic images of horses that they created suggest that the species had great importance in their lives, and possessed symbolic and religious significance.

The five-sided limestone plaque comes from a rock shelter at Monastruc (Tarn-et-Garonne) in France, and was used by a Palaeolithic artist 12,500 years ago to create a

small, mysterious masterpiece. At first sight, the scratched lines seem incoherent, especially as they no longer stand out clearly in white, as they would have done when first cut. But when carefully examined, the design is revealed as the superimposed outlines of three horses and a reindeer. The smallest horse, its ears pricked, is depicted in motion, probably cantering or galloping. It shares its hindquarters, tail and penis with a second, larger horse, which appears to be standing. There are signs of a third horse standing behind the second. Finally, a reindeer occupies the same space. It is drawn with its legs tucked up, probably lying dead on the

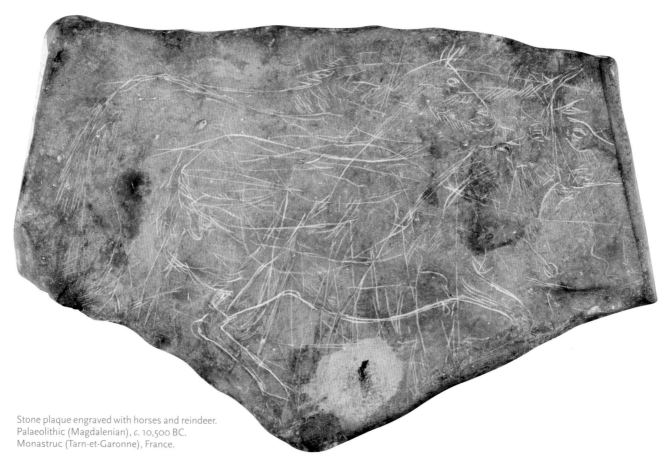

Stone plaque engraved with horses and reindeer.
Palaeolithic (Magdalenian), c. 10,500 BC.
Monastruc (Tarn-et-Garonne), France.

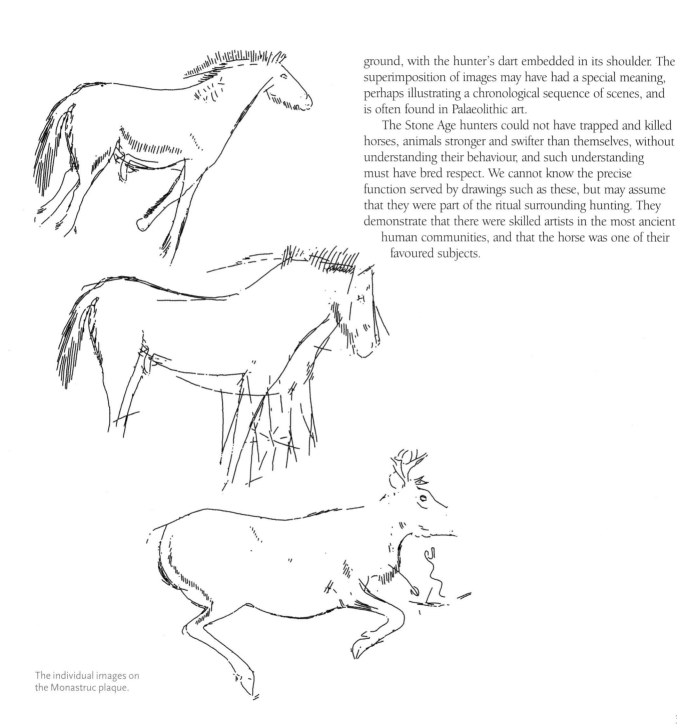

ground, with the hunter's dart embedded in its shoulder. The superimposition of images may have had a special meaning, perhaps illustrating a chronological sequence of scenes, and is often found in Palaeolithic art.

The Stone Age hunters could not have trapped and killed horses, animals stronger and swifter than themselves, without understanding their behaviour, and such understanding must have bred respect. We cannot know the precise function served by drawings such as these, but may assume that they were part of the ritual surrounding hunting. They demonstrate that there were skilled artists in the most ancient human communities, and that the horse was one of their favoured subjects.

The individual images on the Monastruc plaque.

THE DAWN OF ART

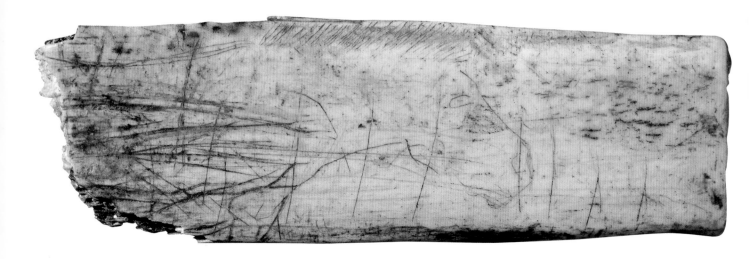

THIS PAGE
A fragment of rib-bone with
an engraving of a horse.
Upper Palaeolithic, c.10,500 BC.
Robin Hood Cave, Creswell Crags,
Derbyshire.
OPPOSITE
George Stubbs (1724–1806),
Horse affrighted by a Lion.
Oil on canvas, 1770.
Walker Art Gallery, Liverpool.

THE engraving of a horse on a small piece of rib-bone dates from around 10,500 BC, and comes from Robin Hood Cave at Creswell Crags. It is the oldest known work of art from Britain. The Palaeolithic artist has accurately portrayed a heavy, deep-muzzled equine head with a bristling, upstanding mane, a horse that looks very like the only wild horse known today, Przewalski's horse. There are vertical, horizontal and diagonal lines that cross and interfere with the drawing, and though we do not know their purpose, it has been suggested that the verticals may represent spears or fence-posts, and may allude to the hunting and killing of wild horses.

The dramatic scene in the painting by George Stubbs, dated 1770, is one of a series of compositions in which he depicted horses startled, attacked and killed by lions against a theatrically wild and romantic backdrop of rocks, caves and trees. Magnificently drawn, the terrified, windblown stallion and the quietly prowling lion epitomize the theme of wild nature that inspired many artists in the later eighteenth century. The rocky landscape was no artistic invention, but a real one: Creswell Crags in Derbyshire. Stubbs could not have known that, in early prehistory, those limestone crags may have seen primeval hunts where the predator that horses had to fear was not a lion but a band of marauding humans.

Apart from the setting, there is another curious link between these two works of art: over the centuries and millennia, all the countless artists who have depicted horses have studied and admired their elegant

outward shape, and many will have been familiar with riding and handling them, but far fewer knew about their muscles, bones, sinews and internal organs. The unknown Palaeolithic artist was one, as he would have seen dead horses butchered after a successful hunt. Another was George Stubbs, whose painstaking studies of equine anatomy (see page 26), carried out in the true scientific spirit of the Enlightenment, are one of his many claims to fame.

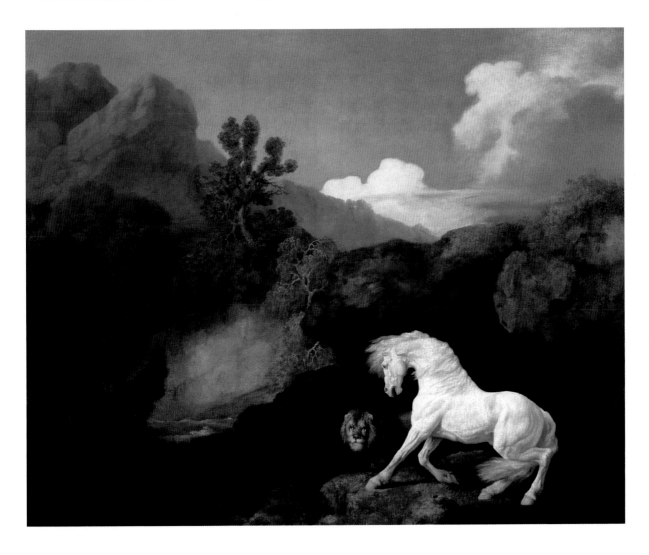

HORSES IN NATURE

BEFORE a species can be domesticated, wild individuals must be caught and tamed. But since it is not always a straightforward matter even to catch a fully domesticated horse in a small field, scenes showing horses and similar animals being chased and roped are not necessarily easy to interpret.

The hunting scenes depicted on the alabaster wall-panels from the palace of Ashurbanipal at Nineveh include onager-hunts, in which the wild asses are pursued by hounds and killed with arrows. These royal hunts took place in the seventh century BC, but wild equids were hunted long before that, and long after. The particular scene shown here,

however, shows one onager evidently being captured alive, using ropes. It is likely that some of the asses were taken for breeding and training, or both, and that not all were destined simply to be targets for the king's marksmanship. In particular, it is thought that onagers were used in the breeding of hybrids, possibly being crossed with both horses and with domestic donkeys, which are a different species from the onager.

The Japanese two-fold screen was painted by the artist Tosa Mitsumochi around the middle of the sixteenth century AD. It, too, shows a captured untamed or free-living animal. The rugged, dramatic landscape evokes the wildness of nature, with hills and crags and a maple tree in its autumn

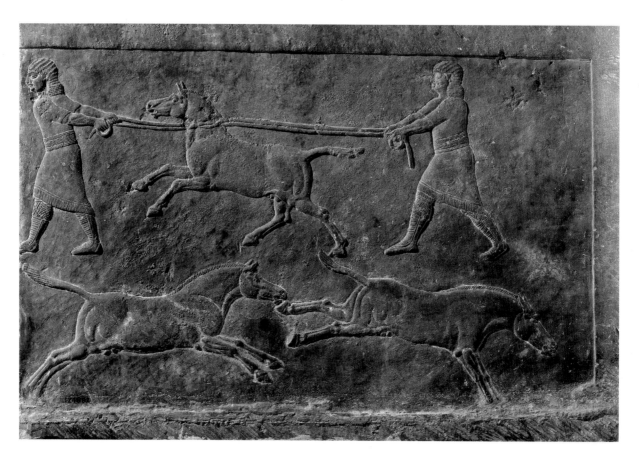

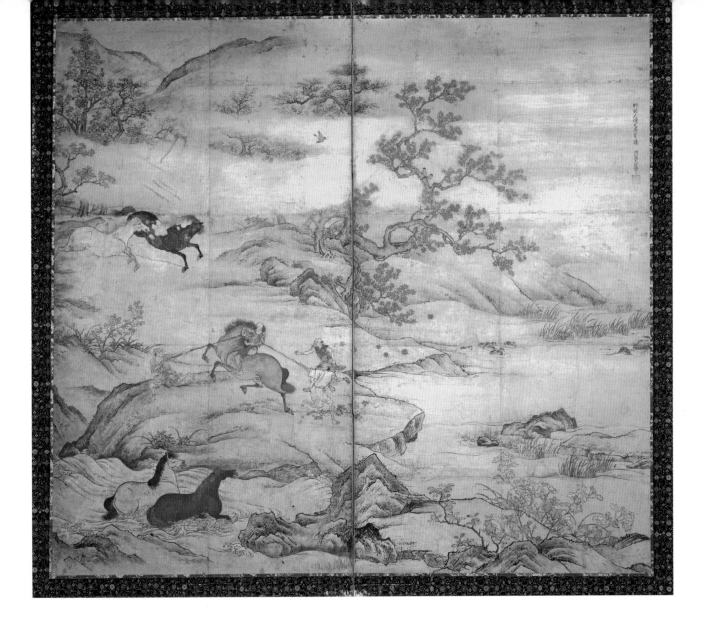

colours; in a rushing stream in the foreground two horses
are swimming, and three more gallop into view in the middle
distance. The focus of the composition is a rearing horse,
roped and held by two men and attempting to dislodge a rider.
Presumably this depicts the first attempts to break and train a
free-living horse, and it conveys a strong sense both of the
beauty and freedom of nature, and of the human compulsion
to control and exploit it.

ARTISTS have often liked to depict horses in a landscape, sometimes with symbolic undertones, but often simply for their own sake, because they are pleasing to the eye.

Pastoral scenes and landscapes were frequently associated in the Roman world with the imagery of the god Bacchus, and this is the case in the decoration of the bowls and dishes from the Mildenhall Treasure, part of a valuable silver dinner-service made in the fourth century AD. Bacchic decoration was an appropriate theme for eating and drinking utensils, since Bacchus was the deity who created wine. The wide horizontal rims of some of the Mildenhall bowls are chased in low relief with pastoral scenes comprising animals of several species, either chasing and attacking one another, or peacefully occupying a landscape suggested by the occasional tree and clump of grass. The mythical griffin features alongside other creatures, both wild and domestic. In a couple of the vignettes, horses are the hapless victims of predators, but in this detail two pairs of horses graze and rest beneath a tree, a timelessly idyllic view of nature.

The Italian plaque, only 7 centimetres long, employs an art-form closely associated with the Roman

THIS PAGE
A pastoral scene: detail from a silver bowl. Roman, 4th century AD. Mildenhall, Suffolk.
OPPOSITE
Glass micromosaic plaque by Antonio Aguatti. Rome, c. 1810–20.

period, but practised here at an almost perversely minuscule scale. Micromosaic, the technique of building up pictures with infinitesimally minute tesserae of stone or glass, was a medium popular for jewellery and small *objets d'art* in the early nineteenth century, and Classical themes, including copies of much larger ancient mosaic pictures, or views of ancient Roman buildings and other romantic ruins, were frequent subjects. Here, however, the artist Antonio Aguatti has chosen to depict a very ordinary brown horse standing in a field. The landscape and the horse are pleasantly mundane, but the method by which the little picture has been achieved is remarkable.

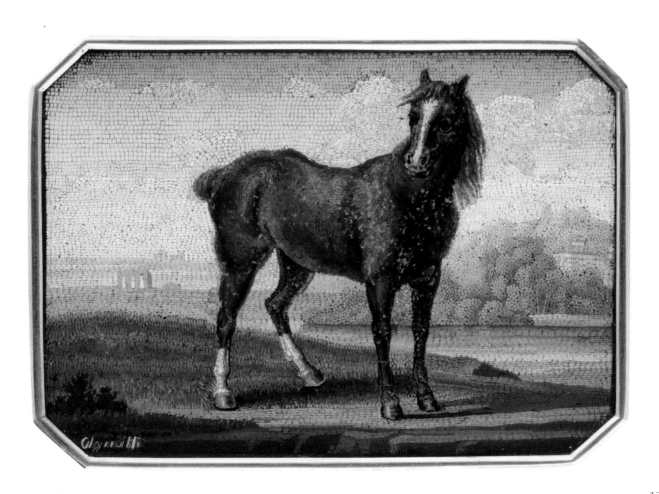

HORSES IN NATURE

THE social behaviour of horses living in the wild often includes fights between stallions, who compete to collect their own family bands of mares. Like all other large, strong male animals, from lions and bulls to stags and boars, stallions are admired for their power and courage, and acquire symbolic significance. The fact that horses have a physical beauty that affects people deeply adds to this perception.

George Stubbs (1724–1806), the greatest of all English horse-painters, created equine images ranging from the most passionately romantic to the most objectively realistic, and the mezzotint shown here, published in 1788, incorporates a little of both

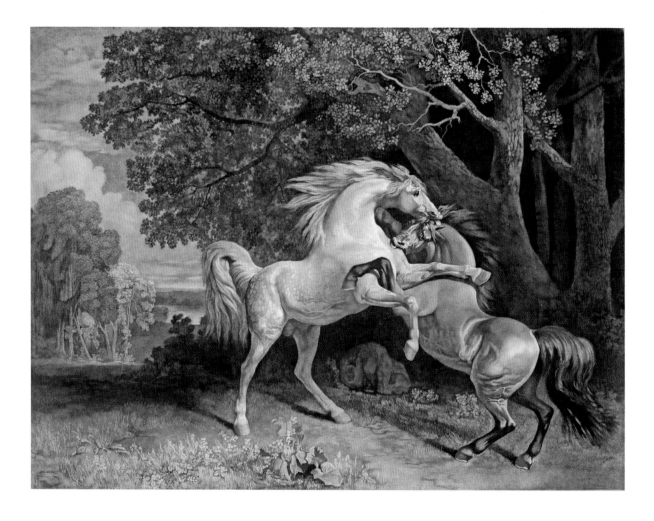

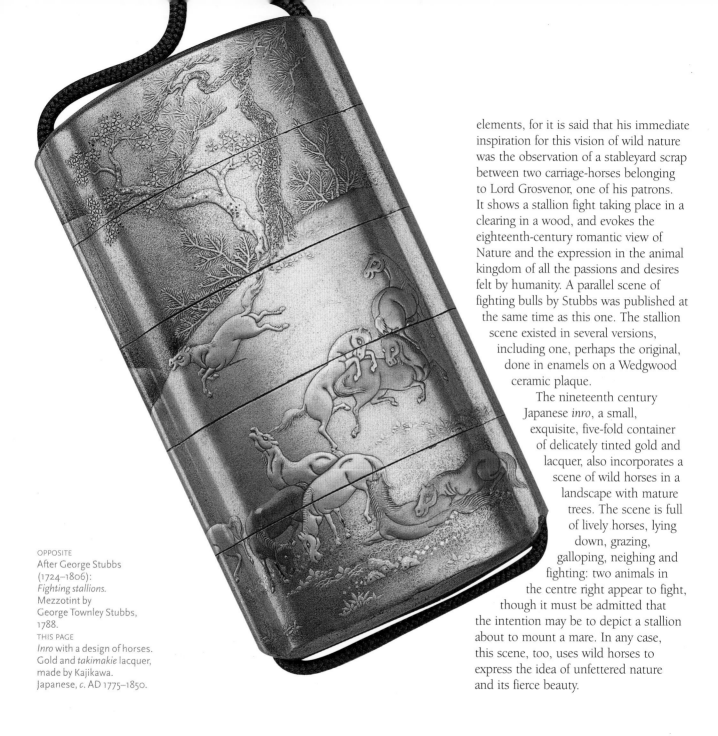

elements, for it is said that his immediate inspiration for this vision of wild nature was the observation of a stableyard scrap between two carriage-horses belonging to Lord Grosvenor, one of his patrons. It shows a stallion fight taking place in a clearing in a wood, and evokes the eighteenth-century romantic view of Nature and the expression in the animal kingdom of all the passions and desires felt by humanity. A parallel scene of fighting bulls by Stubbs was published at the same time as this one. The stallion scene existed in several versions, including one, perhaps the original, done in enamels on a Wedgwood ceramic plaque.

The nineteenth century Japanese *inro*, a small, exquisite, five-fold container of delicately tinted gold and lacquer, also incorporates a scene of wild horses in a landscape with mature trees. The scene is full of lively horses, lying down, grazing, galloping, neighing and fighting: two animals in the centre right appear to fight, though it must be admitted that the intention may be to depict a stallion about to mount a mare. In any case, this scene, too, uses wild horses to express the idea of unfettered nature and its fierce beauty.

OPPOSITE
After George Stubbs
(1724–1806):
Fighting stallions.
Mezzotint by
George Townley Stubbs,
1788.
THIS PAGE
Inro with a design of horses.
Gold and *takimakie* lacquer,
made by Kajikawa.
Japanese, *c.* AD 1775–1850.

RIDING

THE earliest riders, and their horses, must have had much to learn. One very early representation of a rider occurs on a terracotta mould from Mesopotamia, dating from the period 2000–1600 BC. The exact purpose of moulds of this kind is unknown. The image impressed in the clay is of a horse wearing a girth and possibly a saddle-cloth, a collar around his neck, and a rider perched well back on his rump. The rider holds a single rope 'rein', but it is difficult to make out how it connects with the animal's head. Because the head does not look obviously equine, the creature's identity as a horse has been doubted, but the neck, mane, hoofs and tail cannot belong to any other species.

The most effective seat on a horse is the natural one well down in the concavity of the back. A donkey, however, has to be ridden further back towards the hindquarters, because its back is straighter and its withers and head-carriage lower; riding too far forward is conducive to the rider's falling off forwards over the animal's head. Could this early Mesopotamian rider have been accustomed to riding asses or onagers before he bestrode a horse, or is the unusual seat merely an artistic aberration?

In sharp contrast, a small section from the Parthenon frieze shows Greek horsemen of the fifth century BC riding bareback with the most casual ease and grace, their horses lively and spirited, but fully under control; the bridles would have been rendered in metal, now lost. Small but powerful, the horses' prancing pose conveys eagerness and dynamism. The horsemen are taking part in the Panathenaic procession, a religious ceremony and public spectacle that was carefully planned and orchestrated. Accustomed though we are to seeing saddles as essential articles of riding equipment, the image of the naked or near-naked rider on a similarly naked horse remains a powerful expression of the horse–human bond.

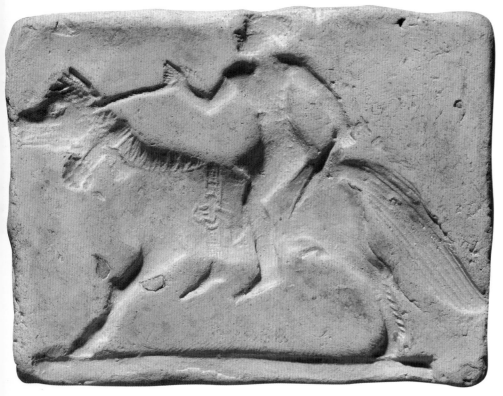

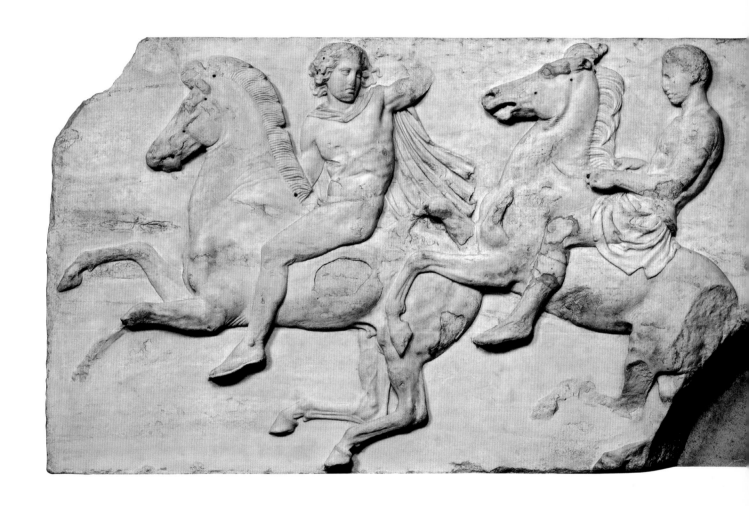

RIDING

THE life-size Roman marble sculpture and the small Greek terracotta figurine illustrated here express very different artistic and symbolic approaches.

The striped terracotta horse and rider was made in the middle of the sixth century BC in Boeotia, north of Athens. It was not simply a domestic ornament. Its purpose was religious and perhaps funerary, either as a grave-gift bestowed by mourners on a deceased person, or simply as a votive offering to a god. The fact that horse-and-rider figurines were common religious offerings at this period reflects the importance of the horse in that society. The possession of a horse was a sign of considerable wealth and elevated social status. What is interesting, and to our eyes, especially appealing, about this figure is the extreme level of abstraction, in

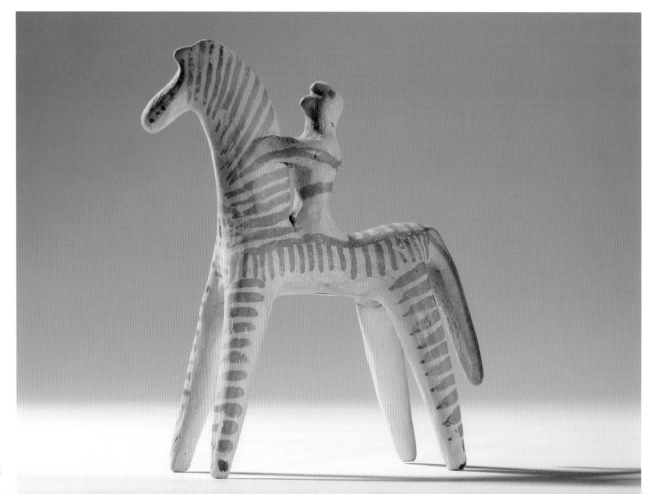

which the rider becomes an
integral part of the horse's body.
No attempt is made at realistic
representation. It is not necessary,
because the object declares itself
as a horse and rider without any
further detail.

The life-size marble statue uses
the opposite approach to achieve
something that, to us, epitomizes
accepted ideas of 'Classical art',
the Western tradition of realistic
representation combined with
varying degrees of idealization.
The statue, found in Rome in the
sixteenth century, is a work of the
first century AD, the early Roman
Empire, and probably represents a
prince of the ruling Julio-Claudian
dynasty. It is not a strictly realistic
representation of an important
young man on horseback. A Roman
general or member of the Imperial
house would not actually have
ridden naked, wearing no more
than a military cloak draped loosely
on his shoulders. The convention
of heroic nudity places this rider
symbolically in the company of the
gods and heroes, and alludes to
the revered traditions of Classical
Greek life and art.

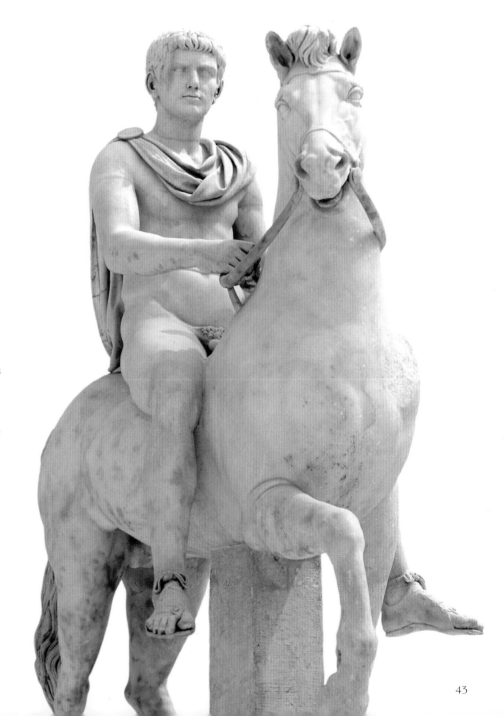

OPPOSITE
Terracotta figurine of
a rider.
Greek Geometric style,
c. 550 BC.
Tanagra, Boeotia, Greece.
THIS PAGE
Roman marble statue of
a Julio-Claudian prince.
Rome, 1st century AD.

43

RIDING

IN art, riders are normally shown in complete and graceful command of their mounts, and fallen riders appear only on the field of battle. But in real life, even the most experienced riders are thrown from time to time: riding is a hard-earned skill that takes time and effort for even the most naturally gifted horseman to master, and in societies where people who lacked that instinctive rapport with horses were nevertheless often obliged to ride, falls must have been common.

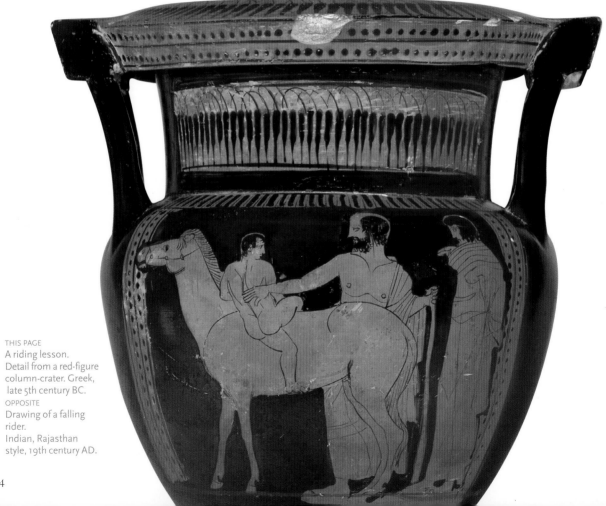

THIS PAGE
A riding lesson.
Detail from a red-figure
column-crater. Greek,
late 5th century BC.
OPPOSITE
Drawing of a falling
rider.
Indian, Rajasthan
style, 19th century AD.

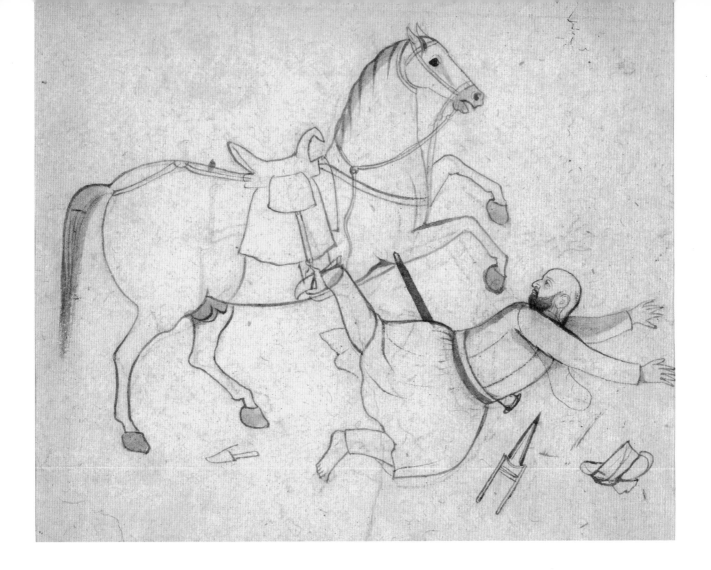

The scene on the Greek vase, a column-crater made in Athens around 440 BC, depicts a boy apparently having a riding lesson. He clambers onto his mount in a most ungainly manner, with a helpful push on his back from one of the two adults present. The young learner will need to grip the pony firmly with his knees once he is astride, and the inept style of his mounting does not augur well. We can guess that the boy will be unable to exercise much control, and have to wonder why one of the adults has not already gone to the animal's head to hold him. As the pony tosses his head impatiently, a fall seems almost inevitable.

In the elegant nineteenth-century Indian drawing in the Rajasthan style, by an unknown artist, we see a fall as it happens, but not the predictable fall of a novice. This is an adult, no doubt a person of importance well accustomed to pacing along arrogantly on his handsome stallion, like so many of the Indian riders in art of this period. But now he has lost his turban, his dagger and one shoe, and his right foot is still ignominiously caught in the stirrup. The horse retains all his beauty and elegance as he dislodges his rider, but the man's dignity is in tatters as he hits the ground.

RIDING

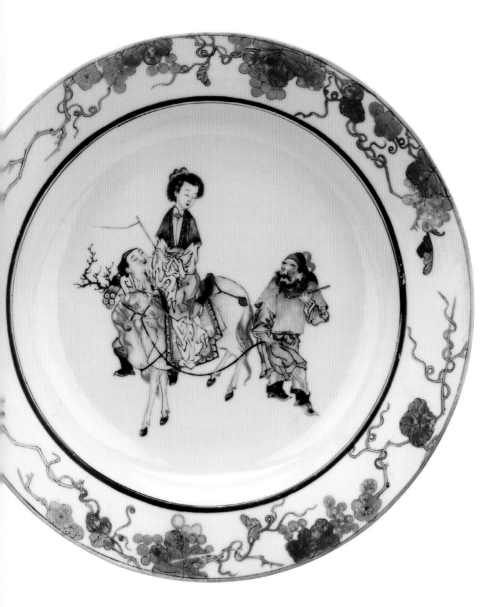

IN many cultures it has been considered unseemly for women to ride astride, and females thus forced to ride in a less natural and balanced posture, usually additionally hampered by long skirts, have needed to acquire even greater equestrian skill than males.

The Chinese lady of the eighteenth century delicately depicted on a *famille rose* porcelain plate seems confident enough in spite of her elaborate costume, but she does have two attendants, one of whom is leading her horse, which appears, in any case, to be a docile animal. The full range of overglaze colours and gold that characterize the *famille rose* style (including the pink enamel that gives the group its name) represent an outstanding level of technical expertise in ceramic production. Many of the new developments in European porcelain and china in the eighteenth century were inspired by Chinese porcelain of the period, yet at the same time, European tastes had an influence on Chinese design.

The rider on a gold ornament, perhaps from a belt, of the fourth century AD is not required to ride side-saddle. It is only from her hairstyle that we can see for certain that she is female, for she rides astride a galloping horse with the same relaxed ease as her male contemporaries. This object, too, displays consummate craftsmanship: goldsmiths of the late Roman and Byzantine world excelled in creating intricately pierced lacy patterns in gold. The scene looks like a lion-hunt, a common theme in the aristocratic art of the time, but the rider carries no weapon in her upraised hand, and the animal at her side is a little hard to identify. Its spots seem to militate against its being a lioness, and its heavy head and rough coat seem incompatible with the smooth, slender appearance of a leopard. Could it be canine rather than feline, a large and powerful hunting hound rather than the hunter's prey?

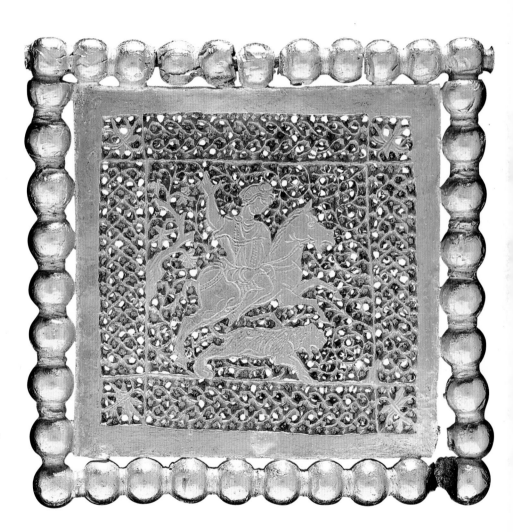

OPPOSITE
Plate decorated with a woman rider.
Famille rose porcelain.
Chinese, Qing Dynasty, AD 1723–5.
THIS PAGE
Gold pierced-work plaque showing
a huntswoman.
Late Roman, 4th century AD.
Asia Minor.

RIDING

TODAY, when we speak of a 'Parthian shot', we mean a pointed or insulting remark, or a final assertion in an argument, uttered on departure. In antiquity, the phrase had a literal meaning. The mounted archers of the Parthian Empire were known for their ability to fire arrows behind them as they galloped away from the enemy in apparent retreat. The feat required consummate horsemanship, especially when no saddle was used. It is shown in art even before the time of the Parthian Empire (third century BC to third century AD), however, and was also associated particularly with the Amazons, a legendary tribe of women warriors.

The small bronze figure is one of four ornaments from the rim of a large cinerary urn (a container for cremated bones) made in Italy in the late sixth to early fifth century BC, and it depicts an Amazon turning while her horse leaps forward at full speed. The bow she originally

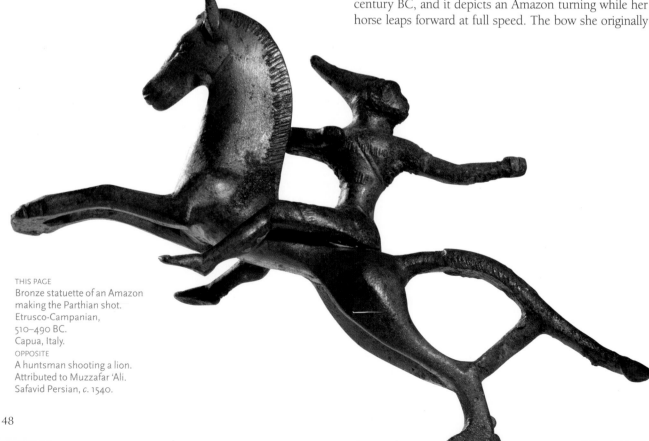

THIS PAGE
Bronze statuette of an Amazon
making the Parthian shot.
Etrusco-Campanian,
510–490 BC.
Capua, Italy.
OPPOSITE
A huntsman shooting a lion.
Attributed to Muzzafar 'Ali.
Safavid Persian, c. 1540.

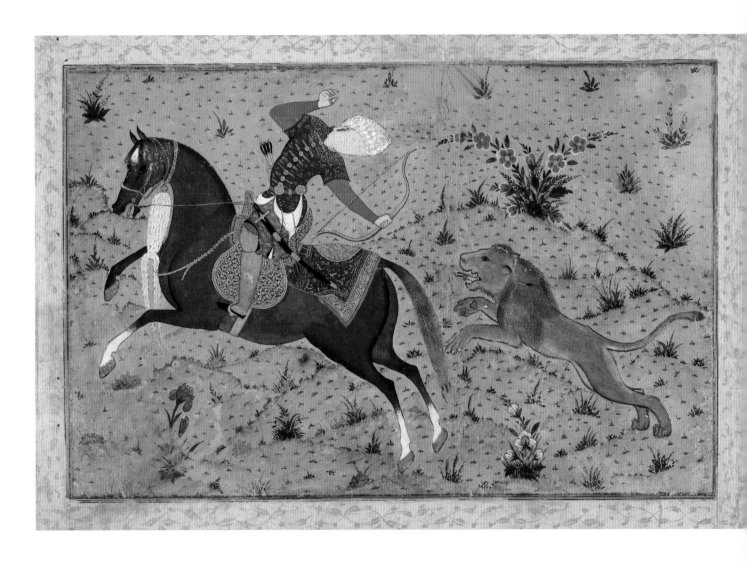

held is now lost, but if we imagine it in her hands, we can see that she was making a Parthian shot, aiming at a target behind her.

The princely Persian in a painting from the Safavid era is attacking a lion, in a tradition that goes back to antiquity. The lion pursues the rider, who turns to draw his bow and shoot in the same classic, athletic pose as the ancient Amazon, while his horse leaps forward. Belying the violence of the action, the huntsman and his splendid horse are colourfully dressed and equipped, and the surroundings are full of clusters of flowers, including a beautiful blue iris beneath the horse's hoofs. The painting is attributed to Muzaffar ʿAli, a Persian court painter who was active in the middle of the sixteenth century.

RIDING

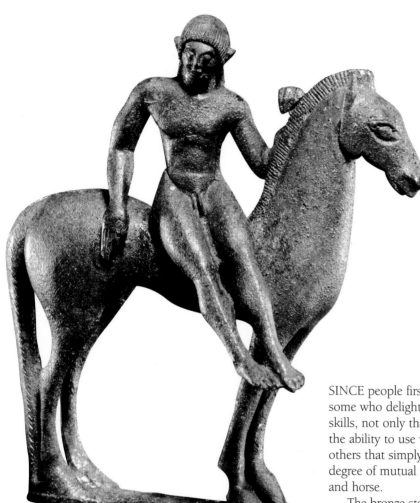

SINCE people first learnt how to ride, there must have some who delighted in showing off exceptional equestrian skills, not only those that had an obvious purpose, such as the ability to use weapons of war when on horseback, but others that simply demonstrated athleticism and a high degree of mutual understanding between man, or woman, and horse.

The bronze statuette of a naked youth apparently dismounting is one of a matching set of four from the rim of a large bronze vessel made in Italy in the early fifth century BC. It has been suggested that the riders are shown towards the end of one of the equestrian events in the ancient Olympic Games, a race called the *anabates*, in which the riders dismounted and ran alongside their horses for the final stretch of the course. In many societies the ability to mount or dismount while the horse is in rapid movement has been greatly admired. It has practical applications in

warfare as well as looking impressive. Unfortunately, it seems a little unlikely that the Greek 'dismounter' race is shown in these statuettes, since the horses appear to be standing stock-still, but the visual reference is probably still to some display of equestrian proficiency.

The scene on the small copper token takes us from military training and competitive athletic events to pure entertainment, and to a scene that may still be paralleled in circus performances today. In the late eighteenth century, displays of acrobatics, including equestrian feats, were popular as mass entertainment. One London venue for such performances was Astley's Amphitheatre. In 1794, there was a fire there which necessitated the temporary relocation of the show to the Lyceum in the Strand, and this coin-like token advertises the Lyceum events. The rider is dressed to represent the Roman god Mercury, and he stands on one foot, apparently with complete unconcern, on the back of a galloping horse.

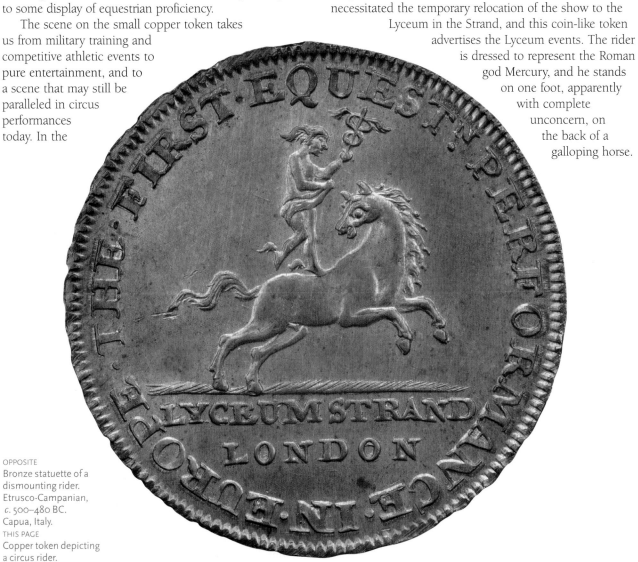

51

RACING

STRENGTH and speed are two of the equine qualities that humans have exploited since horses were first domesticated, and as the urge to compete is strong in many people, we may safely assume that horse-races were held long before they were recorded in either words or pictures.

The separate traditions of harness-racing and ridden racehorses were both firmly established by Classical times, and the former was the sport of choice in the Roman world. The highly trained racehorses who drew the lightweight racing chariots in teams of two or four were bred at specialized studs, most of which were in the North African provinces of the Roman Empire. The Roman bronze statuette of a *biga* (two-horse chariot) from the River Tiber illustrates both the very light and manoeuvrable vehicle, constructed of wood and leather, and the refined, yet powerful, conformation of a horse bred for speed. Roman chariot-racing scenes always show the animals in a leaping movement, both forelegs well off the ground, to represent swift movement.

A similar pose is depicted in the vivid lithograph by Henri de Toulouse-Lautrec (1864–1901), dating from 1899. Entitled *The Jockey*, the work focuses more on the horse than

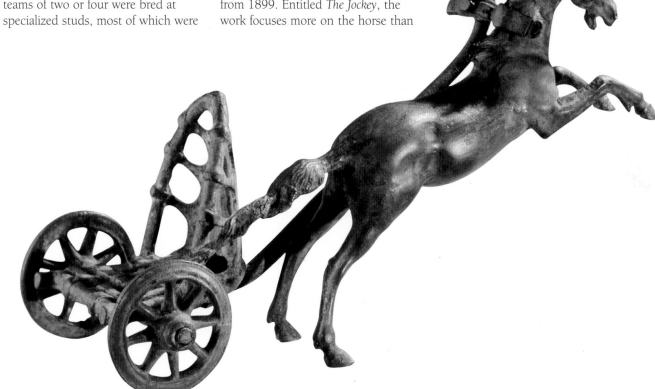

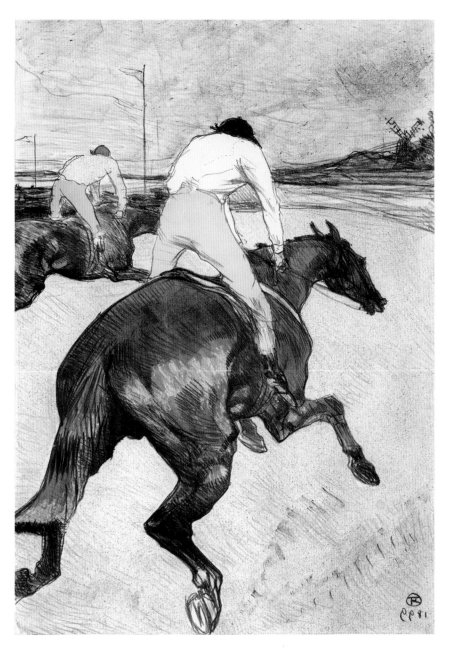

on his rider, with the exaggerated foreshortening and unusual viewpoint heightening the impression of great speed. The viewer is drawn into the midst of the race, rather than observing it from the sidelines. The actual leg action of horses in motion had been photographically recorded and published by Eadweard Muybridge in 1878, giving the lie to generations of drawings, paintings and prints that showed galloping horses apparently in full flight, with their legs stretched out fore and aft. Yet after more than two millennia, the human eye still easily recognizes that convention as depicting rapid motion.

OPPOSITE
Bronze statuette of
a racing *biga*.
Roman, 1st–2nd
century AD.
From the River Tiber,
Rome.
THIS PAGE
Henri de
Toulouse-Lautrec
(1864–1901): *Le jockey*.
Lithograph, 1899.

RACING

ALREADY well established as a popular sport before the time of the Roman Empire, chariot-racing came to occupy a place in Roman society that compares in many respects with the international passion for football today. Though charioteers had a relatively low social status, they could become both wealthy and famous, and the winning horses, too, became celebrities. There were four principal teams or factions, the Reds, Blues, Whites and Greens, so there was ample opportunity for supporters' rivalries to spill over into crowd violence.

The racecourses, of which the largest and most famous, the Circus Maximus in Rome, was capable of holding a quarter of a million spectators, were very carefully designed and built. They were long, narrow structures with an elongated central barrier (the *spina*), which was adorned with

lap-counters, turning-posts (*metae*) and decorative statuary and obelisks. The terracotta oil-lamp, made in Italy in the second or third century AD, contrives to fit into a small circular field a stylized bird's-eye view of the track with all its features, four racing teams and the surrounding banks of enthusiastic spectators.

A race consisted of an initial straight stretch after the teams left the starting-gates, and then seven laps of the circuit, with extremely dangerous turns at each end of the *spina*. Four horses harnessed side by side require sophisticated driving skills, and the horses themselves were highly trained. Charioteers wore protective clothing with crash-helmets, leggings and leather strapping around the body, and the protection was needed. There could be as many as eight or twelve teams competing, and crashes, referred to as *naufragia* (shipwrecks), were commonplace and could be fatal. A chariot-crash is the gruesome subject of the Etruscan gem dating to the mid-fifth century BC. The engraving, on carnelian, conveys the chaotic tangle of horses, wheels and driver in an area measuring only 14 by 11 millimetres.

RACING

AS a typical element in Roman culture, chariot-racing was eagerly embraced in the many disparate nations that became part of the Roman Empire, many of which also had their own ancient traditions of horsemanship. This was certainly the case in Britain and other Northern European provinces.

The Roman glass cup was made in Germany and was found in Colchester: it belongs to a well-known class of inexpensive, mass-produced sporting souvenirs of the first century AD. It is decorated in moulded relief in three horizontal registers, the lowest showing a stylized rendering of a chariot-race with four competing *quadrigae*. The middle zone depicts the distinctive features of the track, with the obelisks, lap-counters and turning-posts of the central barrier, while the top frieze lists four names, Cresces, Hierax, Olympaeus and Antilochus, the first with the word *ave* ('hail'), the others with *vale* ('farewell'). This vessel commemorates and celebrates the victories of a

successful charioteer named Cresces. A drinking-cup with this design would have appealed to any chariot-race fan, and most especially to an admirer of Cresces.

Also from Colchester, and made in Britain, the pottery vessel with the race scene is another vision of chariot-racing, boldly stylized, in a technique in which Romano-British potters excelled, that of piping designs in relief on clay, as sugar icing is piped on a cake. Although racing could theoretically be set up on any flat terrain of sufficient size, until recently no trace had been found of a formal, built circus for racing in the province of Britannia. Now archaeological evidence has emerged to show that there was indeed a standard, properly built circus at Colchester. The potter who made and decorated this provincial pottery beaker had probably seen actual races, not merely pictures of them.

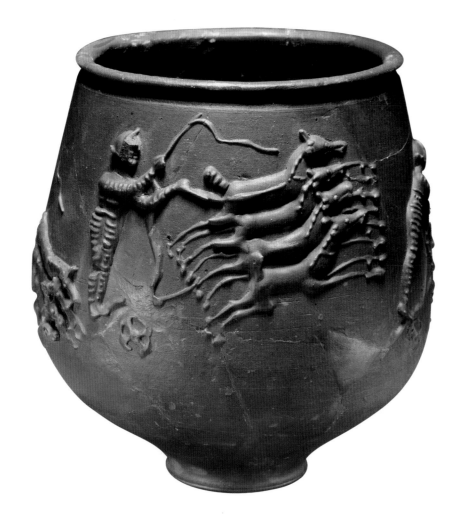

OPPOSITE
Glass beaker decorated with a chariot-race. Roman, 1st century AD. Colchester, Essex.
THIS PAGE
A chariot-race on a pottery beaker. Romano-British, 2nd century AD. Colchester, Essex.

RACING

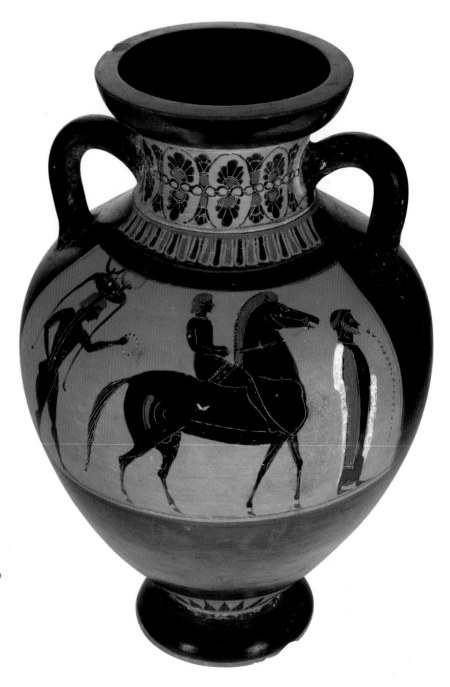

SPORTING celebrities, both human and equine, were admired and fêted in the ancient world. Made in Athens around 520-500 BC, the painted oil-amphora and its contents would itself have been presented as a prize at the Panathenaic Games, along with the victor's wreath and a prize tripod. The decoration shows the winning horse and his jockey, riding bareback, preceded by a herald proclaiming 'the horse of Dusnikeitos wins!', while behind walks a groom with the crown and tripod. The horse is named after his owner, a custom that was still quite common much later: compare the Byerley Turk, the Darley Arabian and the Godolphin Arabian, the founding sires of the English Thoroughbred,

Racing in the Roman world meant chariot-racing, a team sport, but the scene on the Italian terracotta oil-lamp of the first century AD honours the lead horse of a winning team, and features him alone, without the other horses and the charioteer. The man walking ahead of him holds an

inscribed placard which gave the animal's own name and the number of his wins: unfortunately, it is no longer legible. The horse, pacing slowly, wears a large wreath around his proudly arched neck, while behind him jubilant supporters are waving palm-branches, emblems of victory.

Great racehorses feature in Latin literature as well as in the visual arts. The fourth-century poet and teacher Ausonius, a native of Bordeaux, was asked by the emperor to write an epitaph on the death of a famous racehorse named Phosphorus ('Light-bearer'). The poem describes the horse's skill and strategy on the racetrack, delighting the roaring crowd of spectators, and concludes with the wish and belief that in the afterlife Phosphorus might join the immortal winged horses of myth and legend:

Fly with haste to join the wing-footed horses of Elysium; may Pegasus gallop on your right and Arion as your left-wheeler, and let Castor find a fourth horse for the team.

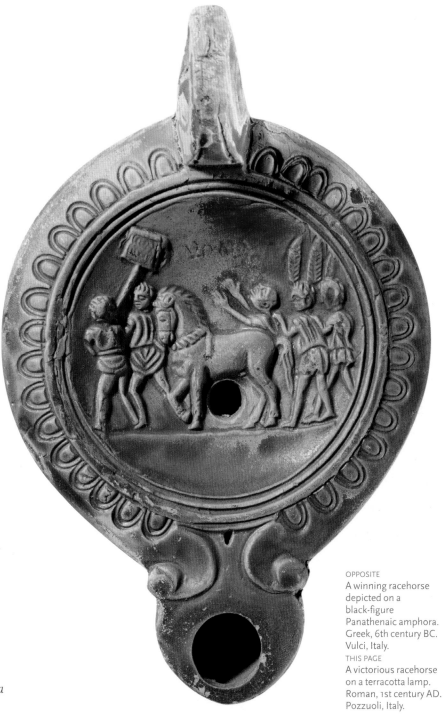

OPPOSITE
A winning racehorse depicted on a black-figure Panathenaic amphora. Greek, 6th century BC. Vulci, Italy.
THIS PAGE
A victorious racehorse on a terracotta lamp. Roman, 1st century AD. Pozzuoli, Italy.

59

RACING

HORSES had been bred for racing since Classical times, if not earlier, and the horses of North Africa and the Middle East have always been pre-eminent for both speed and endurance. The scientific climate of the Enlightenment in Europe led to the improvement of many types of livestock through controlled breeding, and the late seventeenth and eighteenth centuries saw the emergence in England of the breed now known as the Thoroughbred. One of the stars that emerged from that breeding programme and the evolution of organized racing was a chestnut horse named Eclipse, who was foaled during the solar eclipse of 1 April 1764. He won every race he ever entered in a fairly short racing

career (many owners became unwilling to pit their horses against such a legend), lived till 1789 and sired more than 300 winners. His name still appears in the pedigrees of around 80 percent of present-day Thoroughbreds.

George Stubbs (1724–1806) painted many individual portraits of the famous horses of his day. Newmarket was one of his favourite settings for displaying these animals. The print opposite is a version of a portrait he painted around 1770 of Eclipse at the rubbing-down house at Newmarket. The text beneath it sets out Eclipse's pedigree, with his line of descent from the Darley Arabian on the side of his sire, Marske, and from the Godolphin Arabian through his dam, Spiletta.

The celebrated eighteenth-century stallion's conformation is strikingly similar to that of the classic modern Thoroughbred depicted on the reverse of a twentieth-century Irish coin. The pre-decimal coinage of Ireland in the mid-twentieth century featured as their reverse types a series of animals associated with that country, and the horse on the half-crown coin alluded to the fact that Ireland has long had an important horse-breeding tradition, both of racehorses and other types.

OPPOSITE
Eclipse.
Mezzotint after George Stubbs (1724–1806), 1772.
THIS PAGE
A racehorse on a cupro-nickel half-crown. Irish, 1959.

HUNTING

THE hunting of very large predators such as lions and tigers has been a royal and noble pursuit in many cultures, including those of the ancient Near East. The king shown on a partially gilded silver plate is a ruler of the Sasanian dynasty, and the form of his crown suggests that he is Varahran V, also known as Bahram Gur, who reigned from AD 420 to 438. This king was legendary for his hunting prowess, and was often depicted in later Persian art. Here he is seen summarily dispatching a lion, while the lioness leaps up towards his left hand, in which he clutches her unfortunate cub. The powerful, stocky horse shows no apparent signs of panic in spite of the fact that the lion's claws are tearing at him, and both horse and rider are dressed with a degree of splendour that may seem inappropriate to the bloody business of slaughter. The effect, perhaps heightened by the use of precious metal, is theatrical.

We think of cloth as a humble material, but superior textiles were highly prized commodities in antiquity, and only the wealthy could afford the finest; yet, because they so seldom survive in good condition, they are one of the half-forgotten luxuries of the past. The small square of linen also shows lion-hunting, but in a manner far removed from the elegantly brutal Sasanian design. It is later than the silver plate, and was probably made in Egypt in the eighth or ninth century AD. Extremely sophisticated weaving techniques are required to create pictorial motifs of this kind, and though the two riders, the miniature lions and the snarling, curly-tailed hounds all look charmingly naïve to our eyes, when this panel of linen was part of a larger object, and when its reds, blues and creams were strong and unfaded, the overall effect would have been impressively opulent, matching its lion-hunting theme.

OPPOSITE
Silver plate with a king hunting lions.
Sasanian, 5th–7th century AD.
Iran.
THIS PAGE
A lion hunt depicted on a linen textile.
Egyptian, 8th–9th century AD.

HUNTING

HUNTING using trained birds of prey rather than hounds has a long history, and has been practised in many parts of the world. Like other forms of hunting game for sport rather than from necessity, it has been associated principally with the leisured, wealthy classes, and was immensely popular amongst European royalty and nobility in the Middle Ages, and with women as well as men. It was a costly pursuit, as it involved the upkeep of suitable premises and equipment and the employment of skilled falconers.

The gilt-bronze seal-die of an English aristocrat of the thirteenth century, Elizabeth de Sevorc, emphasizes her status as a person of power and property. Like men of her class, she is depicted on horseback, though her horse is not the muscular battle-charger appropriate to a knight. She rides, side-saddle, with great insouciance, bearing her hunting hawk on one wrist and brandishing in her other hand a lure in the form of a large bird's claw. Lures were used in the training of raptors for hunting under human control.

Some six centuries later, in the early eighteenth century, the Indian prince riding out to hunt with a group of five attendants on foot shows the same arrogant confidence. Against a backdrop of idyllic countryside, with hills, woods and a stretch of water thick with flocks of birds, he rides past with a remote dignity that is echoed in the proud, still form of the bird on his wrist. The hawk, probably a goshawk, occupies the very centre of the composition, and another is carried by one of the attendants. The gorgeous dappled stallion, however, is the most striking creature in the scene: a curled plume on the headpiece of his bridle echoes the feather in his rider's turban, and the rippling, curled locks of his mane reach almost to the ground.

THIS PAGE
Gilt bronze seal-die of Elizabeth de Sevorc.
English, 13th century AD.
Goodrich Court, Hertfordshire.
OPPOSITE
Painting of a nobleman hawking.
Southern India, early 18th century AD.

HUNTING

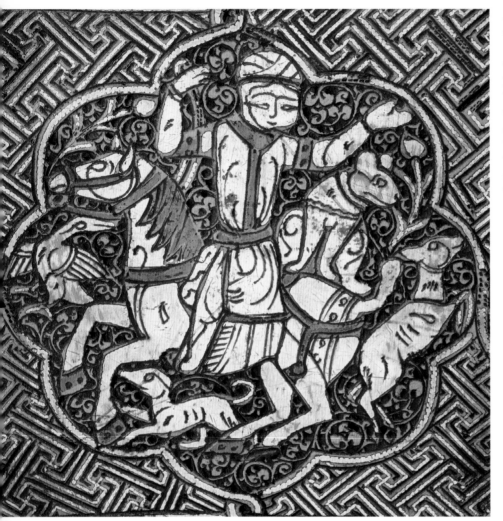

ANY animal shown riding on the back of a horse is usually a human, but there are some exceptions in art, most often monkeys. The unexpected pillion passenger in one of the intricate inlaid vignettes on the Blacas Ewer, an exquisite Islamic brass vessel made in AH 629 (AD 1232) in Iraq, is more unusual: it looks like a large cat. It is, in fact, a domesticated hunting cheetah. Cheetahs were trained and used for hunting game such as deer and gazelle in Persia and India, and there was even a fashion for them in Renaissance Italy. When not actually chasing prey, they would be carried, either in a vehicle, or riding behind their masters. Whimsical as the scene appears, therefore, it is an illustration from the lives of the medieval aristocracy of its place and time. Other scenes on the ewer, which is made and decorated with consummate artistry in brass inlaid with silver and copper, show incidents from Persian courtly

THIS PAGE
Detail from an inlaid brass ewer (right) showing a huntsman.
Islamic, AD 1232.
Mosul, Iraq.
OPPOSITE
Ivory *netsuke* of a horse and a rat.
Japanese, 19th century AD.

s, just as the precious
ons of European aristocrats
iddle Ages were often
d with familiar scenes from
ances.
ivory *netsuke*, signed by the
Masamine, depicts a horse with
ally unusual rider. The horse
his head back, possibly made
what uneasy by the presence
arge rat perching with cheeky
confidence on his back. Decorative
netsuke, forming part of traditional
Japanese clothing and personal
ornament, depict a very broad
range of subjects, serious and
humorous, realistic and
fantastic, but always displaying
the exceptional skills of the
craftsmen who carved them.
Both the Horse and the Rat
feature as Zodiac signs in the
Chinese and Japanese Zodiac,
attributed not only to years in
a twelve-year cycle but also to
sections of a sequence forming
the twenty-four hours in a day,
and this ornament may be
a deliberate and imaginative
combination of two specific
symbols that the owner
regarded as auspicious.

CHARIOTS AND CARTS

LIGHT two-wheeled chariots were of the highest importance in ancient warfare and ceremonial display. The two examples shown here are also very significant antiquities in their own right.

The extremely stylized little terracotta chariot was found in a very rich Bronze Age grave at Enkomi in Cyprus, dating to about 1300 BC. It was probably an import, and the grave certainly contained other imports, including luxury items from Egypt. The artist who created this two-horse chariot has reduced it to a mere suggestion of a wheeled vehicle with a driver and two horses: there are two horses' heads and two bodies, but only four legs, and the chariot itself is a part of the horses' hindquarters and has no wheels. The upper body of the charioteer is broken away, but he, too, was conceived and shaped as part of the single entity. The person in whose grave the terracotta was placed commanded power and wealth, and the image of the two-horse chariot, reduced here to its artistic essentials, was one symbol of that status.

The gold chariot is much later, and is an iconic object

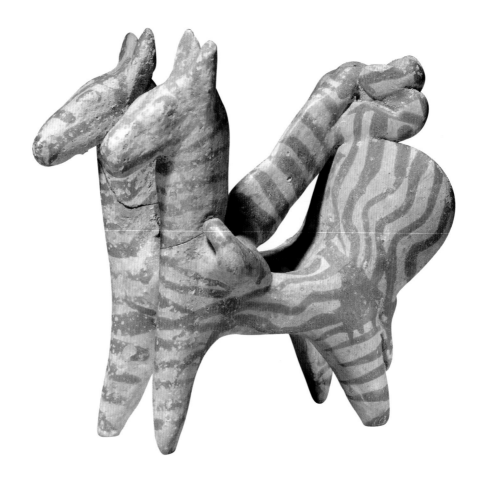

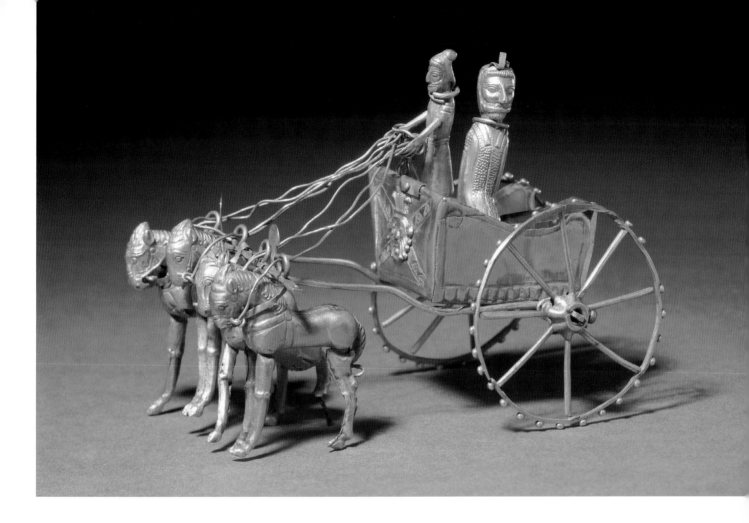

from the Oxus Treasure, a collection of Achaemenid Persian gold and silver objects made in the fifth to fourth centuries BC. The gold model, just under 19 centimetres long overall, depicts a chariot with a boxy body and large, eight-spoked wheels with studded tyres, drawn by four horses. The front panel of the vehicle bears an image of the Egyptian god Bes, a reminder of the complex cross-cultural influences in the Mediterranean and Near Eastern lands at this time, and the two men in the chariot wear Median rather than Persian dress. The harnessing is shown in some detail, and the wheels would originally have turned freely. The horses themselves are quite simply formed, without too much attention being paid to realistic proportion, but the general effect is impressive.

OPPOSITE
Terracotta figurine of a two-horse chariot.
Mycenaean, *c.* 1300 BC.
Enkomi, Cyprus.
THIS PAGE
Gold model chariot from the Oxus Treasure.
Achaemenid Persian, 5th–4th century BC.
Tadjikistan.

CHARIOTS AND CARTS

WINE was normally drunk diluted with water in Classical antiquity, and the large vessels known as craters were used for mixing wine and water before serving. Both of these pottery jars were used for that purpose, and both have painted designs that include horses and chariots.

The graceful vase painted in red slip in a band around the upper body dates back to the Bronze Age, around 1400-1300 BC, and was made in Mycenaean Greece and exported to Cyprus, where it was found. The procession of chariots drawn by two horses was a popular scheme of decoration, and must illustrate formal processions that took place in real life.

Each vehicle carries two passengers, and the horses, slender and long-tailed, are proceeding in a quiet and stately manner, without any prancing and rearing. Filling the spaces between the chariots and below the horses' bodies are the appealing curvilinear patterns typical of Mycenaean art.

The other vase is a Greek black-figure column-crater with a lid, made around the middle of the sixth century BC, perhaps in Italy, where it was found. It is decorated with a central four-horse chariot flanked by two horsemen riding in from the sides. Teams of four horses harnessed side by side were frequently shown in

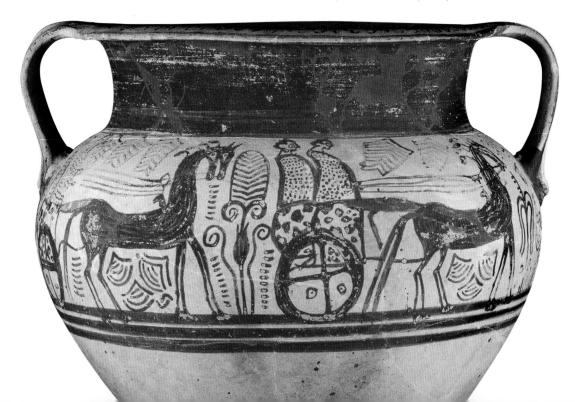

Graeco-Roman art, but were always somewhat demanding for artists to depict in side view. The choice of the frontal view is equally difficult, though it presents a different set of problems. Some vase-painters were prepared to rise to the challenge, however, though they always kept to the familiar profile aspect of the horses' heads. The horses' bodies and legs, the charioteer and the chariot itself, are all shown frontally, but the horses turn their heads inwards and outwards in a pleasingly symmetrical pattern so that they are seen from the side.

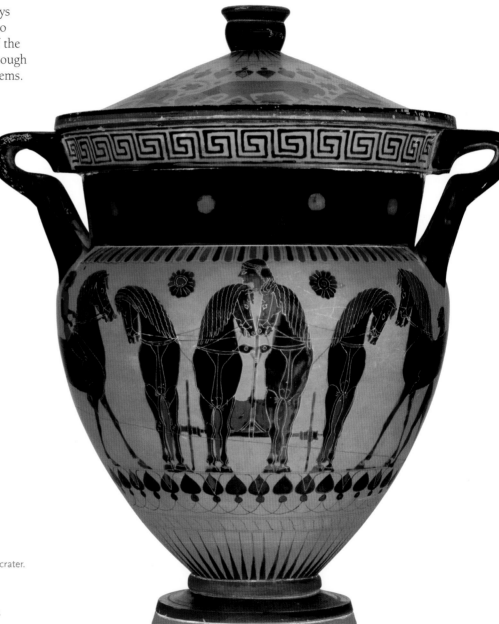

OPPOSITE
A chariot procession decorating a painted crater.
Mycenaean, *c.* 1400–1300 BC.
Maroni, Cyprus.
THIS PAGE
A *quadriga* on a black-figure column-crater.
Greek or Italian, *c.* 540 BC.
Vulci, Italy.

CHARIOTS AND CARTS

BY the Roman period, there were already dozens of different kinds of horse-drawn vehicles, designed for every conceivable purpose from racing to the transportation of heavy goods. There were even apparently some types of conveyance in urban centres in the Roman period that could be hired for short periods – a form of limited public transport – and it is possible that the little terracotta model depicts one of these. It was made in Egypt, in the distinctive Nile clay, in the first or second century AD. The carriage is drawn by two horses and has four small, six-spoked wheels. The high superstructure appears to be constructed of wickerwork on a wooden frame, and has window openings. In the rear window, the heads of two passengers, a man and woman, can be seen, facing one another, while the driver sits in the open front of the carriage. Ornaments dangling from the back of the vehicle, made in the form of bunches of grapes, may be amulets.

Nineteenth-century public transport in a number of Western cities used to include horse-drawn trams, but these were generally superseded

by electrically powered trams and, of course, by the great variety of motor vehicles of the twentieth century. Horse-drawn trams were introduced in the town of Douglas, Isle of Man, in 1876, but there they have not died out. Just as conventional horse-drawn carriages are still used to a limited extent in many cities as tourist attractions, the rails and the original Victorian and early twentieth-century tramcars have been retained in Douglas, and the cupro-nickel crown illustrated is a commemorative coin issued in 1976 to celebrate the centenary of this now very unusual mode of transport.

CHARIOTS AND CARTS

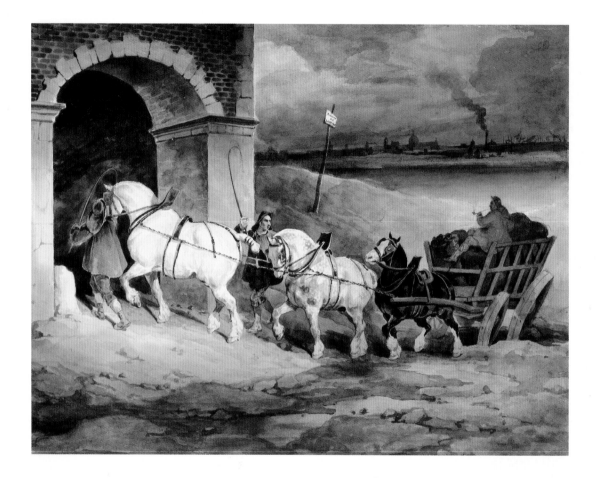

HORSES, donkeys and mules were all employed from the earliest times for transporting heavy goods, though for many reasons it was not until the Roman period that horses were routinely used for pulling heavily loaded carts or agricultural implements. Oxen have been the animals of choice for those tasks in many cultures.

By the modern period, however, a combination of passable roads and large, powerful breeds of horse made it possible for teams of horses to draw loads of all kinds and sizes. The watercolour and chalk drawing by Théodore Géricault, painted around 1820, shows what must have

THIS PAGE
Théodore Géricault (1791–1824): *The coal wagon*.
Watercolour and chalk, 1820–21.
OPPOSITE
Alabaster wall-relief depicting pack-mules.
Assyrian, 645–635 BC.
Nineveh, Iraq.

been a common sight in early nineteenth-century England, a large coal-wagon pulled by a team of three heavy horses harnessed in line rather than abreast. Coal used to be used in vast quantities both for domestic heating and industrial purposes, and horses were even involved in its extraction: for generations small ponies were used inside mines to haul the coal-trucks along the underground railway lines, after it became illegal in the 1840s to employ women for that purpose. Géricault's scene is set in London, but it is not possible to identify the location: the road is no more than a rough track.

Wheeled vehicles cannot be used on all types of terrain, and donkeys and mules are sure-footed on ground and gradients that even horses find challenging, so the pack-ass or pack-mule has played a major role in many human endeavours, from exploration to warfare. The pack-animals on the Assyrian wall-relief from Nineveh were carved in the seventh century BC, and they accompany a royal party setting out on a hunt, laden with whatever equipment and, no doubt, refreshments, would be required by the huntsmen. They are carefully characterized and clearly distinguished from the horses in the adjacent scenes, and their longish ears and horse-like tails imply that they are mules, specially bred for their task.

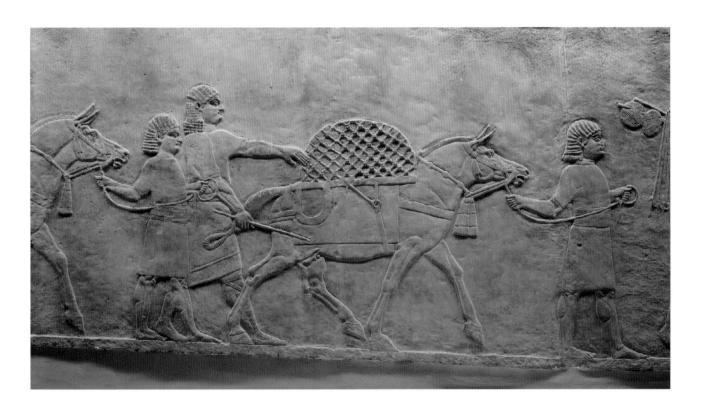

CHARIOTS AND CARTS

IMAGES of horses are sometimes used to decorate carts and carriages. The bronze horse-head, with a large square socket for attachment to another object, is Etruscan, and dates from the sixth century BC. It is one of a set of four, two with horse-heads and two with the heads of griffins – winged, eagle-headed, lion-bodied mythical beasts that were very popular in Greek, Etruscan and Roman art. The exact purpose of the mounts is uncertain, but they would have been used as ornamental terminals for robust square-sectioned shafts, and are very likely to be from a chariot or other conveyance.

The head of the horse is disconcertingly deer-like, with its large, wide ears, huge eyes and small, tapered muzzle. There is no doubt that it is a horse rather than a deer, however, since the mane and forelock are absolutely diagnostic. The exaggeratedly large eyes are a device much used by modern cartoonists and other artists to make a

face, human or animal, seem 'childlike'. The eyes of very
young animals are larger in proportion to their faces than
those of adults, and this feature has a strong emotional
appeal to many adult humans. The faintly smiling line of
the horse's mouth adds to the impression of a bright,
friendly and trusting creature.

The rearing horse looming over a kneeling warrior is
an element from a very special kind of vehicle, one of
the immensely elaborate temple cars used in some Hindu
religious festivals. These tall, wheeled vehicles are drawn
in procession by large teams of worshippers, and look like
highly decorated temple buildings in themselves. The
horse, which is superbly carved in wood, was made in the
sixteenth or seventeenth century AD in southern India.
His bridle, saddle and crupper are ornate, with rosettes,
tassels and other adornments. Originally the figure would
also have been colourfully painted.

HORSES AND HEROES

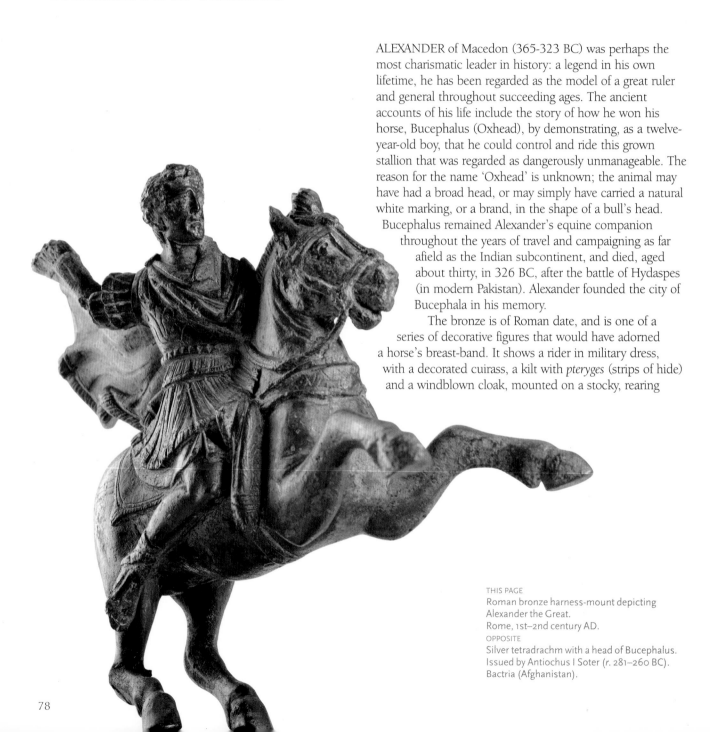

ALEXANDER of Macedon (365-323 BC) was perhaps the most charismatic leader in history: a legend in his own lifetime, he has been regarded as the model of a great ruler and general throughout succeeding ages. The ancient accounts of his life include the story of how he won his horse, Bucephalus (Oxhead), by demonstrating, as a twelve-year-old boy, that he could control and ride this grown stallion that was regarded as dangerously unmanageable. The reason for the name 'Oxhead' is unknown; the animal may have had a broad head, or may simply have carried a natural white marking, or a brand, in the shape of a bull's head. Bucephalus remained Alexander's equine companion throughout the years of travel and campaigning as far afield as the Indian subcontinent, and died, aged about thirty, in 326 BC, after the battle of Hydaspes (in modern Pakistan). Alexander founded the city of Bucephala in his memory.

The bronze is of Roman date, and is one of a series of decorative figures that would have adorned a horse's breast-band. It shows a rider in military dress, with a decorated cuirass, a kilt with *pteryges* (strips of hide) and a windblown cloak, mounted on a stocky, rearing

THIS PAGE
Roman bronze harness-mount depicting Alexander the Great.
Rome, 1st–2nd century AD.
OPPOSITE
Silver tetradrachm with a head of Bucephalus.
Issued by Antiochus I Soter (*r.* 281–260 BC).
Bactria (Afghanistan).

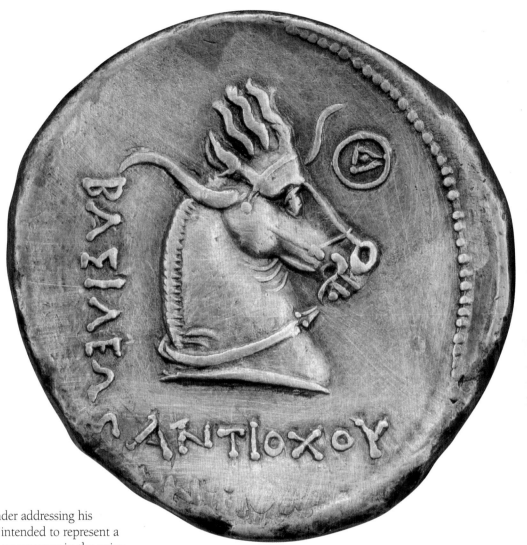

horse. The image is of a commander addressing his troops, and although it could be intended to represent a Roman emperor, it would still be an emperor in the guise of Alexander: the pose is one that was associated with the great Hellenistic ruler.

The silver coin is a tetradrachm, minted in Bactria (modern Afghanistan) and issued by Antiochus I Soter, who ruled Syria and lands further east in the third century BC. The king's head is on the obverse, but his name and title on the reverse accompany an image of Bucephalus, equipped with bull's horns, a semi-divine animal who represents direct connection and descent from Alexander himself.

HORSES AND HEROES

HORSES frightened, attacked and slain by lions are a recognized theme in art: a lion vanquished by a horse is more unexpected, but the horse shown here was no ordinary animal.

This magnificent painting is attributed to Sultan Muhammad, a Persian court painter of the sixteenth century AD. It was probably painted around AD 1515–22 as an illustration to a manuscript of the great Persian national epic, the *Shahnama* (Book of Kings), which was composed in the eleventh century AD. The picture illustrates one of the tales of the legendary hero Rustam and his red horse, Rakhsh. This hero was, from birth, an individual of superhuman size and strength, and only one steed, Rakhsh, was large and powerful enough to carry him. Rakhsh became a close companion who played an intelligent and significant role in all Rustam's adventures.

Rustam and Rakhsh had set out on a quest, a long journey to rescue a king held captive by demons, and one night they stopped to rest, unaware that they were close to a lion's den. During the night, the lion came to attack them, and while Rustam slept on, Rakhsh fought and killed the savage beast. On the following morning, Rustam thanked his horse for his courage and skill, but suggested that on a future occasion he should wake his master and not try to deal with the threat alone. This instruction led to some human–equine misunderstandings in a subsequent encounter with a dragon, but ultimately man and horse together slew the monster.

In Sultan Muhammad's painting the wild, lush forest surroundings are depicted in minute detail, with trees, flowers and rocks forming intricate patterns. The convoluted forms of the rocks resolve themselves in places into fleeting, dream-like semblances of faces, including those of a lion and a horse. The peacefully sleeping Rustam on his striped mat provides a note of calm, contrasting with the violent action in the foreground, where Rakhsh, as beautiful as he is powerful, deals with the dangerous predator. Blue-eyed, with a lightly dappled red coat, this is truly a super-equine horse, a horse of legend.

Rustam and Rakhsh: a page from a manuscript of the *Shahnama*.
Attributed to Sultan Muhammad.
Persian, AD 1515–22.
Tabriz, Iran.

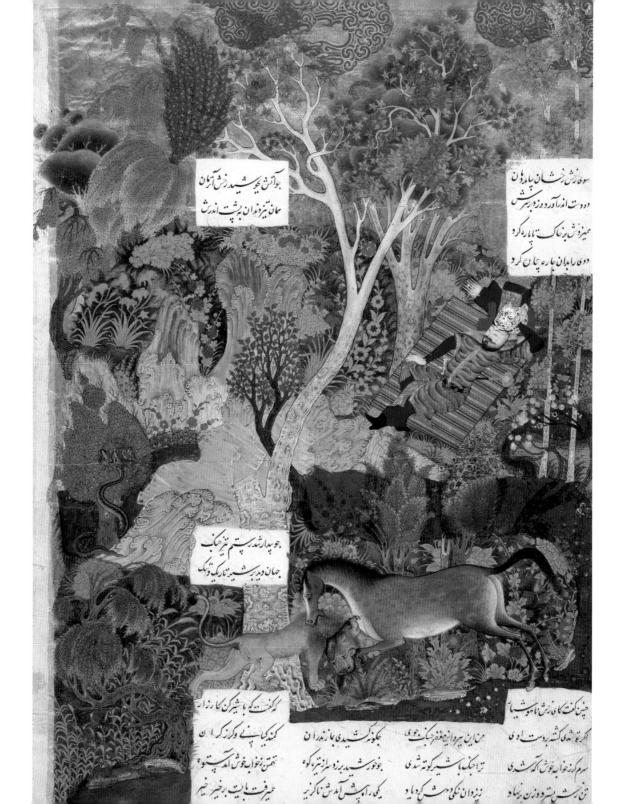

برخ ترش رخشان سپاهبدان

سوی رخش رخشان سپاهبدان

ودست اندر آورد و زد بر سرش

بمیرز و رخش بر خاک بیاره کرد

دو کی را بدان چاره چان کرد

جوانش بخو شید رخش آزمان

همان تیز بزدان بر پشت اندرش

جو پدار شدر پستم تیج جنگ

جهان دید بر شید سیه تاریک و تنگ

چنین گفت کای رخش نا هوشیار

کر کنید که با شیر کن کنار زار

اکر تو شدی کشته بر دست اوی

من این سپر وا این غفر جنگجوی

جگونه کشیدی باز بدران

کنید کیا پی و کراز کران

سرم کرد خواب بر زد آکه شدی

تا جک باشیر که خوش آکه شدی

بوخورشه بزد سر از تیز کوه

نهفتن بنخواب خوش آمد آشنو

زیندان نکی بسترد و زین بنهاد

یکی راه پیش آمدش ناکزیر

جیرفت بابت بر خیر خیر

GODS AND SAINTS

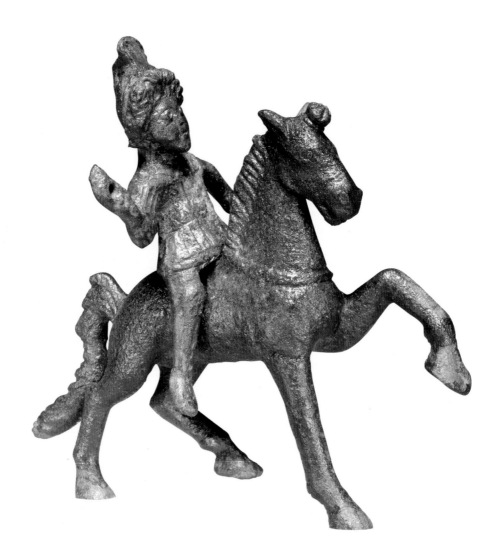

GODS and great religious teachers, as well as heroes and kings, may be shown on horseback. The rider on the small bronze horse was probably a minor local god in a frontier province in the very north of the Roman Empire, and we do not even know his name. The statuette is from Britain, and dates from around the second century AD. It is one of many small Romano-British representations of a rider-god in military dress, a native divinity who may have been conflated with the Roman god Mars, who was a protective deity as well as a warlike one.

The rider is in Roman armour and the horse is shown pacing in a distinctive way, his left fore and hind leg off the ground together, and the action of the foreleg exaggeratedly

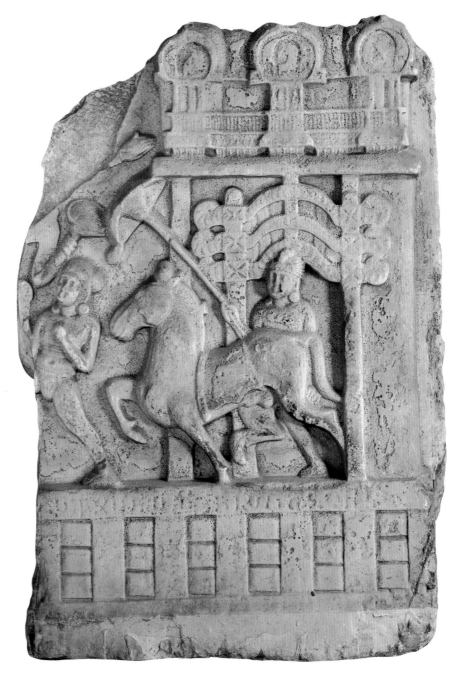

high. The effect is not unlike that of the 'Spanish walk', a movement that does not come naturally to a horse, but must be learned. The horses and men of the Roman cavalry were highly trained, and it comes as no surprise that they might have developed special, showy actions and paces for use on ceremonial occasions.

The limestone sculpture from India is of about the same date as the little Romano-British bronze, the second century AD, and it also shows a handsome stallion pacing with a high-stepping action, but apparently riderless. The horse was named Kanthaka, and this scene depicts one of the critical moments in the story of the Buddha. It is the Great Departure of the Prince Siddartha from the royal palace where he grew up, to embark upon the spiritual quest and ascetic life which led to his enlightenment. At this date, the Buddha himself was not directly represented in art: his presence is implied by the parasol that an attendant holds over Kanthaka as he leaves the gateway of the palace.

GODS AND SAINTS

ENGRAVED gems and cameos were extensively used in Greek and Roman jewellery, but they were not chosen solely for their decorative qualities. Images of deities were carried for their amuletic power, the protection and good fortune they were believed to promote. The goddess Victory was particularly popular with the Roman army, but her aid and support could be invoked by both men and women in a great many situations, not only military ones.

On the sardonyx cameo, carved in the first or second century AD, Victory is shown driving a racing chariot with a team of four horses. Sardonyx is a variety of microcrystalline quartz that is naturally banded in shades of grey, white and brown, and the contrasting layers of the stone have been exploited by the artist to separate and distinguish the horses, dark brown for the nearest, grey and light brown for the two in the middle, and white for the wheeler on the far side. The winged goddess herself appears in the lighter colour. This is a large, high-quality cameo that would have been a valued possession of its original owner.

Although the sea-god Neptune had some connections with horses, there was no Classical deity who specifically protected these animals, so that when the Roman cavalry in the province of Gaul (now France and adjacent areas) encountered shrines to the native goddess Epona, they eagerly adopted her, and the worship of this Celtic deity spread throughout the Roman Empire. Epona is often depicted on horseback, riding side-saddle, but in this small bronze statuette, probably designed as a decorative fitting for a cart or chariot, she is in her other classic pose, seated between two horses. The animals are shown at a much smaller scale than the deity, but they are adults, a stallion and a mare, not foals. Epona has some aspects of a fertility goddess, for she holds ears of corn, symbols of plenty. A yoke rests on her left arm.

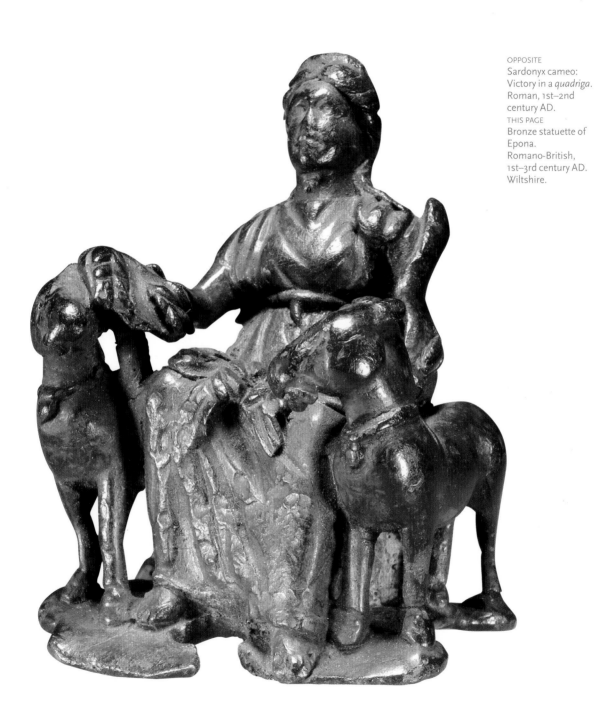

GODS AND SAINTS

SAINT George was an early Christian saint, purportedly martyred during the persecution of Christians under Diocletian in AD 303. As a warrior saint he is directly connected with the many rider gods and heroes of pagan antiquity, and has become the patron saint of numerous countries, places and institutions. The dragon-slaying incident was told as a literal story of George ridding a country of a savage man-eating monster (a precise parallel to the story of Bellerophon and the Chimaera, see pp.172–5), but also functions as a symbolic tale of the Christian conquest of evil.

St George was adopted as the patron saint of England in the reign of Edward III (r. 1327–77). From 1817, an image of St George was used as the reverse type for the gold coinage. The outstanding design was by the Italian sculptor and engraver Benedetto Pistrucci

THIS PAGE
St George depicted on a gold £5 coin of 1893. Engraved by Benedetto Pistrucci (1783–1855).
OPPOSITE
Icon of St George. Byzantine, 14th century AD. Pskov, Russia.

(1783–1855). Seen here on a £5 coin of 1893, it is a purely neo-Classical visualization rather than the 'medieval' image that would surely have resulted if it had been designed by an artist of the later nineteenth century. The saint, heroically nude apart from his helmet and swirling cloak, is a Greek warrior, riding bareback on a horse that could take his place without attracting attention within the processional frieze from the Parthenon.

The icon from Pskov in Russia is known as the 'Black George'. It is one of innumerable medieval and later icons from Orthodox churches, and dates from the fourteenth century. Here, the saint does not look like a Classical warrior, and he wears a golden halo rather than a helmet, but his graceful horse leaps, almost flies, in the expected fashion as his rider spears the monster. The fact that the horse is black rather than white or grey is unusual and noteworthy, and is the reason for the popular name of this picture. It is not George who is black but his steed.

GODS AND SAINTS

PATRON saints appear in popular folk art and in the most formal contexts. St George, the patron saint of England, is seen here in both guises.

The large lead-glazed earthenware dish was made in Staffordshire in the 1720s, and is slip-painted with a bold and delightfully naïve design of St George slaying the dragon. There is a placard or panel with an inscription identifying the saint, just in case there should be any confusion, and the potter's initials, JB, are also included. In order to fit the space, the horse has very short legs, but he arches his neck and swishes his tail in a suitably noble manner. The dragon, rolling over on its back, has even shorter limbs, and as these, together with its head, wings and tail, are solid brown, while its body is yellow with brown spots, it looks a little as though it is wearing a polka-dotted jumper.

The other English St George could not be more formal. Made in 1628-9 for William Compton, the first Earl of Northampton, it is part of an object of the highest intrinsic and symbolic value, the collar of the insignia of the Order of the Garter, founded in 1348, and the oldest order of chivalry in Europe. The whole collar is a masterpiece of the goldsmith's art, constructed of intricate gold elements embellished with translucent and opaque enamels, diamonds and rubies. The dragon-slaying saint is the pendant to the collar. He, too, is made of gold. His horse is enamelled in opaque white, and the saint himself wears medieval armour and brandishes a very large sword above his head. He is about to slaughter the spotted green dragon, which has wound its tail around the horse's hind legs. The saint, his sword and his horse are all lavishly set with diamonds.

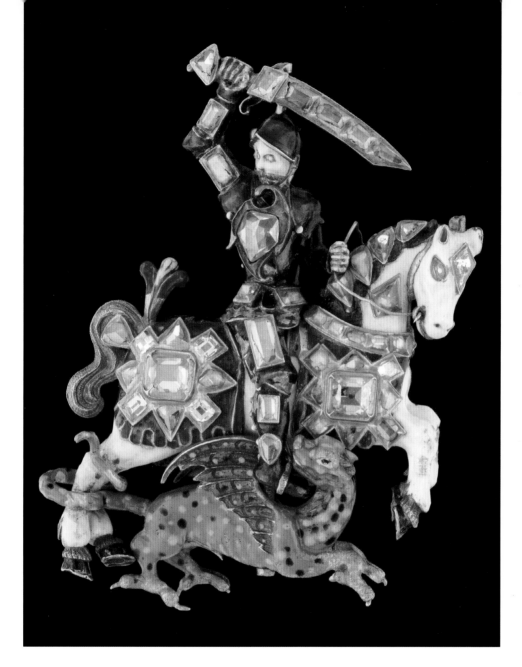

OPPOSITE
St George depicted on a pottery slipware dish.
English, 1720–30.
THIS PAGE
Insignia of the Order of the Garter.
Gold, gems and enamel.
English, 1628–9.

GODS AND SAINTS

ST MARTIN was a fourth-century Roman saint, a provincial born in Pannonia, present-day Hungary. He ended his days, in AD 397, as Bishop of Tours. His day in the calendar of saints, 11 November, is still celebrated with joyful torchlight processions in many areas of Europe. The legend tells that one day, while still serving in the Roman army, Martin saw a naked, shivering beggar, and felt moved to cut his military cloak in half to clothe him. This act led to his conversion, for he dreamt that Jesus appeared to him and miraculously restored the divided cloak, which later became a holy relic. The cloak-cutting scene identifies St Martin in art, and this example is carved in one panel of a fourteenth-century ivory diptych made in France. The saint's horse is a plain animal – indeed, his long ears are quite mule-like – and the small vignette clearly expresses Martin's character as a man of modesty and compassion.

Thomas Becket, first Chancellor of England, who became Archbishop of Canterbury from AD 1162 till his assassination in 1170, was a rather different kind of saint, a person of worldly wealth, pride and influence, who schemed and plotted in the high politics of his day. Although he was a personal friend of King Henry II, the cause of his eventual downfall was his opposition to the king's attempts to bring the Church in England under the civil jurisdiction of the Crown. His murder led to his canonization as a saint and martyr.

The stone mould was used for manufacturing pilgrim badges to be worn by those who, like Chaucer's pilgrims, visited St Thomas Becket's shrine at Canterbury. The prelate is depicted like a knight or a great lord, mounted on a handsome dappled stallion, with a hound and a groom in attendance. His status as a prince of the Church is indicated by his mitre and by the cross he carries.

OPPOSITE
St Martin: detail from an
ivory diptych.
French, 14th century AD.
Mansfield, Nottinghamshire.
THIS PAGE
Stone mould depicting
St Thomas Becket.
English, 12th–13th century AD.
Kingston-upon-Hull,
Yorkshire.

KNIGHTS AND WARRIORS

NEARLY two thousand years separate these two mounted, helmeted warriors: one was made in the sixth century BC, and the other in the late thirteenth century AD.

The older piece is a large (23.6 cm high) bronze statuette of Greek manufacture which was found in southern Italy, and it is a notable work of art of its period. The rider wears a tunic and a helmet of Corinthian type that once bore a crest running across it from side to side. There would have been a bridle and reins, added in copper or bronze strips, and the rider originally held a weapon as well as the reins. The horse himself is highly stylized, with an abnormally long and slender body, but his pose is a very natural one, and his head, with its large eyes, concave profile and small, dainty muzzle, is clearly intended to convey the idea of refinement and superior breeding. The forms and planes of his body are carefully observed, and decorative, curving lines describe the positions of bones and muscles.

The second, larger bronze, found in the River Tyne at Hexham, is a

functional object. It is an aquamanile,
a vessel for holding and dispensing
water for hand-washing at table.
Water was poured in through the
rider's helmet, and out through the
spout that projects from the horse's
forehead. The heavily armoured rider
wears a closed great helm, mail shirt
and surcoat. He has lost his lower
right leg, and would originally have
held both lance and shield; the
horse's tail is also missing. The horse
is small and fine-boned in spite of the
heavy equipment of the knight, but
the overall effect is still imposing.
However, the medieval artist has
paid less attention to the underlying
structure of the horse's body than
did his ancient Greek predecessor, so
that the smoothly rounded forms and
lack of visible joints, together with
the four-square pose, make the animal
look a little like a rather charming
stuffed horse.

OPPOSITE
Bronze statuette of a horse
and rider.
Greek, *c.* 560–550 BC.
Armento, Italy.
THIS PAGE
Bronze aquamanile in the
form of a knight.
English, late 13th century AD.
Hexham, Northumberland.

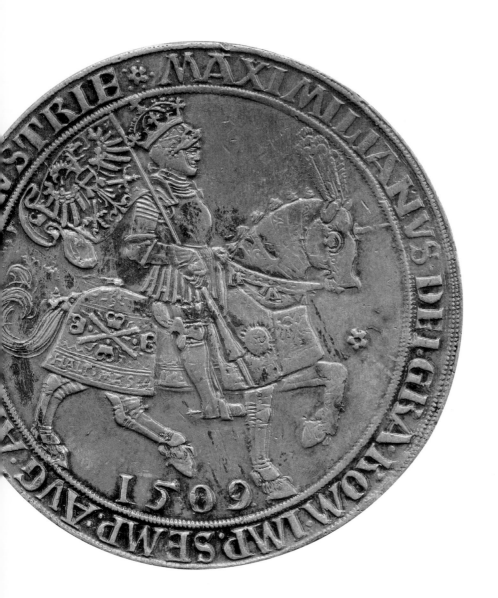

PROTECTIVE armour for war-horses has a long history going back into antiquity, but it reached its greatest degree of elaboration in fifteenth- to early sixteenth-century Europe, when some battle-chargers were almost as comprehensively encased in cloth and metal as their riders.

The image of Maximilian I, Holy Roman Emperor from 1493 to 1519, on a commemorative silver coin of 1509 depicts the ultimate in horse-armour, though the Emperor himself has also taken things to extremes, with a very large Imperial crown perched rather rakishly on top of his helmet. The horse wears not only the chamfron (face-plate) and crinet (neck-protecting plates), and very probably other metal elements – the peytrel, flanchard and crupper that covered the chest, sides and rump – beneath his decorative textile caparison, but also articulated metal armour completely enclosing all four *legs*, right down to the fetlocks. This equipment is so rare that there seems to be no general word for it: indeed, it appears that such

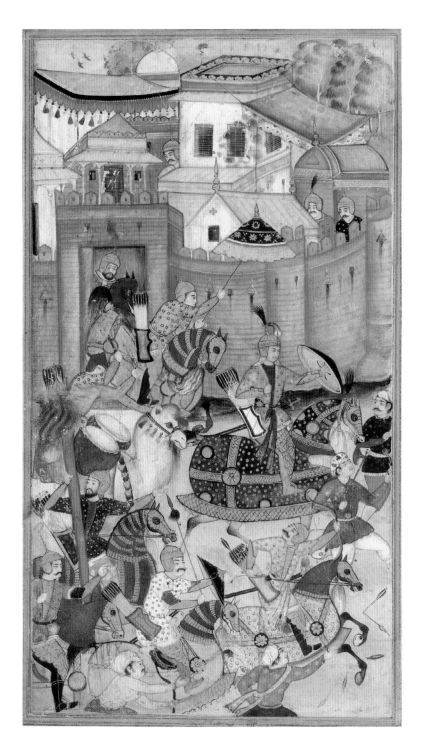

equine 'greaves' were made only by certain German or Austrian armourers specifically for Maximilian I. However impressive this kind of equipment might have looked for parades and displays, it seems doubtful whether it would have been practical in combat.

The founder of the Mughal dynasty, Zahir-ud Din Babur (1483-1530), was a near contemporary of the European Hapsburg ruler depicted on the coin. The scene painted in India about 1590 for an edition of his memoirs, the *Baburnama*, shows Babur's army leaving a fort and starting to engage in a military encounter. The Asian knights and their horses are more lightly clothed than their central European contemporaries, and the horses themselves are not such heavy animals as those favoured as military mounts in the north, but there are many points of similarity. The horses' heads and necks are armoured, and their bodies are draped in colourful cloth, which would afford some protection as well as helping to identify individuals in the mêlée of battle.

OPPOSITE
The Emperor Maximilian I
(r. 1493–1519).
Silver double guldiner, 1509.
THIS PAGE
Babur's army leaving a fort in 1497: painting from a *Baburnama*.
Mughal India, *c.* AD 1590.

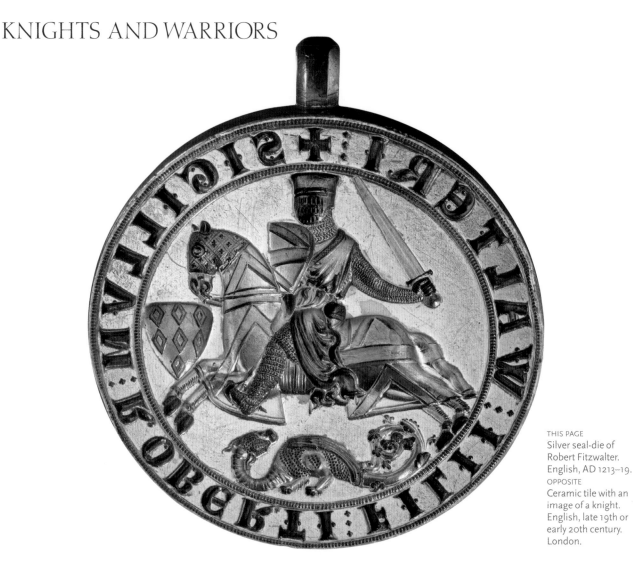

THIS PAGE
Silver seal-die of
Robert Fitzwalter.
English, AD 1213–19.
OPPOSITE
Ceramic tile with an
image of a knight.
English, late 19th or
early 20th century.
London.

THE heavily armoured medieval knight, identified by the heraldic device painted upon his shield, and mounted on a noble war-horse, is still regarded as a figure of romance. The superb silver seal-die of Robert Fitzwalter (died 1235) epitomizes this image, though when inspected closely it appears more sinister than romantic. This man was one of the most powerful barons of the early thirteenth century, not only a warrior but also a formidable politician, and was involved in the revolt that led up to the signing of the Magna Carta by King John in 1215, one of the key events of English history.

The grimly helmeted and mailed rider brandishes his sword, ready to slay the dragon that lurks beneath the hoofs of his horse. A close-fitting hood protects the horse's head, and as Fitzwalter's arms were charged with red chevrons on gold, his mount's caparison in real life would have been in those rich, glowing colours.

The floor-tile was made nearly seven centuries later, a product of the Victorian and Edwardian enthusiasm for the Age of Chivalry. Made by the firm of Minton, it was commissioned for the restoration of the medieval Temple Church in London in the nineteenth century, and was closely based both on the style and on the sophisticated ceramic techniques of inlaid medieval floor-tiles. The aim was a deliberate archaeological recreation of a formative, and by then greatly romanticized, time in the nation's history. The Temple Church was damaged in a bombing raid during the Second World War, in 1941. Based on a medieval tile design, this image is also remarkably close to Baron Fitzwalter's seal-die. Yet somehow the knight does not look nearly as dangerous as his thirteenth-century prototype, and the horse looks as though he might be more at home on the hunting field than in the brutal mêlée of a medieval battle.

PARADES AND PROCESSIONS

PARADES and processions are more impressive if horses are involved, and even today, pageantry still frequently includes horse-drawn vehicles. The tradition is an ancient one.

The decoration on the magnificent *dinos* (wine-bowl) painted in Athens by Sophilos around 580 BC has as the theme of its uppermost frieze a wedding procession, in this case the marriage of the hero Peleus and the sea-nymph Thetis, who were to

become the parents of Achilles. The wedding guests are the gods and goddesses of Olympus, led by Zeus and Hera in a chariot, and other major supernatural beings such as the Fates, Graces and Muses. They arrive at the bridegroom's house just as mortal guests would have arrived at a Greek wedding, some on foot, some in chariots, and all bearing gifts. They have all been neatly labelled by the artist with their names. The horses,

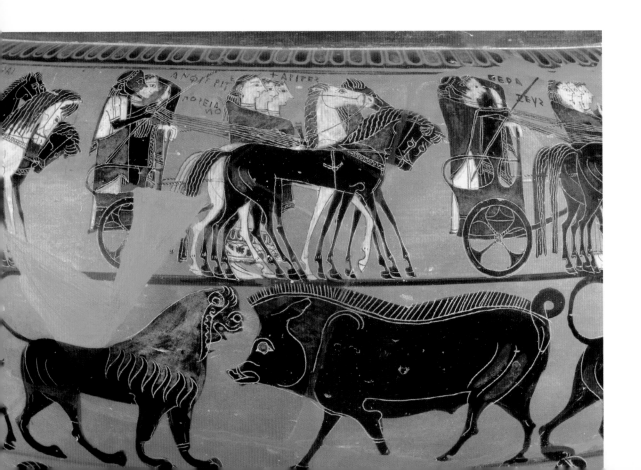

some picked out in white so as to make it easier to read the side view of four animals abreast, are unrealistically slender and delicate, yet they are still very pleasing to the eye.

The scene on the terracotta relief dates from about the second century AD, and it shows one small part of another kind of parade, a Roman triumph, which was a public event staged to celebrate military victory and therefore one which most onlookers undoubtedly enjoyed. The victorious general or emperor rode in a triumphal chariot drawn by four horses, and there were sacrificial animals and captured loot to add to the spectacle. But there were also human captives, humiliatingly paraded before their conquerors. The small, compact horses drawing a simple two-wheeled cart step out proudly, but the two bearded men that it carries wear shackles and chains at neck and ankle: they are prisoners of war, defeated and ashamed.

OPPOSITE
A wedding procession from a black-figure *dinos* by Sophilos.
Greek, *c.* 580 BC.
THIS PAGE
Terracotta relief depicting a triumphal procession.
Roman, 2nd century AD.
Italy.

PARADES AND PROCESSIONS

BOTH of these images are from religious processions, one ancient and pagan, the other modern and Christian.

The terracotta figure was made in Egypt in the Ptolemaic (Greek) period, probably in the third century BC. The rider wears military dress, with a *chlamys* (cloak) over one shoulder, a cuirass and a short tunic, and he also wears on his head a large floral wreath with long ribbons fluttering down onto his shoulders: the wreath indicates that he was taking part in some kind of religious ritual or parade.

The horse is well-proportioned, and he paces in a solemn and showy fashion, his foreleg raised high. Originally the figurine was brightly painted, and enough colour remains to show that the horse was white, and that details of both the rider and the mount were picked out in pink, red, green and black.

Though over two thousand years later, the religious procession in the Ethiopian picture may well have had some elements in common with that in which the Ptolemaic officer took part. It is a nineteenth-century painting on parchment of a celebration in the Ethiopian Christian church. The figures stand out against a vibrant, sunny yellow background, and are observed from a dark blue cloud by a winged entity representing the Holy Spirit. A priest mounted on a sleek, lively brown donkey leads the way, and others carry processional crosses and a censer. The figure enveloped in a decorated red robe may be bearing a sacred Tabot, which must be kept hidden from view. Overhead is St George. He is an important protective saint in the Ethiopian Church, and this procession may well be in his honour. The saint rides a very fine white horse with a decorated bridle and crupper, and is equipped not only with his spear but also, more unusually, a gun.

OPPOSITE
Terracotta figurine of
a rider in a procession.
Ptolemaic Egyptian,
probably 3rd century BC.
Middle Egypt.
THIS PAGE
A religious procession.
Painting on parchment.
Ethiopian, 19th century.

ROYAL HORSES

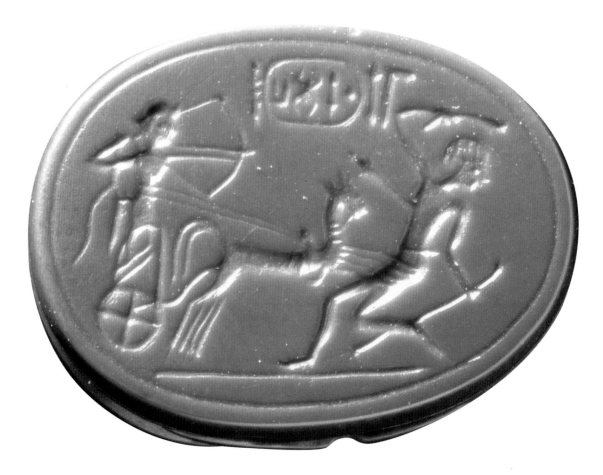

KINGS and rulers of antiquity liked to be shown as mighty conquerors, and the war-chariot was an appropriate part of that image.

The Egyptian gem is a scarab made of green jasper, a form of opaque microcrystalline quartz. The scarab beetle was significant in ancient Egypt as a symbol of the rising sun and of creation and resurrection, so amulets in scarab form were in widespread use. On the upper side, the gem depicts the scarab beetle itself in careful and realistic detail, while on the base, an oval surface only 1.53 centimetres long, is an engraved scene showing a king in his chariot killing an enemy. A tiny cartouche contains the hieroglyphs giving the name of the king, the Pharaoh Tuthmosis I of the 18th Dynasty, who reigned from 1524 to 1518 BC. The hapless foe who falls back, pierced by an arrow from the king's bow, appears to be a Nubian.

The chariot, with its four-spoked wheels, is delineated in a few deftly placed strokes, and the two horses leap forward in the usual pose, full of liveliness and vigour in spite of the minuscule scale. The iconography was so familiar that it was as effective on a surface the size of a thumbnail as it was on a colossal scale on the wall of a temple.

Though the Assyrian king Ashurbanipal I reigned nearly a

thousand years after Tuthmosis I, in the seventh century BC, his status is also expressed with horses and chariots. The royal chariot, forming part of a sequence of scenes carved on the walls of the palace at Nineveh, is part of a hunting scene rather than a battle, but the horses, chariots and weapons are the same. The Assyrian horses and their equipment are depicted in great detail. They are large and powerful animals, their harness is elaborate, with plumes and bells and tassels, and they draw a heavy chariot that has huge eight-spoked wheels.

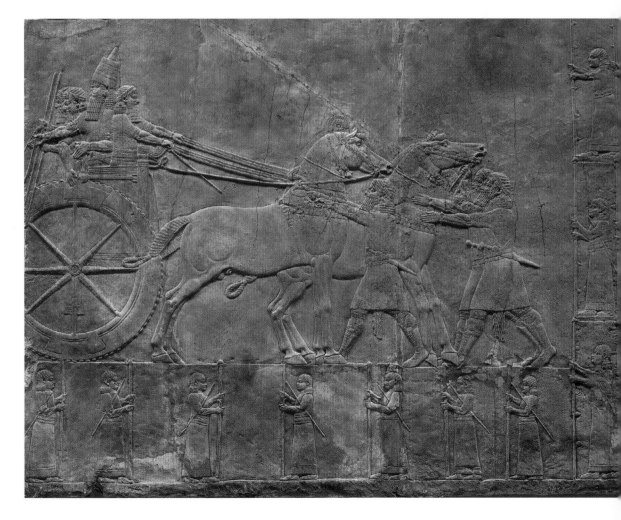

ROYAL HORSES

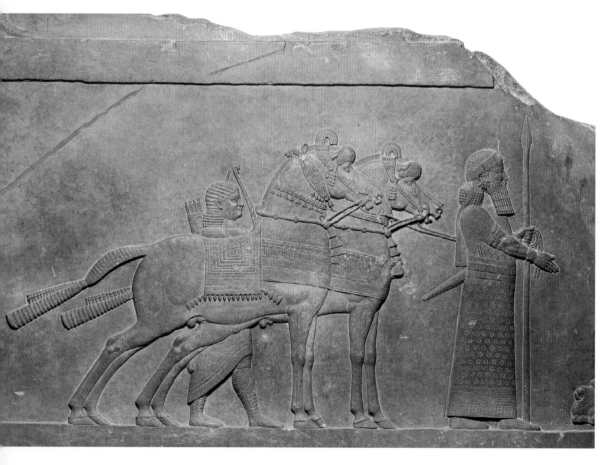

LIKE so many kings and rulers, Ashurbanipal, king of Assyria from 668 to 627 BC, must have owned vast numbers of horses, and the representations of them on the wall-reliefs of his palace at Nineveh show that they were handsome, highly bred and superbly trained animals. The chariot-horses and the saddle-horses in the royal hunting scenes appear to be of the same type and size, though whether this is a matter of actual observation or of artistic convention is uncertain. They have fine, aristocratic heads, clean legs and powerful, well-muscled (and well-nourished) bodies, and their equipment and harness, depicted in great detail in the carvings, was elaborate, decorative and obviously carefully designed for its purpose. The two riding-horses depicted here are held by a groom, and stand, proudly displaying all their best qualities, as though in a show-ring. In front of them is the king himself, dressed in a rich robe and engaged in complacently inspecting the corpses of two lions he has slaughtered.

Another king's horses are painted in underglaze blue on a very large porcelain beaker made in China during the Qing Dynasty, in the later seventeenth or early eighteenth century AD. Leaping and gambolling over the surface, they are the legendary horses of the Emperor Mu Wang, fifth ruler of the Zhou Dynasty, who reigned in the tenth century BC. He is said to have owned eight chariot-horses of exceptional qualities, and with them to have made a long journey westwards out of his kingdom. The details of the story seem somewhat variable, not to say mythical, but these eight horses became a common decorative motif associated with the legend of the early Chinese ruler.

ROYAL HORSES

FELIPE IV. REY DE ESPAÑA.
Pintura de D. Diego Velazquez del tamaño del natural: en el R.l Palacio de Madrid, dibujado y grabada por D. Franco Goya, Pintor. Año de 1778.

IN the fourth century BC, Xenophon explained precisely how to train a horse to perform the *levade*, the controlled prance with both forefeet off the ground, and observed,

> *This is the attitude in which artists represent the horses on which gods and heroes ride, and men who manage such horses gracefully have a magnificent appearance.*[1]

That comment continues to hold true in all succeeding ages, and though Xenophon does not spell it out, it is also the case that men who might not seem very impressive on their own two feet can borrow status and presence from a prancing horse. This is exemplified in the etching by Goya after a portrait of King Philip IV of Spain (r.1621–65) by another great Spanish artist, Velázquez (1599–1660). Other portraits of Philip IV, who

THIS PAGE
Francisco Goya (1746–1828), after
Diego Velázquez: *King Philip IV of Spain*.
Etching, 1778.
OPPOSITE
Silver seal-die for the Great Seal of
King William IV (r. 1830–37).
London, 1831.

presided without any marked skill or efficiency over a difficult period in the history of Spain, leave us only with the impression of his Hapsburg jaw, long, lugubrious face and excessively rich clothing. But on a conventionally prancing horse with luxuriant, flowing mane and tail, he presents the appearance of a strong and authoritative leader.

King William IV of England, the former Duke of Clarence, was already sixty-five years old when he succeeded his brother George IV in 1830. His whole career had been spent in the Navy, and it must have been daunting to ascend the throne at a time when retirement from public life might have seemed more appropriate. The silver matrix for the obverse of his Great Seal makes use of maritime imagery to reflect the King's naval background, as well as to emphasize the importance of the Royal Navy to Britain's reputation. But a monarch's Great Seal, used for authenticating official documents, is a primary symbol of his or her authority, so, in spite of the warships and trident, William is shown, in traditional manner, mounted on a handsome, high-stepping horse.

1. Xenophon, *The art of horsemanship*, XI.8, trans. G.W. Bowersock.

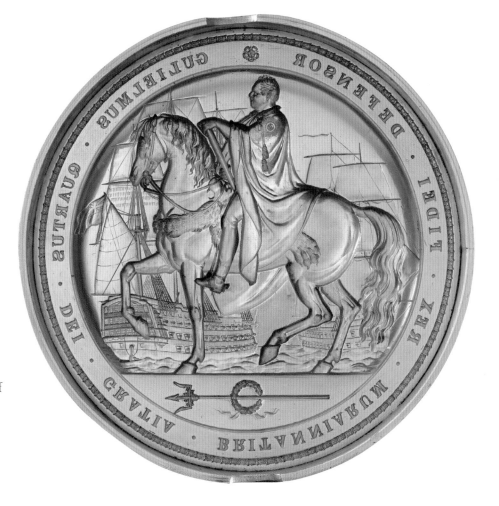

ROYAL HORSES

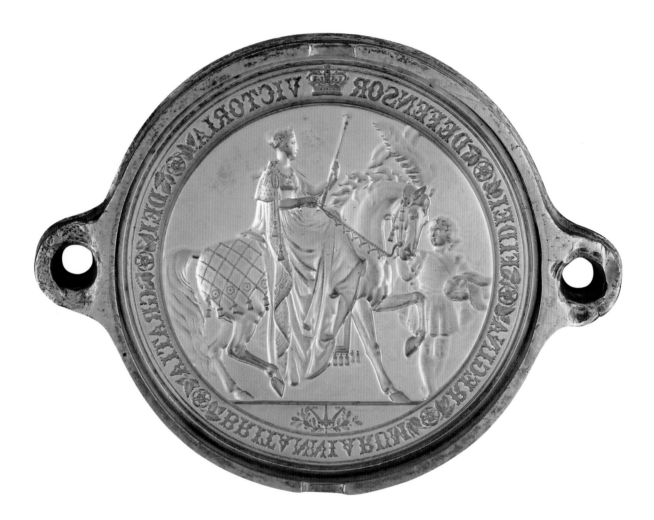

THE image of a male monarch or leader mounted on a splendid horse is one that spans many periods and cultures. The female equivalent is less common, not because women do not ride as well as men, but because they are less often rulers in their own right.

Two queens regnant are seen here in the classic pose of ruler on horseback. The silver matrix for a Great Seal of Queen Victoria (r. 1837–1901) was hallmarked in London in 1859, and although Victoria was then a woman

of forty, she appears as the very young woman she was at her accession. The design is romantically medieval in style: the monarch wears jewellery and a crown, and is enveloped in a robe so magnificently voluminous that the horse seems to be in danger of stepping on its hem. The animal himself wears a richly decorated caparison over his rump, a bridle with rosettes and tassels, and prettily decorated reins. A page holds his head, but his high-stepping gait and tossing mane and tail imply

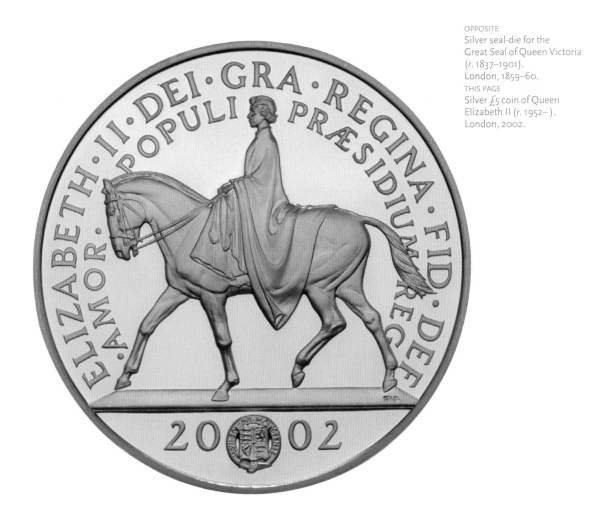

OPPOSITE
Silver seal-die for the
Great Seal of Queen Victoria
(r. 1837–1901).
London, 1859–60.
THIS PAGE
Silver £5 coin of Queen
Elizabeth II (r. 1952–).
London, 2002.

equine power easily controlled by the slender young
woman on his back.

 Queen Elizabeth II, who ascended the throne of the
United Kingdom in 1952, was depicted on horseback on
coins celebrating her Coronation, her Silver Jubilee, and
on this, a £5 coin struck in honour of her Golden Jubilee
in 2002. Like Victoria, she is shown as a young woman,
riding side-saddle as she regularly did on ceremonial
occasions throughout the early and middle years of her

reign. There the resemblance ends. This modern
constitutional monarch presents an altogether more realistic
and unaffected image than her great-great-grandmother.
Neither the horse nor his rider wears any ornament, and the
animal's long stride and head-carriage are controlled but
natural; he is a handsome horse, but not a dazzling,
fairy-tale one. The Latin inscription following the Queen's
titles is in harmony with that more prosaic image: translated,
it reads, *The love of the people is the Queen's protection.*

ROYAL HORSES

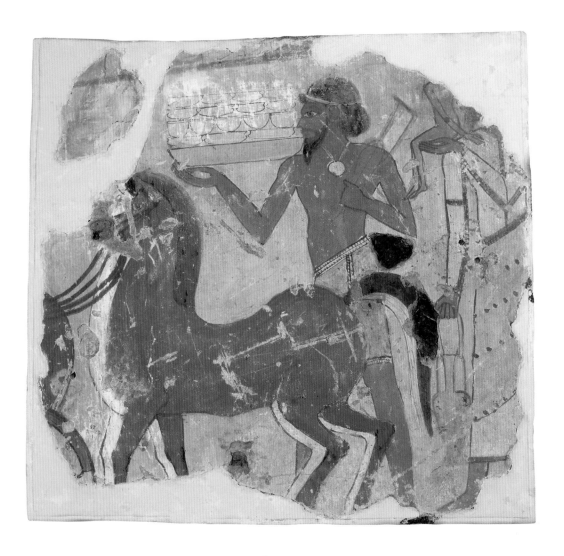

ROYAL horses had many roles. The fragment of painted
wall-plaster from an Egyptian tomb shows a pair of horses
being brought in a procession as diplomatic gifts to the
pharaoh. The tomb is that of Sobekhotep, a senior treasury
official during the reign of Tuthmosis IV of the 18th
Dynasty, around 1400 BC. One of Sobekhotep's duties
would have been to receive tribute on behalf of the king,

and the scenes painted in his tomb recorded the status and privileges he had enjoyed in life. The horses, one brown with a dark tail, and a grey visible only as an outline offset from the shape of the nearer horse, are followed or accompanied by an Asiatic man with a pointed beard, who is carrying on his shoulder a tray of what appear to be silver vessels. Part of a chariot wheel is visible in front of the horses, and other figures follow. The horses are not very large, but they carry themselves proudly, and were clearly seen as a worthy gift to present to a monarch.

The horse on the gold coin from northern India is also probably a royal animal, and one with a complex and unusual symbolic task. The coin was struck in the reign of Kumaragupta I, in the fifth century AD. On the reverse there is a female figure, probably Lakshmi, the Hindu goddess of good fortune, and on the obverse a very handsome tethered horse. After a military victory, a ritual was enacted in which a designated horse was permitted to roam freely for a year, and all the lands through which he passed were deemed to belong to the victorious king. At the end of the year, the horse was sacrificed with appropriate ceremony.

ROYAL HORSES

ZEBRAS have never been domesticated, though many individuals have been tamed and trained, and there is no reason to doubt that domestication would be possible. Instead, they have been regarded as suitable animals to hunt, and one unique variety of zebra, the quagga, has become extinct as a result. In 1763 George Stubbs painted a striking portrait of a zebra presented to Queen Charlotte, George III's queen, in the previous year. This animal, a female, was the first of her species ever seen in Britain, and as she resided in the Royal Menagerie, she was, if not a royal horse, at least a royal equid. Apart from their occurrence in illustrated alphabets for children, zebras are not very common in art, and all too often artists simply draw a horse or ass, and add some stripes. Stubbs, naturally, avoided that trap, and observed the creature minutely and accurately. The English woodland

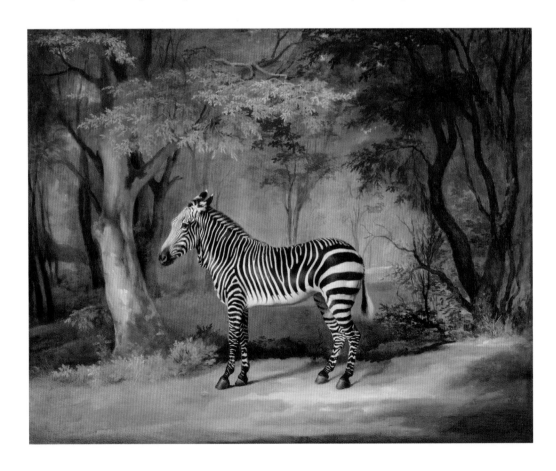

setting in which he has placed her only emphasizes her extraordinarily exotic appearance. The pattern of stripes and the dewlap under the throat show that this mare was a Hartmann's zebra (*Equus zebra hartmanni*), a species which is now seriously endangered.

Zebras feature, along with many other African animals, in a superb Ethiopian painting which commemorates the coronation of the Emperor Haile Selassie I in 1930. All those present are represented as animals, the Emperor himself being a lion, the Lion of Judah. The composition is overtly religious, recalling traditional paintings of the Last Supper in European art, a wholly appropriate treatment in view of the belief in some quarters that Haile Selassie was the long-awaited Black Messiah. In the group of creatures flanking the Emperor at a circular table, the ass and the zebra sit side by side.

OPPOSITE
George Stubbs
(1724–1806): *A zebra*.
Oil on canvas, 1763.
Yale Center for British
Art, Paul Mellon
Collection, USA.
THIS PAGE
Allegory of the
coronation of the
Emperor Haile Selassie I
(r. 1930–74).
Oil on canvas, 1930.
Ethiopian.

HORSES AND NOBLES

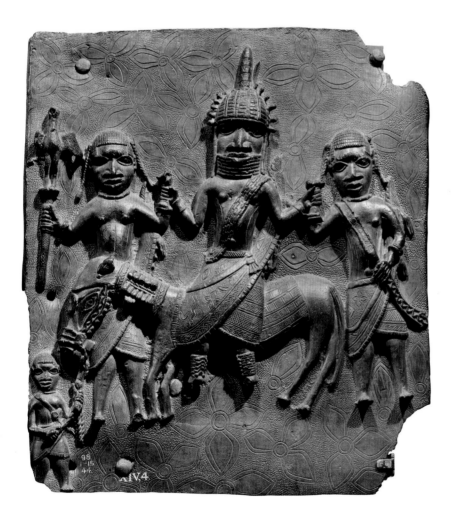

VERY important persons on horseback were sometimes depicted accompanied by attendants: both horse and servants underlined their social status.

During the sixteenth century AD, the kingdom of Benin in West Africa produced sculpture in a highly distinctive and sophisticated style. Brass plaques like the example illustrated here were used to decorate the walls of the royal palace, and they are masterpieces both of design and technical expertise in metal casting. The noble rider sits upon his horse, a rare and valuable possession, as though it were a mobile sofa, and is accompanied and supported by respectful attendants. Two of them hold his hands, while a third, at a much smaller scale, leads the horse. The intricate headdresses, personal ornament and patterned textiles extend to the horse as well as to its rider and those who accompany him.

The Indian nobleman painted in the Rajasthan style around 1800 appears to be a rather more confident horseman than his African counterpart. He is relaxed enough to smoke his

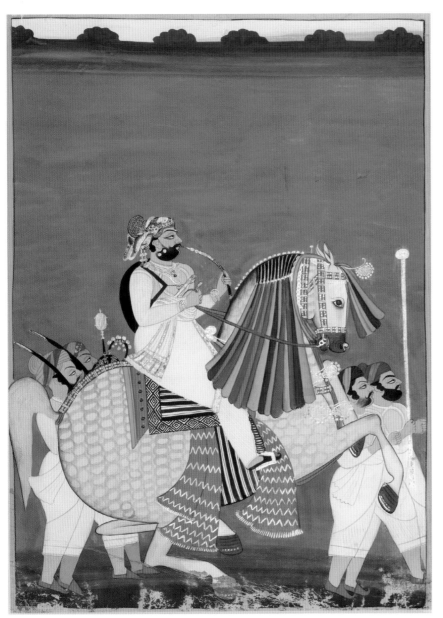

silver-embellished *huqqa* (water-pipe) while in the saddle of a horse who is prancing in the approved manner for a fine war-charger. Four attendants walk with him, carrying the *huqqa* and other items. The horse is more richly dressed than the rider, with patterned textiles, silver mounts on his bridle and crupper, and breastbands of silver lace. His mane and forelock are embellished in a rainbow of colours, perhaps in the form of silk ribbons, and even his shoes and horseshoe nails are carefully picked out in silver. There is gold leaf on the painting, too, on the rider's clothing. The horse is a dapple grey, rendered in the most charming regular pattern of pale oval spots on a blue background. The rider looks proud and arrogant, but much of his splendour derives from his mount.

OPPOSITE
Brass plaque depicting a ruler on horseback.
Benin, West Africa, 16th century AD.
THIS PAGE
A chieftain on horseback.
Painting with gold and silver leaf.
Indian, Rajasthan style,
c. AD 1800.

HORSES AND NOBLES

A GREAT military leader, like a royal ruler, appears to best advantage on a powerful, prancing steed with flowing mane and tail. The large tin-glazed earthenware dish was made in London in the late seventeenth century, and probably depicts General George Monck (1608-70), later created Duke of Albemarle for his part in the restoration of King Charles II to the throne after the English Civil Wars. Monck was a highly successful professional soldier, whose pragmatic approach to the turbulent politics of his time enabled him, at different periods, to support both sides in the bitter struggle between the Crown and Parliament. The naïve but forceful drawing shows him as a stern and soldierly armoured figure, mounted on a leaping stallion of warlike aspect. The yellow highlights pick out details of the design, including the horse's testicles, as though to emphasize the manliness of the entire concept.

Duke Ferdinand of Brunswick (1721-92) was a high-ranking Prussian nobleman who distinguished himself in several European campaigns, including the Seven Years' War, and was no less successful as a senior military commander than Monck. However, his equestrian portrait in English soft-paste porcelain, made around 1760, makes little attempt to depict him in that martial role. The banner and the trophy of arms beneath his horse are the only indications that the rider was a famous soldier. In his pink coat, lace ruffles and extravagantly flowered waiscoat, his orders and insignia adding additional touches of red, blue and gold, he looks more like a dandy than a rough, tough field marshal, and though the delicately dappled horse is powerfully muscled, his pose is not the fierce charge of a war-horse but the beautifully controlled *levade* of a ceremonial mount.

HORSES AND NOBLES

ROMANTIC overtones may often be sensed in images of a man and a woman riding together side by side. In this Mughal painting, this is more than a general impression, for the riders are a couple who epitomize romance in Indian history and legend. They are Báz Bahádur, the sixteenth-century ruler of Malwa in Central India, and his beautiful consort, Rúpmati. Their story has a sadly unedifying end, with the Mughal conquest of Bahádur's realm in 1561, and his flight in battle. Rúpmati committed suicide rather than fall into the hands of captors.

But here, in this elegant painting dating from the end of the eighteenth century, the lovers are depicted in idyllic style, riding through a tranquil moonlit landscape with trees, a lake, and a distant hilltop palace. The poet-prince is armed with bow and sword, while Rúpmati, dressed in pink, is richly bejewelled. Both horses prance

gracefully, and are adorned with
decorative bridles and saddle-cloths;
Rúpmati's mount is a beautiful
cream-coloured creature with white
mane and tail, a true fairytale horse.

The aristocratic riders on the ivory
mirror-back are not specifically identified.
The object is a carved cover for a small
metal mirror, and was made in France in
the fourteenth century AD. A mirror of
this kind was a luxurious item that
would have been owned by a person of
wealth and high social status, and the
scenes favoured for the decoration would
echo the interests and pastimes of the
class for which it was intended. The
riders are shown in a wooded setting,
each with a hawk on the left wrist; the
woman rides astride, and an attendant,
carrying a spear, is in the background.
Because women took an active part in
falconry, the opportunity to show men
and women hunting together could be
used to imply a romantic sub-text.

HORSES AND NOBLES

OBJECTS dedicated to the dead during burial rituals have immense symbolic and religious meaning, and some of our interpretation of ancient societies is based on tombs and the grave-goods that they often contain. Many societies have provided the departed with objects that they may require in the afterlife, or during the journey to another plane of existence, from food and drink to transport, riches and real or symbolic servants and attendants.

These horses are all ceramic, and they are all tomb-

figures, models of the real horses that would have signified the wealth and status of their owners in life. The stylized horse-head in red terracotta comes from a large *haniwa*, a tomb-guardian, made in Japan during the Kofun period, in the fifth or sixth century AD. 'Kofun' refers to the tumulus burials that characterize that culture, a period of military power and expansion that included the use of cavalry. The complete figure would have had a short back, long, thick, straight legs, and a tiny, upturned tail, and would have been

modelled with a saddle and crupper as well as the bridle clearly shown here.

The Chinese glazed earthenware horses are a little later, from the grave of Liu Tingxun, a senior official of the Tang Dynasty, who died in AD 728. His tomb included a whole retinue of very large glazed pottery figures (the horses are about 80 centimetres high at the head) – humans, mythical creatures, camels, grooms and these two horses, one a golden chestnut, the other white, improbably spotted with green. The Tang horses are far more realistic than the older Japanese figure, and the confident use of coloured lead glazes reveals a slightly more advanced level of ceramic technology, but all embody the essence of Horse with equal brilliance, and all emphasize the great importance of the animal in the societies that made them.

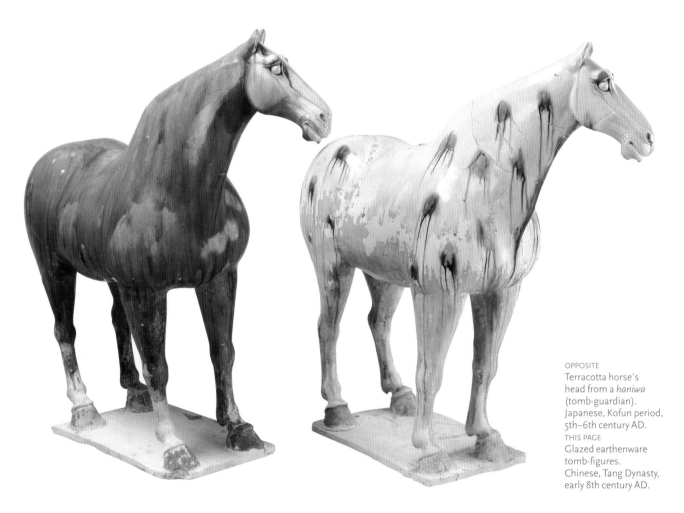

OPPOSITE
Terracotta horse's head from a *haniwa* (tomb-guardian). Japanese, Kofun period, 5th–6th century AD.
THIS PAGE
Glazed earthenware tomb-figures. Chinese, Tang Dynasty, early 8th century AD.

121

ART AND STYLE

A SKILLED artist can convey the form and the dynamic spirit of a horse in a few sweeping lines. The two examples here come respectively from 19th Dynasty Egypt (fourteenth to thirteenth century BC) and eighteenth-century Japan, and both achieve, with a few strokes of the brush or pen, horses that have a universal appeal.

The ancient Egyptian manuscript is part of a poem celebrating the Battle of Qadesh, which was fought early in the reign of Ramses II (*r.* 1279–1213 BC) against the armies of the Hittite Empire. Though portrayed by the pharaoh's propagandists as a great Egyptian victory, the actual result of this major battle between thousands of chariot-borne warriors and infantry was indecisive, and Egypt was lucky to avoid outright defeat. The poem is written in hieratic script, the 'handwriting' style in which

the purely pictorial form of hieroglyphs was adapted to a more abstract system, making it easier and quicker to use in literary and other documents on papyrus. The beautiful calligraphy of the text is further enhanced by the three little prancing horses at the head of the page.

The Japanese screen is signed by the artist Mori Shuho, who worked in Osaka in the late eighteenth century. Horses are not a marginal decoration on the paper screen but the sole subject. Ten of them are shown in all. Some prance and gallop, while others stand head-to-tail, and one enjoys an uninhibited roll. They are rendered with an economy of line and a liveliness that convey a strong sense of joy and freedom. Both the subject and style show some Chinese influence.

OPPOSITE
Poem on papyrus celebrating the Battle of Qadesh.
Egyptian, 19th Dynasty, 14th–13th century BC.
THIS PAGE
Painted four-fold screen by Mori Shuho (1738–1823).
Japanese, Edo period, late 18th century AD.

ART AND STYLE

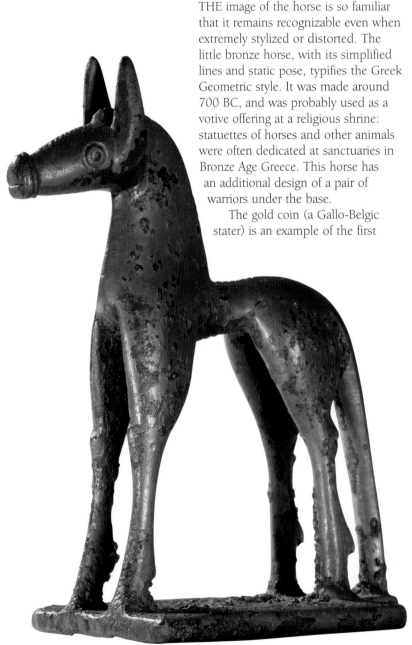

THE image of the horse is so familiar that it remains recognizable even when extremely stylized or distorted. The little bronze horse, with its simplified lines and static pose, typifies the Greek Geometric style. It was made around 700 BC, and was probably used as a votive offering at a religious shrine: statuettes of horses and other animals were often dedicated at sanctuaries in Bronze Age Greece. This horse has an additional design of a pair of warriors under the base.

The gold coin (a Gallo-Belgic stater) is an example of the first coinage that was ever seen in Britain, in the second century BC. It was struck in France, and was an item of high value; coins were not yet in general circulation as part of a money-based economy, but were probably occasional gifts or traded items between high-ranking individuals on opposite sides of the Channel. Although tribes in the south began to issue their own currency soon after this, coinage as an everyday medium of exchange, and including low-value denominations, was introduced only when Britain became a Roman province in the first century AD.

These Gallo-Belgic coins are copies, at several removes, of the Greek staters issued by Philip II of Macedon (r. 359-336 BC), the father of Alexander the Great. The Celtic and Gaulish mercenaries who served in the Macedonian army would have been paid in Greek gold coin. The original Greek coins have an idealized, Classical head of the ruler on the obverse, and on the reverse a racing *biga* (chariot drawn by two horses), realistically depicted. Celtic die-engravers, working from copies, and from copies of copies, expressed their own artistic preferences by creating increasingly abstract versions of these designs. Here, chariot, chariot-wheels and charioteer have all mutated into a whirling mass of lines and spots and spokes, but the horse, albeit a dislocated fantasy creature of turbulent curving lines and dots, may still be recognized as a horse.

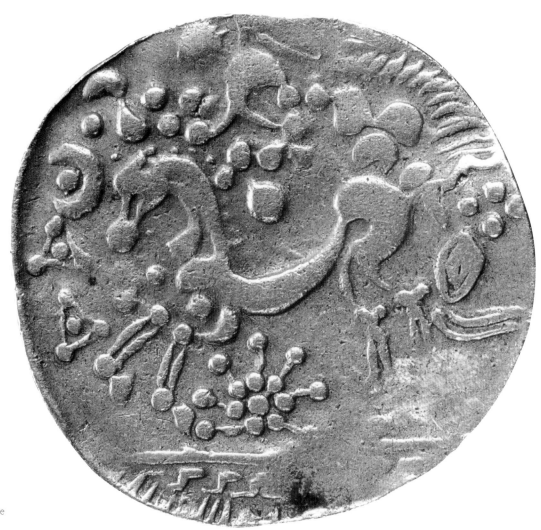

ART AND STYLE

HORSES have noble and beautiful heads, whether they are shaggy draught-horses or refined Arabians. There is something about the elongated profile, the soulful eyes and delicately pointed ears, the mobile lips and sensitive, flaring nostrils, that has always appealed deeply to human sensibilities. The two heads illustrated here are vastly different, and yet fundamentally the same.

The beautiful colossal marble head of one of the horses of the moon-goddess Selene from the east pediment of the Parthenon is an iconic object in the art of the Western world. Carved in the fifth century BC, it belongs to the finest period of Classical Greek art, a pinnacle of human

achievement that has influenced countless
artists throughout the succeeding centuries and
millennia. This horse is a divine horse; he is an
embodiment of equine beauty which rises
above mere realism, though the sculptor has
minutely observed and reproduced every subtle
plane and contour of a real horse's head.

The contrasting piece may seem, at first
sight, almost crude. A small sheet-bronze relief
only 10 centimetres long, it was made in
Britain at the time when Roman culture had recently been
introduced, in the first century AD. Its exact function is
unknown, but it would have been an applied adornment
to some object or utensil, perhaps a vessel for beer or other
alcoholic drink. The form of the head is totally simplified,
and the elliptical eyes with their lugubrious outward droop,
the long ridges sweeping from brow to flared nostril and
evoking the bony structure of the equine skull, are so
stylized that it might be a cartoon horse; yet it conveys the
essence of horsiness as surely as does the elegant, highly
finished sophistication of the Greek animal who drew the
chariot of the moon. Realism and extreme stylization remain
contrasting traditions in representational art, and these two
examples illustrate how each can be effective in evoking the
quintessential spirit of the subject.

ART AND STYLE

THE legacy of Classical 'fine' art from about the fourth century BC to the second century AD has always occupied a special place in Western consciousness. Like Graeco-Roman literature, it is the common heritage of all the countries that once formed part of the Roman Empire, and those that were colonized from them in recent centuries. It was not until the late nineteenth century that artists and collectors began to pay serious attention to the merits of totally different artistic traditions, those of Oceania, Africa and various Asian cultures.

The large glazed earthenware pot is a fine example of quality studio pottery of the early twentieth century, when artists and craftsmen were eagerly absorbing influences from many different sources. It was made around 1925 by Hedwig Marquardt in Kiel (Germany). The ideas behind the design of the leaping horses, plants and geometric motifs are not easy to identify precisely, for they have been filtered through the artist's own creative mind, but we can infer that she had looked at painted pottery and at other artefacts from many places and

eras. The horse, strong, bold and
simplified, pleases the eye as much
on this Art Deco piece as it does
on an antiquity.

Graeco-Roman craftsmen did not
always aim for realism. The austere
stylization of the Greek Geometric
style is well known, but this terracotta
figurine is from the opposite end of
the Classical world, the very late
Roman period. It was made at Aswan
in Egypt in the sixth to seventh
century AD. The saddled horse has a
satisfyingly equine appearance, even
though his hollow body
and legs are moulded
as a single arched
shape. He wears a
breast-band and
crupper with
dangling
ornaments, and
details were
picked out in black
and red. The actual
purpose of the
object is not known,
and it is not
impossible that it
may have been
used as a toy.

OPPOSITE
Earthenware pot by
Hedwig Marquardt.
German, 1920s.
THIS PAGE
Terracotta figurine.
Egyptian, 6th–7th
century AD.

129

BREEDS AND TYPES

THIS PAGE
Albrecht Dürer
(1471–1528):
The large horse.
Engraving, 1509.
OPPOSITE
Théodore Géricault
(1791–1824): *Horses
being led to a fair.*
Lithograph, 1822.

FROM the earliest days of domestication, people must have exercised choice in the types of horses they used and bred for different purposes, selecting sometimes for strength and size, sometimes for endurance and speed. The genetic potential within the species is illustrated by today's hundreds of breeds, ranging from the delicacy of the Arab to the monumentality of the Shire. Although the use of heavy metal armour in the Middle Ages required strong, muscular horses, those chargers were still usually smaller, lighter and more agile than the modern heavy draught breeds, bred to haul very heavy loads.

Dürer's 1505 engraving shows the mount of an early sixteenth-century warrior. It is interesting to analyse why this animal looks to us rather more like a draught-horse than a battle-charger. It is not only a matter of the powerful musculature, emphasized by the foreshortened three-quarter rear view,

and the massively boned legs and feathered heels: all of these are perfectly suitable for a weight-carrying mount. But we think of a war-horse as a fierce, prancing, pawing, snorting creature, eager for battle, and this horse is an off-duty charger, looking dreamily docile and relaxed.

The string of horses being taken to an English fair is an 1822 lithograph by Théodore Géricault. The partially obscured horse on the far right is a good deal smaller and more lightly built than the four heavy horses, and is probably a saddle-horse. However, one of the large cart-horses is actually being ridden, bareback, by one of the two rustics that control the group.

Even in a monochrome print, we can infer that the central, nearest animal is a strikingly marked skewbald or piebald, the second, seen from the back, a chestnut, and the leader a dapple-grey. The smaller horse has a docked tail, but the long tails of the others are knotted up, much like the tail of Dürer's horse.

BREEDS AND TYPES

TWO-COLOURED horses, called piebald (black and white) and skewbald (any other colour and white) in British English, and 'paint' or 'pinto' in American, have sometimes been regarded with slight condescension because of their bright, almost gaudy impact, but most people take pleasure in their decorative, eye-catching appearance. Pied horses, both those with large solid patches of white and other colours, and those with intricately spotted coats, appear in the art of many cultures, and they have often been favoured for formal public or ceremonial roles.

The handsome glazed earthenware horse was made in China during the Tang Dynasty (AD 618–906). The artist's mastery of clay and glazes enabled him to blend realism with an imaginative element in this large statuette, which was used as a tomb-figure. Though the splashes of blue on white are not naturalistic, they convey the impression of a densely marked piebald, while the proportions of the animal are also carefully exaggerated and judged to emphasize his power and presence. Many glazed and unglazed earthenware figurines were made in the Tang period, depicting humans and various animals, and the horses are amongst the finest.

The Mughal artist who painted the picture of a golden-and-white stallion in the middle of the seventeenth century was recording a specific animal rather than a type; this is an individual horse portrait in a Persian tradition. The inscription tells us that the stallion's name was 'Amber Head'. He poses as proudly as any human sitter, wearing his most decorative saddle and bridle, brushed and groomed to perfection, and with the tip of his tail dyed crimson, probably with henna. His colouring and conformation are very different from those of the Tang horse, but both the Chinese sculptor in clay and the Indian painter have expressed their enjoyment and admiration of beautiful horses.

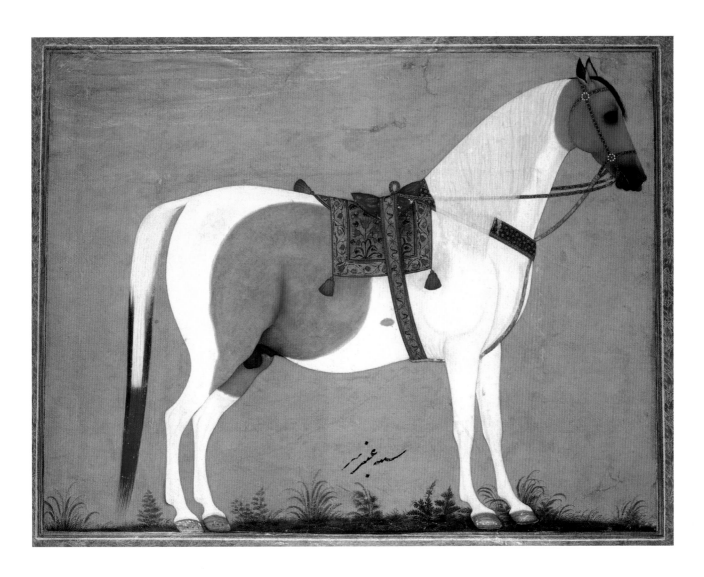

BREEDS AND TYPES

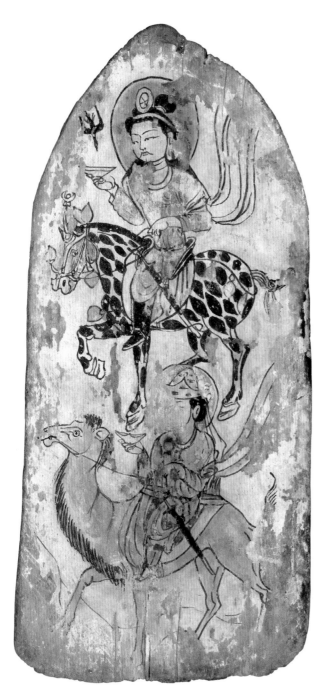

SPOTTED coats have long occurred in many types and breeds of horses, and the modern American Appaloosas, whose bloodlines were first developed and perfected by a Native American people, the Nez Percé Indians, are now a very popular breed. Their ancestors would have been Spanish horses, whose spotted forebears, in turn, were depicted in both European and Asian art before the inhabitants of the New World had encountered any kind of horse.

The painting on a wooden plaque is a votive object, a rare archaeological survival from Khotan, a kingdom on the Southern Silk Route. It dates from the sixth century AD. Two aristocratic riders, one mounted on a camel, the other on a spotted horse, carry bowls or wine-cups, and a scene such as this undoubtedly had complex layers of religious and mythological meaning. The horse, with its rather heavy head, stocky conformation and large, regular spots, is very similar to the slightly later Chinese horses of the Tang Dynasty. The wooden panel has pegs on the back to enable it to be attached to the wall of a shrine.

An aristocratic and fashionably dressed European lady rides a charmingly spotted horse in the hard-paste porcelain figurine made at Ludwigsburg in Germany around 1760. The rider seems to be perched somewhat casually on her side-saddle. She wears a jaunty black hat, and her very dashing habit has a patterned skirt, gold braid and frogging, and wide cuffs turned back to reveal the deep lace flounces at her wrists. In addition, she has gold earrings, gold-buckled yellow shoes, and powdered hair. Combined with the horse's scarlet saddle-cloth and his own black-spotted white coat, the overall effect is festive and colourful. The horse's markings would be described, in modern Appaloosa terminology, as a leopard pattern.

OPPOSITE
Wooden votive plaque
painted with riders
carrying bowls.
Chinese,
6th century AD.
Khotan Oasis, Xinjiang
Province, China.
THIS PAGE
Hard-paste porcelain
figure of a woman
riding a spotted horse.
Made in Ludwigsburg,
Germany, c. AD 1760.

ASSES, ONAGERS, MULES

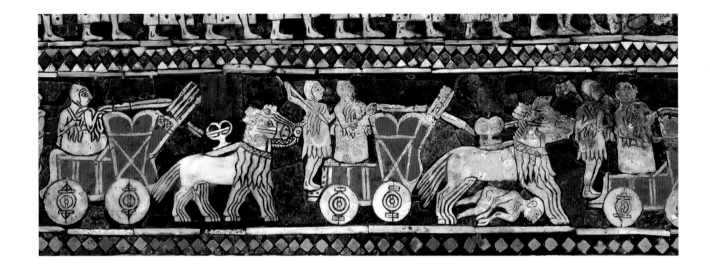

SOME of the very earliest representations of equine animals drawing wheeled vehicles are to be seen on a wonderful Sumerian object from the Royal Cemetery at Ur, made around 2600–2400 BC. Known as the Standard of Ur, its actual function is unknown, though it may have been part of a musical instrument. It is a wooden box, inlaid in stone and shell with scenes of battles and processions. The carts or chariots have four solid wheels, and are pulled by teams of animals that have been identified variously as asses and onagers. The question of whether the onager, *Equus hemionus*, was ever truly domesticated in ancient Mesopotamia remains an open one, though it seems very possible that wild-caught individuals may have been kept in captivity and tamed, if only for mule-breeding. The draught-animals on the 'standard' could equally well be domesticated donkeys, however, descended from

Equus asinus, the African, rather than the Asian, wild ass. Their ceremonial role as depicted on this very valuable and sumptuous object suggests that they were held in high esteem.

From the same culture and about the same period, a precious-metal fitting for a highly decorated ox-drawn sledge is embellished with a figure of an animal that looks very like an onager. The object is a double terret or rein-ring of silver, which was fixed on the pole of a sledge: such terrets, somewhat out of scale, are clearly shown on the poles of the donkey-carts on the standard of Ur. It comes from the 'Queen's grave' at Ur, the rich burial of a woman whose name (inscribed on a seal found in the grave) was Pu-abi. The statuette surmounting the terret rings is made of electrum, a natural gold-silver alloy, and was therefore an object of considerable intrinsic value.

OPPOSITE
Carts drawn by equids:
a scene from the
'Standard of Ur'.
Inlaid wood.
Sumerian,
c. 2600-2400 BC.
Ur, Iraq.
THIS PAGE
Silver and electrum
terret with a figure of
an onager.
Sumerian, c. 2600 BC.
Ur, Iraq.

ASSES, ONAGERS, MULES

ASSES tend to be regarded today as 'inferior' to horses. They are generally smaller, not so beautiful to our eyes, and, because their social organization differs from that of the horse, they are in certain respects more difficult to train and control, giving rise to the view that they are more stubborn than horses and less docile. Yet they are intelligent creatures that have served humanity very long and very well, and in many countries are still indispensable beasts of burden.

The 1649 etching by Wenceslaus Hollar, after a drawing by the Venetian artist Jacopo Bassano, is an example of a realistic animal portrait, executed with loving attention to detail. Hollar, most famous for his landscapes, delighted in accurately reproducing form and texture, yet this picture is much more than an almost scientific exercise in recording the external appearance of an ass: in the typical resting pose of the equid he has conveyed the patience and sense of

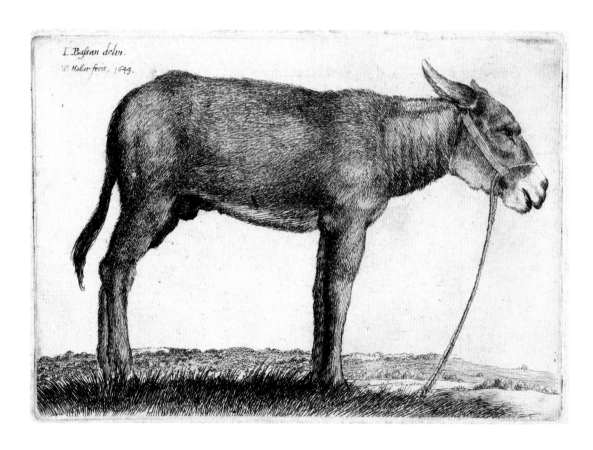

resignation that we so often associate with the donkey.

The contrast between human perceptions of the ass and the horse is well illustrated in the engraving by Albrecht Dürer. This horse is a soldier's mount, and despite the heavy conformation that would be regarded as 'common' by many horse-lovers today, he exudes the alert and eager confidence of the war-horse, pawing the ground and snorting like the charger described in the Old Testament:

> He paweth in the valley and rejoiceth in his strength: he goeth on to meet the armed men.
>
> He mocketh at fear, and is not affrighted: neither turneth he back from the sword.
>
> (Job 39:21-2)

It is easy to admire the glamorous virtues of courage and fiery pride, but those of quiet reliability and industriousness are at least equally estimable, and are common to both horse and ass.

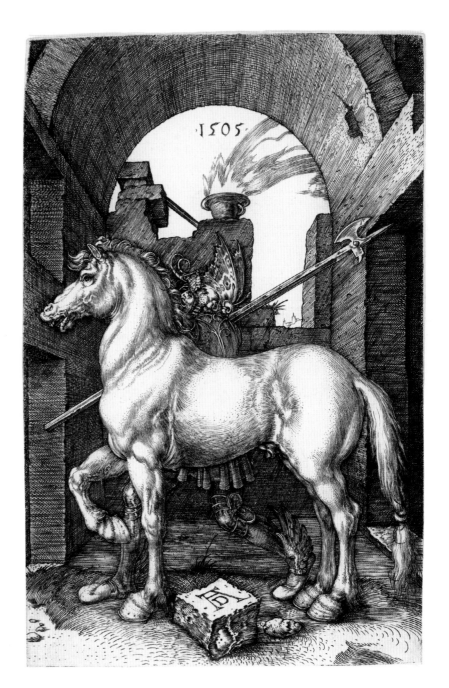

OPPOSITE
Wenceslaus Hollar
(1607–77), after Jacopo
Bassano (c. 1510–92):
A donkey.
Etching, 1649.
THIS PAGE
Albrecht Dürer
(1471–1528):
The small horse.
Engraving, 1505.

ASSES, ONAGERS, MULES

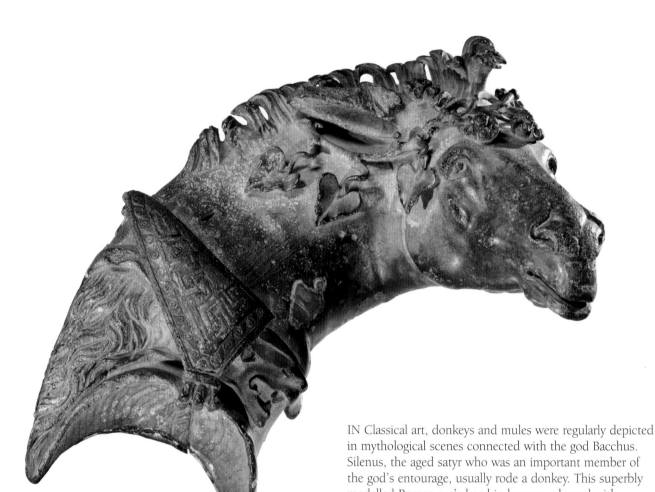

IN Classical art, donkeys and mules were regularly depicted in mythological scenes connected with the god Bacchus. Silenus, the aged satyr who was an important member of the god's entourage, usually rode a donkey. This superbly modelled Roman ass's head in bronze, adorned with delicate silver inlay on his collar, is a Bacchic animal, a fact indicated by the ivy wreath twined around his head. It was found in France, and served as the ornamental terminal of a *fulcrum*, the curved, decorative metal mount that embellished each side of the head-rest of a Roman couch. A luxurious, high-quality article of furniture such as this, with silver-inlaid bronze mounts, would have enhanced the home of a provincial landowner of considerable wealth and taste. Other decorative details from the same couch would

very likely have continued the Bacchic theme, perhaps with figures of other appropriate animals associated with the god, such as panthers, and of vines and olives, wine-cups and musical instruments. The style of the work is typical of the vivid realism of early Roman art: this donkey is the companion of a god, and has a confidence and vitality worthy of any war-horse.

The little bronze statuette of a braying ass wearing two large panniers, also a Roman object, is much less elegant and highly finished, and its precise function is not known. A child's toy would have been made of a cheaper material than bronze, and so we might speculate that this donkey was a table-utensil, perhaps designed to contain spices or very small delicacies of some kind loaded into the panniers. Decorative and elegant table equipment was an important signifier of social status in the Roman world, though silver, rather than bronze, was the preferred material if the owner could afford it.

ASSES, ONAGERS, MULES

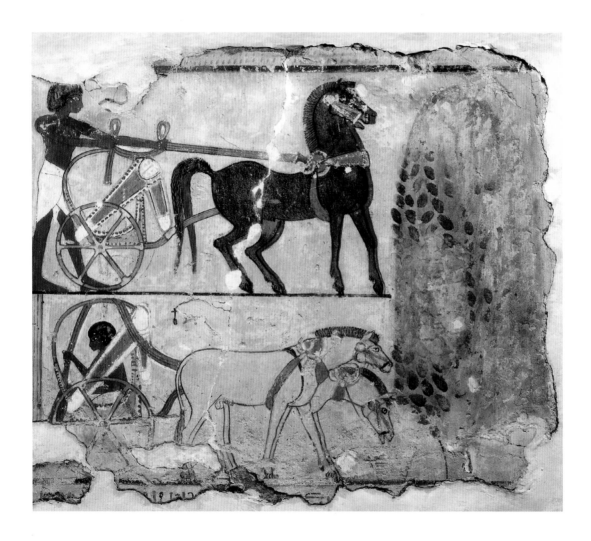

PRECISE identification of equine species in ancient art is not always easy. Asses, onagers and various equine hybrids, which may have included mules of types that are not bred today, cannot always be told apart.

The wall decoration in the tomb of Nebamun at Thebes (Egypt) was painted during the 18th Dynasty, around 1350 BC. Two types of equids are contrasted in this fragment. In the upper panel is a two-horse chariot, the further horse

only just visible behind the nearer one. The horses are in highly collected poses, their heads held high, tails arched, and hind legs tensed beneath them. They embody the age-old ideal of the showy carriage horse, eager, lively and spirited, but also fully under control.

In the lower register is another vehicle, drawn by a pair of grey or white animals, clearly different from the horses, whose identification has given rise to much scholarly debate. They have been variously identified as Przewalski's horses, onagers (Asian wild asses) or horse/domestic ass hybrids, that is, mules or hinnies. While the first identification may be dismissed because they simply do not look like *Equus przewalskii*, cases can be made for all the others, or even for other possible equine hybrids. If they are a matched pair of trained onagers, they would have been rare, exotic and expensive imports. If, as seems more likely, they depict either of the horse-ass hybrids, probably hinnies, they bear witness to deliberate breeding and the careful choice and training of animals for varying purposes. In any case, the artist has taken care to differentiate between horses and other horse-like animals trained to pull wheeled vehicles.

The tiny bronze weight, weighing 16.6 grammes, is also from Egypt, but was made in the Roman period. It is in the form of a reclining foal, which does not appear to be either a horse or an ass, and seems most likely to be a hinny, the offspring of a donkey mare and horse stallion.

143

ASSES, ONAGERS, MULES

is a first cross between a horse and a donkey. Usually inheriting the hardiness and strength of their donkey sire and the greater size of their horse dam, mules have always played an important part in human communities, not only as draught and pack animals, but also for riding.

There were strict and complex regulations about the use of vehicles in Roman cities, and riding in a carriage within the city was a special privilege reserved to certain classes of people on certain occasions only. The *carpentum*, a two-wheeled, covered and open-fronted carriage, was usually drawn by mules, and a very handsomely appointed example is seen here on a coin issued by the Emperor Caligula (r. AD 37–41) in memory of his mother, Agrippina the Elder. Mules were perfectly appropriate draught animals for the use of members of the Imperial family.

The saddle-mule depicted in a woodcut by the Danish artist Melchior Lorck in 1576 also evidently belongs to a person, probably a woman, of wealth and high status. The animal's equipment is exceedingly elaborate. All the bands and straps of his harness are highly ornamented, and he wears neck-bands that consist of strings of small bells, with additional pendant bells on these and on his breastband and crupper, as well as decorative tassels. The large saddle is thickly padded and upholstered like a piece of furniture. This is no humble beast of burden, but the mount of a person of importance.

HORSES and donkeys would be extremely unlikely to interbreed in nature. The hybrid species was created, and must be maintained, by human intervention: because asses and horses have different chromosome counts (62 and 64 respectively), mules have an odd number, and are therefore normally infertile. Each and every mule

NAGL. 48.

OPPOSITE
A mule-cart depicted
on a bronze sestertius
of Caligula.
Roman, AD 37–41.
THIS PAGE
Melchior Lorck
(*c*.1526-after 1588):
A saddle-mule.
Woodcut, AD 1576.

CARE OF HORSES

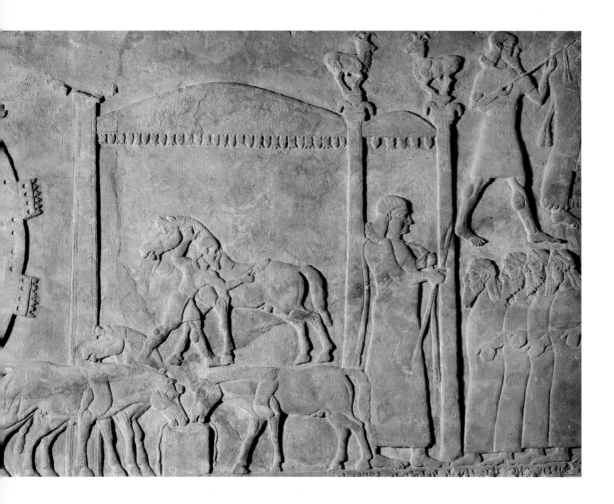

THE process of grooming a horse has not changed a great deal in the last two or three thousand years. Horses that work hard under saddle or as draught animals sweat and become spattered with mud or covered with dust, according to the prevailing conditions. Responsible owners (or their servants) rub down, brush and polish the animals' coats, check their feet, and make them clean and comfortable on a regular basis, as well as ensuring that they have sufficient food and water. The grooming rituals are not only physically agreeable for the horse, but also strengthen equine–human bonds. The horses being fed and groomed on the stone relief from the palace of Ashurnasirpal II at Nimrud (Iraq) were carved in the

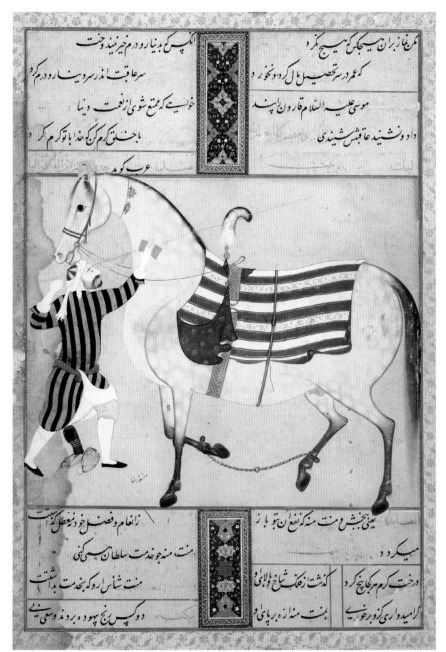

ninth century BC. This scene of everyday horse care is set between a panel depicting a bird's-eye view of the Assyrian battle camp and one that shows prisoners of war and rejoicing, victorious, soldiers. Horses were part of the ancient Assyrian army, and so their care was woven into the activities of that body of men, as it has been in all cavalry units throughout the ages.

Moving forward to the end of the sixteenth century AD, a page from a Persian manuscript shows a horse equipped with a bridle, a gaily-striped saddle-cloth and girth, and a rope hobble, being rubbed down. Part of the text above the painting refers to the horse as 'said to be Arab': the reputation of Arab horses for speed, endurance and beauty was already widespread by this period. This stallion's small head, powerful quarters and slender limbs are emphasized, and even though the actual position of the legs, with both fore and hind feet on the same side off the ground, is unrealistic, we have no difficulty in perceiving the impression of aristocratic superiority that the artist wished to convey.

CARE OF HORSES

HORSES have sensitive, complicated feet, and if they are damaged or painful, the horse will become lame. The horn of the hoof grows constantly, like a fingernail, but adverse conditions can cause it to wear down too fast, or to become soft, cracked or uneven. Hoof-protection to try to avert some or all of these problems was introduced during the Roman period, and took the form both of heavy iron hipposandals, which were lashed onto the hoofs and easily removed, and nailed horseshoes, which may have been invented in the damp climate of the northern provinces. Neither device was in common use in the Roman world, but shoes became standard equipment in the Middle Ages. The techniques and tools for forging, fitting and attaching horseshoes have not changed significantly in two thousand years.

The two scenes both show a horse being shod: one was painted by a Mughal artist around AD 1600, while the other is a print after the French master Géricault, made when he was in England around 1822. In the everyday scene from the reign of George IV, we see three horses that are servants of humankind. Their conformation is that of common light draught- or riding-horses, and their tails are docked, for practicality rather than beauty. The horse in

the foreground tries to nip the grey which is being shod, and the blacksmith fends him off unceremoniously with his tongs; the man is in charge.

In the Indian scene, the exceedingly elegant stallion, with his refined head, dainty legs and flowing mane and tail, is being ministered to by three men rather in the manner in which servants might assist a noble master with his toilette. The horseshoes and tools of farriery that lie in the foreground are universal, but the magnificent animal, clearly the valued companion of some great man, is the subject of the picture, and the groom, the farrier and his assistant are his acolytes.

OPPOSITE
Théodore Géricault (1791–1824):
The English farrier.
Lithograph, 1822.
THIS PAGE
Shoeing a horse.
Mughal painting, *c.* AD 1600.
India.

CARE OF HORSES

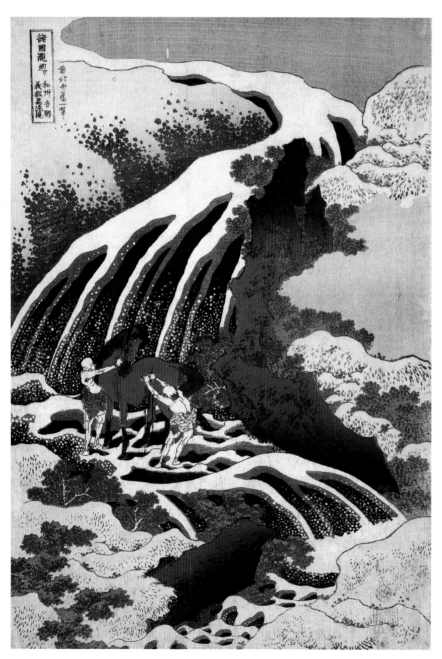

THE care of horses sometimes includes washing as well as brushing them: a bucket of water is usually sufficient for the purpose, but most horses enjoy bathing, and if a pond or river is conveniently available, working horses may still be washed down in a large body of water. A particularly scenic waterfall is not, however, a necessity.

The colour woodblock print was made around 1830 by one of the most famous Japanese artists, Katsushika Hokusai, and shows two men energetically washing down a slightly gaunt brown horse in 'the waterfall where Yoshitsune washed his horse'. Yoshitsune was a legendary Japanese general of the twelfth century, whose story encompassed not only military glory and high courage, but also a tragic ending when, betrayed by former allies, he killed his family and committed suicide. Hokusai's print does not appear to depict Yoshitsune himself, but perhaps suggests that the association with the great romantic and

THIS PAGE
Katsushika Hokusai
(1760–1849):
The waterfall where Yoshitune washed his horse.
Woodblock print.
Japanese, *c.* AD 1830.
OPPOSITE
Inro decorated with a scene of a horse getting into a boat.
Nashiji lacquer, made by Jokasai.
Japanese, 18th century AD.

tragic hero made this an auspicious place for anyone to wash his horse.

The other object is also Japanese, and was made in the early eighteenth century of *nashiji* lacquer (lacquer incorporating gold leaf). It is an *inro*, a little container that was worn attached to the belt of the kimono. These functional objects were often exquisitely decorated, and this is no exception. Using a limited palette of golds and black, and a subtle range of patterned textures, the artist, Jokasai, has created a vivid scene that perfectly communicates the feelings of an unhappy horse who is most reluctant to get any closer to the water, or at any rate to the unstable environment of a boat upon the water. Two men holding ropes try to persuade the black horse to embark from the landing-stage, while others, including some anxious-looking passengers already aboard, look on. Though his front feet are already in the stern, every line of the animal's body expresses resistance and mistrust.

OBJECTS OF USE AND ORNAMENT

THE techniques for engraving intaglio (sunken) designs on decorative hardstones, principally the many colourful varieties of quartz, were developed as early as the fourth millennium BC in the ancient Near East, and seal-stones began to be used for both practical and purely decorative purposes: positive casts were employed for sealing locked doors or containers, or for sealing the earliest written documents, while the engraved gems themselves could be worn as amulets or for personal adornment. The two intaglios here are small masterpieces of the gem-engraver's art, one from Egypt and the other from Crete.

The tiny rectangular plaque (it is only 1.78 centimetres long) in brilliant yellow jasper is intended for use as a swivelling ring-bezel, for it is pierced lengthways and engraved on both sides. On the back, it is dated by an

inscription which names the Pharaoh Amenhotep II of the 18th Dynasty (*r*. 1453-1419 BC), while on the side shown here, the name of the god Amun appears over the horse, with hieroglyphs signifying 'great (of) majesty, he is victorious'. Amenhotep II was legendary for his great physical strength, and the horse, shown with proud, arched neck and tail, acts as a symbol of the king's power and invincibility,

The other gem is also pierced, and may have been worn as an ornament, though it is likely to have been a functional seal-stone as well, used in Minoan Crete's highly developed administrative system. It can be dated somewhere in the period 1450–1300 BC. The scene engraved in the translucent carnelian shows a whip-wielding charioteer driving a two-horse chariot with four-spoked wheels. The zig-zag line above the horses may be an attempt to depict some aspect of the harnessing. The horses themselves are sleek and stylized, and they may have had some special significance for the owner of this small Bronze Age work of art.

OBJECTS OF USE AND ORNAMENT

BROOCHES are jewels that may be functional – primarily intended to fasten clothing – or purely ornamental, and zoomorphic (animal-shaped) brooches occur in many different cultures. All kinds of animals, from insects to large predators, have attracted the notice of jewellery designers and craftsmen, and of course, they include horses, represented sometimes because they have a special interest for the wearer, and sometimes simply because they are aesthetically pleasing.

Coloured enamelling on bronze was a technique in which the native inhabitants of northern Europe, including Britain, already excelled before they became part of the Roman Empire, and their craftsmen continued to make highly decorative objects of use and ornament in this tradition. The little spotted horse is a simple bronze brooch, inlaid with spots of coloured enamel and probably made in Gaul (France) around the second century AD. Its original appearance would have been bright and colourful, as the polished bronze, now patinated greenish brown, would have been golden, and the enamels, now faded, would have been a vivid, almost gaudy, contrast. The horse's head

and neck are cast fully in the round, though the body is flat at the back.

The delicate and extremely intricate carved ivory brooch, featuring three horses within a border of oak branches, could not be more different in material, style and technique, yet it still depends on the charm of the horse for its effect. Both the horses and the vegetation are rendered in highly realistic detail at a small scale – each horse is around 1.5 centimetres long. Ivory-carving of this outstanding quality was manufactured in the nineteenth century in the German town of Erbach, and the brooch is probably the work of a member of the Kehrer family, active between about 1830 and 1860.

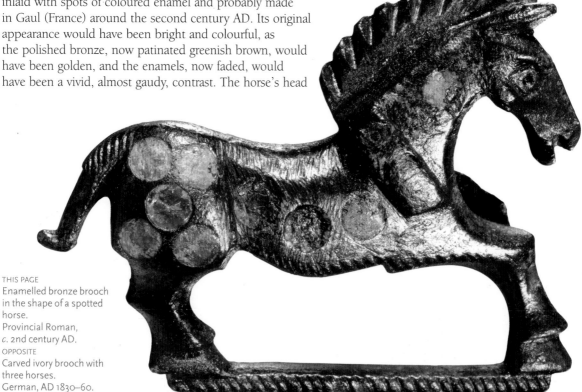

THIS PAGE
Enamelled bronze brooch in the shape of a spotted horse.
Provincial Roman, *c.* 2nd century AD.
OPPOSITE
Carved ivory brooch with three horses.
German, AD 1830–60.

OBJECTS OF USE AND ORNAMENT

PERSONAL ornament, whether functional or purely decorative, carries a multitude of social messages in all human communities. Its choice is governed by many factors, of which the intrinsic value of the material and the aesthetic quality of the design are only the most obvious.

The two objects illustrated here are both belt-fasteners. The bronze belt-hook belongs to the Iron Age of Korea and dates to the second or first century BC. In simple, rounded forms, it conveys not only the shape, but also the concentrated power of the horse. As in other cultures, the introduction of iron for weapons and tools did not diminish the importance of bronze, the durable and beautiful copper alloy of which they had formerly been made. It is thought that horse-shaped belt-fasteners of this kind were a symbol of rank.

The gold belt-buckle is a valuable functional jewel of the late Roman period, found in a hoard of gold and silver objects hidden at Thetford (Norfolk) at the end of the fourth century AD. Elaborate metal fittings for leather belts – buckles, strap-ends and decorative plaques and stiffeners – were worn by men of high civilian or military status in this period. The less valuable examples, made of bronze, often feature two stylized animal heads in the design of the bow through which the free end of the belt passes. They can be interpreted as anything from dolphins' to boars' heads. Here, the bow includes the confronted heads of two horses, realistically modelled. The buckle-tongue, now missing, would rest between them. The hinged rectangular gold plaque that was riveted to the other end of the belt bears a Bacchic device, a dancing satyr. Each detail of this luxurious costume accessory was carefully designed, and the horses were part of its status-enhancing imagery.

OBJECTS OF USE AND ORNAMENT

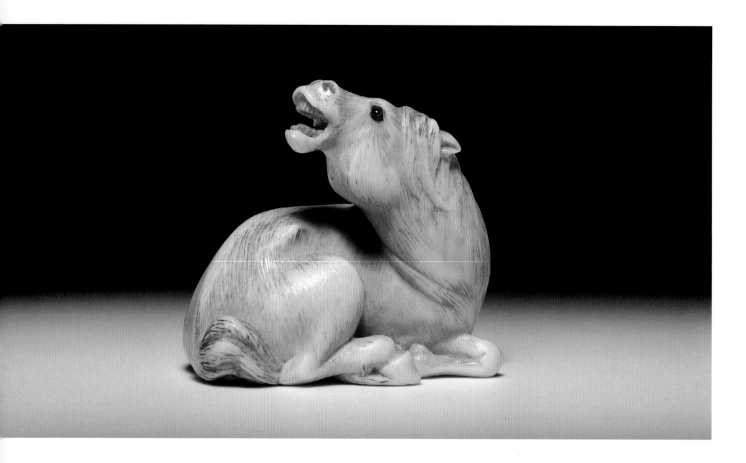

THE three objects shown here are all both functional and decorative examples of personal ornament.

The ivory *netsuke* is typical of its kind: designed for use as part of the Japanese costume, it is also an object of beauty and value, and probably also conveys symbolic meanings. It represents a reclining, neighing horse, and the artist has carved it in minute detail, down to the teeth revealed in the open mouth. For the owner, it might well have been significant as a Zodiac sign, or for some other personal reason. The plump shape of the horse and his compact pose have been carefully designed to be both appealing and practical.

The nineteenth-century cravat pin is another remarkable example of carving in ivory, this time from Europe, probably Switzerland. Mounted on a silver pin, the miniature sculpture is simply a direct and realistically proportioned representation of a horse trotting on a section of flat ground. In wear it would have been far more vulnerable to damage than the *netsuke*, with its incredibly delicate legs, tiny, pricked ears and swishing tail. The artist is showing off his virtuosity, and it is up to the wearer to ensure the safety of his creation.

The third object is probably a hairpin, and though we know it was made in ancient Egypt, it is difficult to date

it accurately. It might have been made at any time from the early New Kingdom, around the sixteenth century BC, to the Roman period, the first few centuries of the Christian era. Carved in wood, it is topped with a stylized horse-head with large, pricked ears and an upstanding mane. The people who wore these little sculptures, in such different times and places and ways, all appreciated the appearance and the symbolism of the horse.

OPPOSITE
Ivory *netsuke* in the shape of a reclining horse.
Japanese, 19th century AD.
LEFT
Wooden pin carved with a horse's head.
Egyptian, probably New Kingdom.
BELOW
Silver and ivory cravat-pin with a trotting horse.
Probably made in Switzerland, *c.* AD 1840.

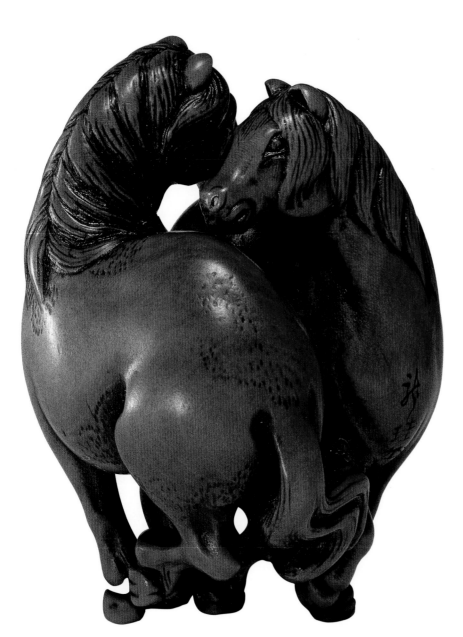

JAPANESE *netsuke* in the form of a horse or horses are not uncommon, because of the universal appeal of the animal and also probably because it was one of the Oriental Zodiac symbols. The function of a *netsuke*, as a toggle on a cord, makes it desirable for the carving to have a fairly smooth and rounded form, though this principle was certainly not invariably followed: some carvers seem to have been concerned chiefly with demonstrating their great skill and virtuosity rather than making a convenient fastener.

A horse is very far from being a simple, smoothly rounded shape devoid of fragile protuberances, and two horses have twice as many

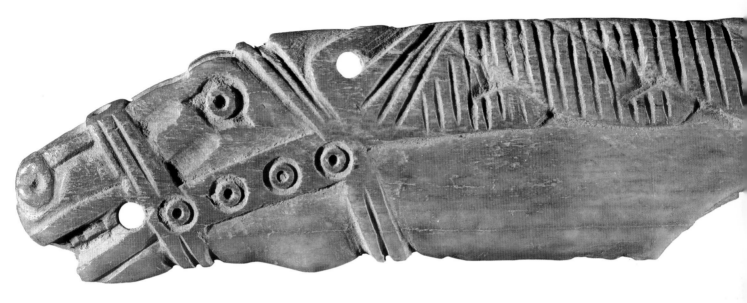

delicate, flowing tails, excessively thin legs and little pointed ears as one: yet in this small masterpiece of design and execution, the artist, Ryukei, has contrived to create in wood a pair of horses that together form an almost ovoid entity. At the same time, they are behaving in a natural equine manner, standing head to tail and grooming one another. The visual and tactile appeal of the object is irresistible.

In the Roman world, the small folding knife was an essential piece of everyday equipment: its sharp iron blade was kept safely sheathed when not in use in a handle made of cast bronze or carved bone or wood. The handles were sometimes quite plain, but decorated forms were also popular,

for example a hound chasing a hare, or an erotic scene. This carved bone knife-handle was made in Egypt in the Roman period, and is in the form of a horse's head and neck. The animal's ears are laid back to keep the outline smooth, even though this gives him an angry expression, and he wears a simple bridle with circular ornaments.

OPPOSITE
Wooden *netsuke* by Ryukai in the shape of two horses. Japanese, 19th century AD.
THIS PAGE
Bone horse-head knife-handle.
Romano-Egyptian.

OBJECTS OF USE AND ORNAMENT

CONTAINERS and vessels of various kinds can be made in zoomorphic (animal-shaped) form, though in ceramic materials the essentially ovoid shapes of birds and fishes tend to be more practical and robust than the more complex shapes of mammals, with their often slender legs and tails. The two very different ceramic containers shown here illustrate different design solutions for incorporating a horse figure in a container, and for avoiding the inherent fragility of equine legs.

The little earthenware flask comes from the Fayum, a fertile region west of the Nile valley in Egypt, and was made in the Ptolemaic period, perhaps in the second or first century BC. It is very small, only 5.2 centimetres in height, and was probably designed to hold perfume or perhaps a medical or cosmetic preparation. The problem of the legs has been solved simply by representing the horse lying down, with all four legs folded neatly under him. The animal has rather long ears, so there is a possibility that he is a mule, though a horse is perhaps more likely. He wears no bridle, but is equipped with a simple saddle-cloth with a

textured surface suggesting fleece, and an adjustable girth. The mouth of the flask has been drawn up, without any concern for verisimilitude, from the animal's rump.

A Chinese ceramicist of the eighteenth or nineteenth century has used a different approach in his charming, colourful porcelain horse. This little creature, with its cream body and brown mane and tail, plunges through the most decorative white-capped turquoise waves, so its legs are well protected. Three small tubular containers, turquoise and red, are carried on the horse's back.

OBJECTS OF USE AND ORNAMENT

BOARD-GAMES have a very long history indeed. They have exercised the ever-active human brain, symbolized the universal competitive themes of the hunt, the race and warfare, and provided a leisure activity for those who actually enjoyed some leisure, who were generally the same people who made decisions in warfare and hunting.

The carved ivory box, some 29 centimetres long, was found in a Bronze Age tomb at Enkomi, Cyprus, and dates from the twelfth century BC. Its lid is marked out as a board for the 'game of twenty squares', and

it would originally have contained the gaming pieces themselves; the rules of the game are unknown. The hunting scenes on the sides of the box have very strong echoes of the contemporary cultures of the Near East and Egypt: a king in a light chariot drawn by galloping horses draws his bow at a selection of large prey – deer, goats, bulls and a lion. This was an object of value that emphasized the rank and importance of its owner.

The Lewis chessmen, found on the Isle of Lewis off the north-west coast of Scotland about 1831,

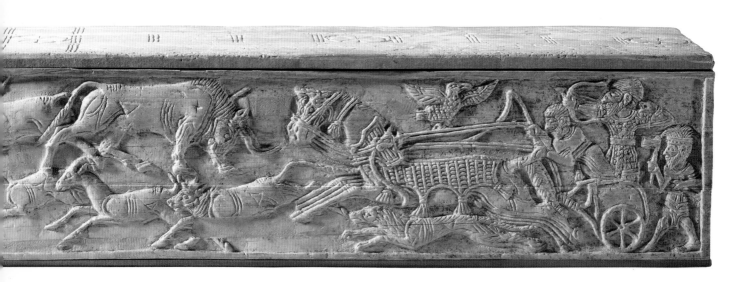

are well known even to people who
know little about board-games or
medieval iconography: they are truly
iconic objects. Carved from walrus-
tusk ivory, they were probably made
in Norway in the twelfth century AD.
More than eighty pieces were found,
and fifteen of the mounted knights
survive today, varying in size
according to the taper of a walrus's
tusk. The knights all carry spears and

kite-shaped shields bearing simple
early heraldic devices, and they wear
varying types of helmet, some conical
and some which look disconcertingly
like bowler hats or upturned bowls.
The horses, or rather, ponies, are
delightful. They are small, chunky and
compact, with demure expressions
and long, full manes and tails,
and they wear simple bridles and
long saddle-cloths with zig-zag hems.

OPPOSITE
Ivory game box decorated with a
hunting scene.
Cypriot Bronze Age, 12th century BC.
Enkomi, Cyprus.
THIS PAGE
Walrus-ivory chessmen: two knights.
Made in Norway, AD 1150–1200.
Found on the Isle of Lewis, Scotland.

OBJECTS OF USE AND ORNAMENT

THE walrus-ivory chess-piece is at first sight somewhat reminiscent of the famous Lewis chessmen, but it is a later and far more florid object, dating to the fourteenth or early fifteenth century AD. It was probably made in Germany. The piece is a bishop on horseback, characterized by his mitre and crozier, and he is accompanied – indeed, surrounded – by an extensive retinue of no fewer than fourteen small attendants or bodyguards, including other priests and armed men carrying crossbows. The bishop's mitre, his robes and his horse's bridle and reins are decorated with beading, and the overall effect is almost decadently opulent.

The other gaming-piece is not a chessman but a large flat counter, probably used for the game called *tabula*. This game, played with dice and apparently not unlike backgammon, was already well established in Classical antiquity, when quite plain counters were often used, sometimes even home-made ones fairly

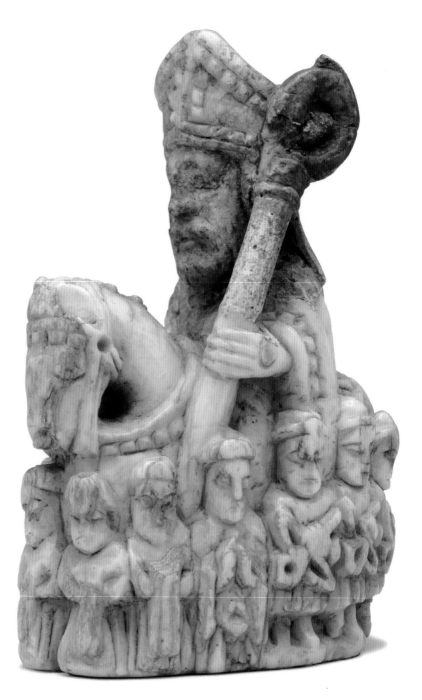

roughly chipped out of broken sherds of pottery. The game remained popular in the medieval period, especially around AD 1200, the date of this piece. It is one of a luxury set made in Cologne from elephant ivory, a valuable imported material. Around 6 centimetres in diameter, the pieces all have a raised, decorated border and a carving in high relief depicting an animal. Many, like this mare and foal, show an animal with its young, but there are others with proud male animals and predators. Although the proportions of the foal are not realistic – it has the smaller head and shorter legs of an adult horse – the vignette has been designed to fit its space naturally and attractively. Like the elaborate chess-pieces, these counters were objects of value that would have be owned and used by persons of importance.

MYTHS AND MONSTERS

THE speed and grace of the horse suggests flight, and the myth of a winged horse arose independently in many times and places. The name that we usually attach to any winged horse is, however, that of a specific Greek myth – Pegasus, the son of the sea-god Poseidon, who sprang from the neck of the Gorgon Medusa when she was decapitated by Perseus.

The representation of Pegasus on a silver coin of Carthage, dating from the middle of the third century BC, is a perfect Classical rendering of the immortal Greek winged horse, a divine super-horse which is the apotheosis of all the equine virtues. It is an image that evokes

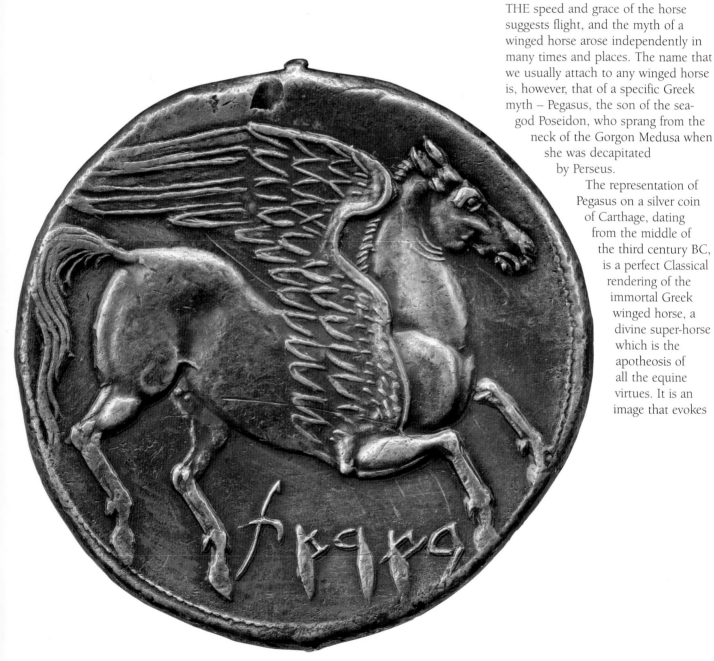

beauty, freedom and nobility. Later used extensively in medieval heraldry, the winged horse has come down to our own time as the symbol of innumerable institutions, ideas and products, from computer software to equitation, from aviation to poetry.

Pegasus is the focal point of one of Josiah Wedgwood's masterworks, a vase of which he was so proud that he presented it to the British Museum in 1786 – and the Trustees, who did not at that time normally collect contemporary objects, admired it enough to accept it. The white figures on the blue jasperware body were modelled after the decoration of a specific Greek vase by the pre-eminent neo-Classical sculptor John Flaxman (1755–1826), many of whose designs for Wedgwood still remain in production more than two centuries later. Flaxman's rearing white Pegasus on his pale-blue cloud takes his place in a continuum of fantasy from prehistory to the present day.

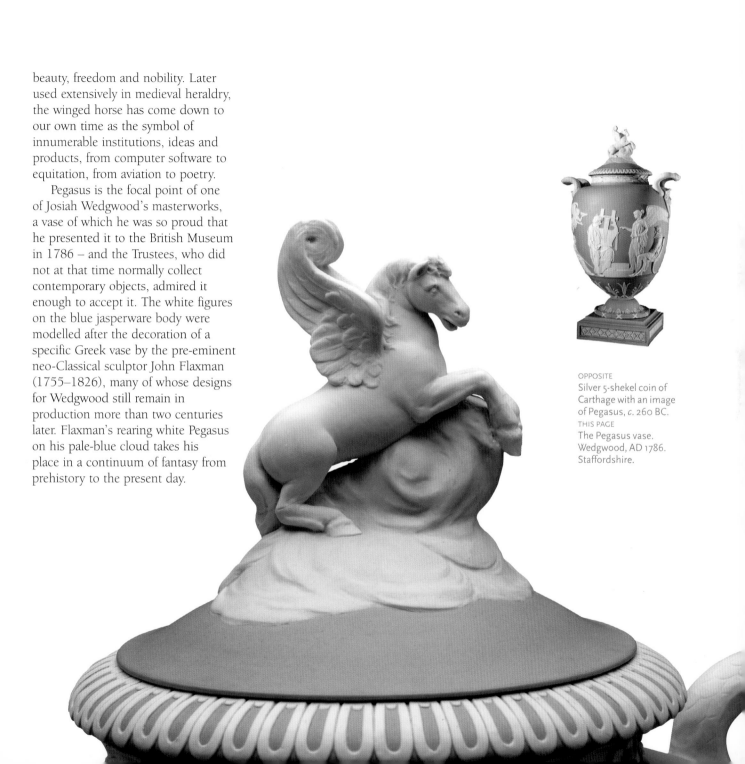

OPPOSITE
Silver 5-shekel coin of Carthage with an image of Pegasus, *c.* 260 BC.
THIS PAGE
The Pegasus vase. Wedgwood, AD 1786. Staffordshire.

MYTHS AND MONSTERS

THE winged horse we call Pegasus, son of Poseidon and Medusa, was not created by the Greeks. This fabulous creature appeared, fully imagined, in the art of the ancient Near East long before Greek vase-painters were depicting him on their pottery vessels.

Engraved stone cylinder seals were functional objects, developed in Mesopotamia around 3500 BC to mark clay sealings on containers and other objects with distinctive and recognizable designs, but they were also worn as jewellery and valued as magical amulets. The example illustrated here was engraved in the thirteenth century BC, the Middle Assyrian period, on chalcedony, a coloured, translucent variety of quartz that is still used in jewellery. The scene on this sophisticated prehistoric object, which is only 4.1 centimetres high, is of animals in combat – a rearing winged horse confronting

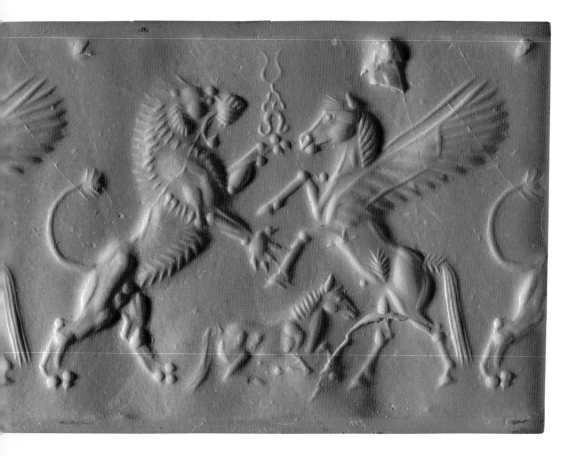

OPPOSITE
Chalcedony cylinder seal
engraved with a winged
horse and a lion. The
impression on the left shows
the complete scene.
Middle Assyrian,
c.1300–1200 BC.
THIS PAGE
Wooden bracket in the shape
of a winged horse.
Southern India,
18th century AD.

a leaping lion. Both creatures are
represented with a confident elegance
astonishing when we consider the small
scale and the convex surface of the
cylinder. At the base of the balanced
triangular composition is a smaller,
reclining horse, which, though without
wings, may be intended as the foal of
the fighting Pegasus.

More than three thousand years later,
the prancing winged horse appears as
an ornamental element on an Indian
temple car, a huge, complex vehicle used
in religious processions. Carved in wood,
this is a very domestic winged horse
compared with the god-like equine
creature of Classical antiquity. His
diminutive wings, though they spring in
the traditional fashion from his shoulders,
would scarcely have lifted him off the
ground, and he is equipped with the
elaborate horse-trappings that we see
in other representations of horses in
eighteenth-century Indian art – decorative
neck-bands and leg-rings as well as the
functional bridle, saddle and crupper.

MYTHS AND MONSTERS

LIKE many heroes of myth, Bellerophon of Corinth had to kill a monster, a ravening beast called the Chimaera, which had the body of a lion, a goat's head growing from her back, and a tail in the form of a serpent, complete with head. Like all traditional dragons, she breathed fire.

The goddess Athena gave Bellerophon a golden bridle and told him how to catch the winged horse Pegasus when he came to drink at a fountain. Mounted on this immortal animal, the offspring of a god, Bellerophon was able to slay the monster. Pegasus and Bellerophon undertook other exploits together, but in the end Bellerophon was punished for his hubris in attempting to reach Olympus and was thrown to earth: Pegasus, on the other hand, has a permanent place in the Classical pantheon, amongst the horses of Zeus.

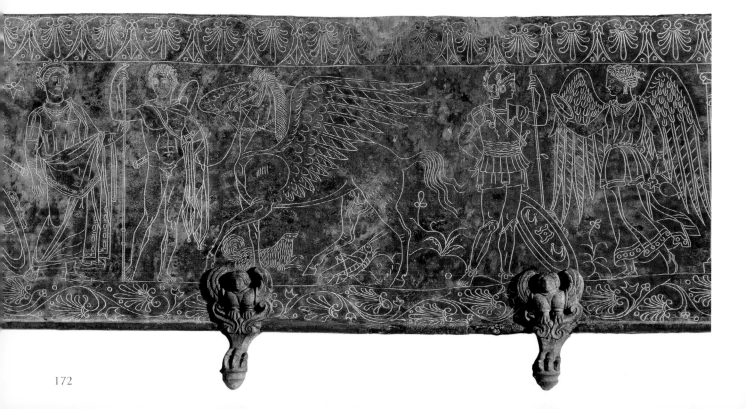

On the elegant *cista* (a bronze casket probably intended to contain toiletries), made in Italy around 300 BC, Bellerophon simply stands proudly, holding his divine mount, but the small image engraved on a gem shows the iconic scene of the slaying of the Chimaera. Cut on a glass setting in a gold ring, this piece of jewellery was found in England, and it was used in the final decades of the centuries-long Roman administration of Britain.

Tiny though it is, the image calls to mind scenes of dragon-slaying Christian saints, and the resemblance is not fortuitous. In the fourth century AD, as Christianity gained influence in the Roman world, this was one of the many ancient pagan scenes adopted by Christians and interpreted in a new way. The ring may have been worn by a Romano-British Christian who saw Bellerophon as a symbol for Christ slaying the Chimaera of Evil – or by a person who still respected the old pagan Graeco-Roman traditions and was inspired by the story of an avenging hero on his beautiful winged stallion.

OPPOSITE
Bronze *cista* with a scene of Pegasus and Bellerophon. Praenestine, 325–275 BC. Palestrina, Italy.
THIS PAGE
Gold finger-ring set with a gem engraved with Bellerophon slaying the Chimaera.
Late Roman, 4th century AD.
Havering, Essex.

MYTHS AND MONSTERS

ALTHOUGH in the usual telling of the myth, Bellerophon was riding the winged Pegasus when he slew the savage Chimaera, there are also ancient representations that show the hero mounted on a mortal horse without wings. The Greek terracotta plaque, from the island of Melos in the Cyclades, was made in the middle of the fifth century BC. It shows the helmeted hero mounted on a graceful and well-proportioned horse, about to dispatch a Chimaera whose leonine body, snake tail and goat's head rising from her back are all so convincingly integrated and realistically

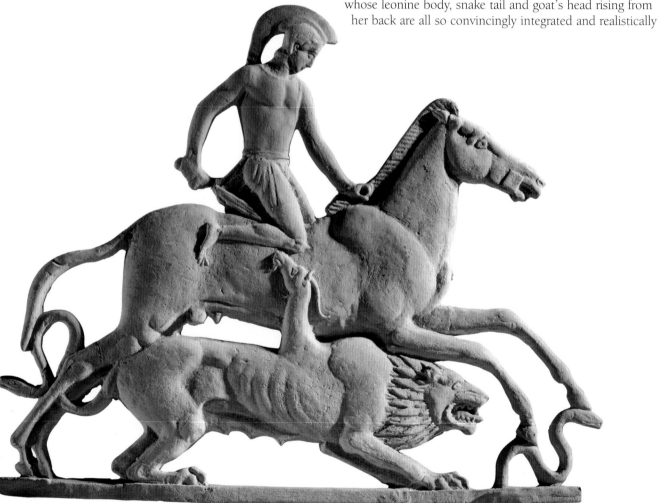

depicted that she seems almost believable. The function of these plaques is not known for certain, but they are thought to have been used for decorating domestic objects such as furniture.

The Chimaera appears as an even more complex hybrid beast in the other object shown here, an Etruscan gold fibula (a brooch of safety-pin construction) dating to the sixth century BC. In the Classical world, safety-pins designed to fasten and embellish clothing were sometimes made in precious metals and in very decorative shapes – functional items of jewellery that also expressed the wealth and taste of the wearer. The Chimaera was a popular subject in Etruscan art, and the most famous ancient representation of the creature is a large-scale bronze statue from Arezzo. The tiny gold Etruscan Chimaera here has

wings in addition to her lion's body, serpentine tail and goat's head. Her prospective victim is depicted at the foot of the brooch, a little reclining horse apparently unaware of the nightmarish predator creeping up on him and crouching, ready to pounce. The monster's prey has a small body and a large head, the proportions of a foal rather than an adult horse.

OPPOSITE
Terracotta plaque: Bellerophon slaying the Chimaera.
Greek, *c.* 450 BC.
Melos, Greece.
THIS PAGE
Gold fibula decorated with the Chimaera and a foal.
Etruscan, 6th century BC.

MYTHS AND MONSTERS

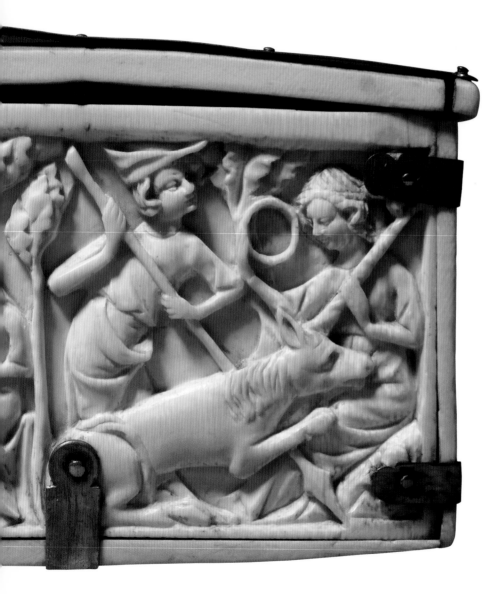

THOUGH legends of an Indian wild ass with a single horn were known in Classical antiquity, it was not until the Middle Ages that the unicorn became fairly standardized in appearance, acquired a complex symbolic role and was widely represented in the decorative arts. Heraldic animals became part of the familiar visual vocabulary of a population in which literacy was confined to a small educated class. The unicorn was a very popular heraldic beast, and remains as familiar to the eye today as most natural species: we all know what a unicorn should look like. This magical equine creature was usually depicted as a white horse with cloven hoofs, a tasselled tail, a goat-like beard, and a distinctive long, straight and spiralling horn growing from the forehead.

Though they were symbols of virtue and purity, unicorns were not shy, timid creatures. On the contrary, they were believed to be brave and dangerous fighters, and to be too fleet and fierce to be caught by any

THIS PAGE
A maiden and a unicorn: detail from a carved ivory casket. French, AD 1325–50. Paris.
OPPOSITE
Gold unicorn coin of James III of Scotland (r. 1460–88).

conventional hunting methods. However, if a virginal young woman were used as bait, the unicorn could easily be trapped: he would come and lay his head meekly in her lap. This is the scene depicted on the fourteenth-century casket illustrated here. The richly decorated ivory box, perhaps intended for the safe storage of jewellery or documents, bears a selection of scenes from medieval romance and legend.

The supporters of the Royal Arms of Scotland were unicorns, and on the obverse of the gold coin of James III of Scotland (r. 1460–88), a single, proud unicorn appears, displaying a shield with the Scottish lion rampant. These attractive coins were known as 'unicorns', and were worth eighteen (later twenty) Scottish shillings. A Scottish heraldic unicorn retains its place as one of the supporters of the present Royal Arms of the United Kingdom, along with the lion that symbolizes England.

MYTHS AND MONSTERS

IN English, the old-fashioned term 'cock-horse' means both a child's toy – a stick topped with a horse's head – and the extra horse that was sometimes available for hire to assist teams of draught-horses in pulling a load up a steep hill. The ancient Greek cock-horse was one of the more bizarre flights of mythological fantasy, a beast with the head and forequarters of a horse, and the body of a cockerel. Known as a hippalektryon, it is rarely depicted in art or mentioned in literature, and some scholars think it may simply be an aberrant version of the winged horse. On the black-figure *kylix*, a shallow wine-cup, each side shows a knight riding this improbable creature. The vessel was made in Athens in the late sixth century BC, and the apotropaic eyes that flank the central image were regarded as having the power to avert ill-luck.

Another drinking vessel of exactly the same date and type features a species of horse-monster that became far

THIS PAGE
Hippalektryon, from
a black-figure *kylix*.
Greek, *c.* 520–500 BC.
OPPOSITE
Poseidon riding a
hippocamp, from a
black-figure *kylix*.
Greek, 520–500 BC.
Vulci, Italy.

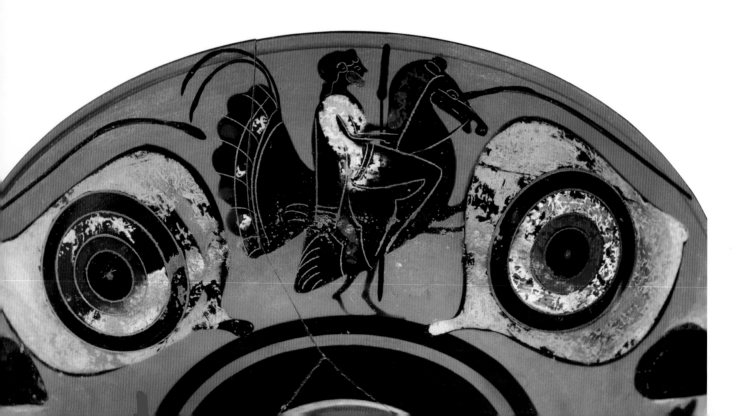

more familiar: the hippocamp. Though not as widespread in post-Classical European art as winged horses and unicorns, hippocamps took their place in the medieval heraldic bestiary and have survived as one of the more recognizable mythical horse-hybrids. With the foreparts of a horse and the body and tail of a fish, they are the equine equivalents of Tritons or mermaids. The Graeco-Roman mythological repertoire also included marine lions and tigers, bulls and stags, and many other mammal/fish monsters, but the horses were perhaps the most numerous.

Poseidon, the god of the sea, had a special rapport with horses of the natural, terrestrial, four-legged variety, but in his own element his chariot was drawn by four hippocamps, and occasionally he would ride on one. He is shown here wielding his trident and mounted on a particularly magnificent hippocamp with an elegant head and spotted, serpentine tail.

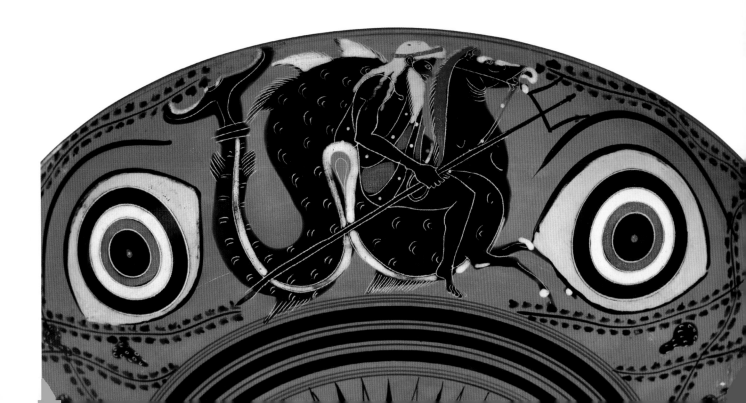

MYTHS AND MONSTERS

NEREIDS were the sea-nymphs of Graeco-Roman mythology, and they habitually rode upon or swam with hippocamps or other hybrid marine monsters, such as sea-panthers. The relief image is a single detail from the opulent decoration of a very large silver serving-platter, an item from a partial set of silver dining utensils of the fourth century AD, the late Roman period, found at Mildenhall, Suffolk. The scenes on the Mildenhall dish relate to the worship of Bacchus on both land and sea. This Roman Nereid swims gracefully alongside a hippocamp who turns his head back to look at her. The animal has an enormous, spiralling, scaly tail, and wears a neat bridle. His mane and hoofs are entirely those of a horse, and it is only around the girth area that he turns into a piscine being.

Hippocamps continue to appear in Renaissance and Neo-Classical art, especially on cameos and other gems, as well as in heraldic contexts, where some of them become increasingly fish-like. The pink coral hippocamp

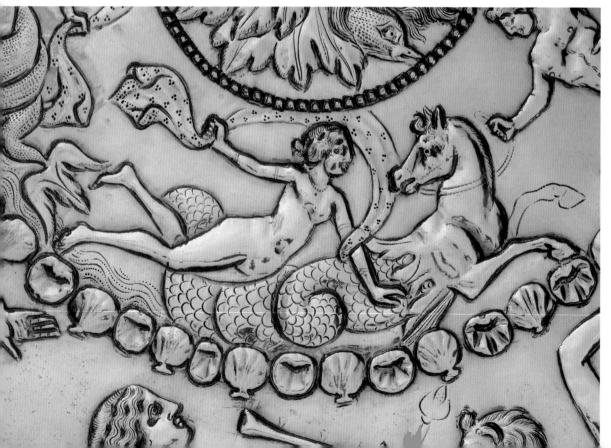

from an item of nineteenth-century jewellery is quite exceptional. It is one of a pair forming the terminals of an intricate coral tiara, one piece from an entire coral *parure* (matching set of jewels) carved in Italy around 1850–70. The coral is of the prized blush-pink 'angel's skin' variety. Like an heraldic, rather than a Classical, hippocamp, this little coral beast has webbed feet and a fin-like mane, and a tail that looks like a frond of seaweed. He swims amongst marine vegetation and holds a shell between his feet.

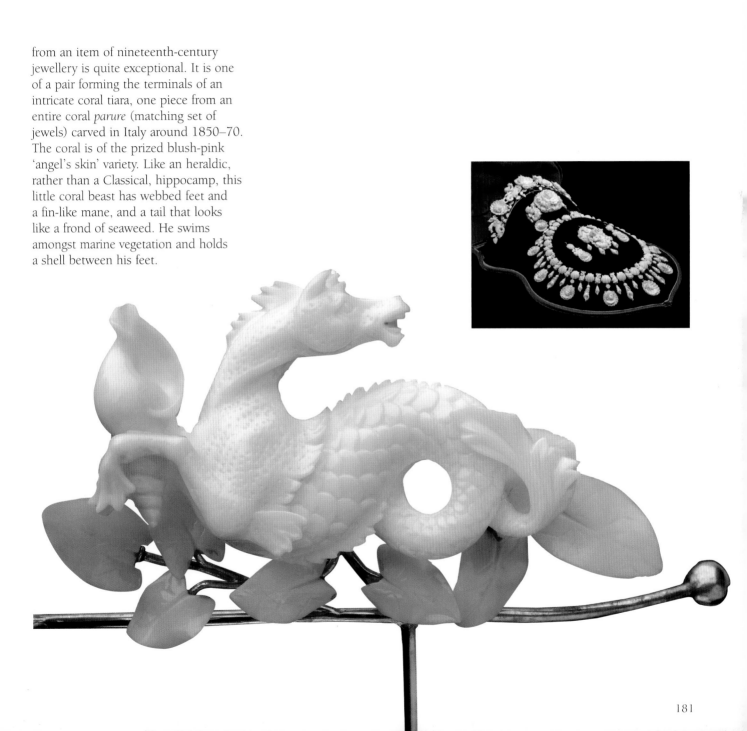

MYTHS AND MONSTERS

CENTAURS were half-human, half-horse creatures who dwelt in Thessaly. Some scholars have speculated that the original inspiration for the myth of a hybrid horse/human creature may have arisen in prehistory from the earliest reports of the exotic sight of men seen riding on horses' backs.

In general, centaurs were depicted in Greek myth as wild and rather violent animals, quarrelsome and uncontrolled in the extreme, especially when drunk. However, there were some more noble and worthy centaurs, notably Chiron, who was a wise and learned person, a great musician and healer, and the teacher of

gods and heroes, notably Achilles and the god of medicine himself, Asclepius.

Chiron is depicted in the wedding procession of Peleus and Thetis, the scene that decorates a magnificent black-figure wine-bowl (*dinos*) painted by Sophilos around 580 BC in Athens. Chiron's name, like those of the other characters, is inscribed close to his head. He carries over his shoulder five deer hanging from a pole, which are evidently his contribution to the feast. As in most of the early portrayals of centaurs, he has coarse, satyr-like facial features and a complete human body joined to the torso and hindquarters of a horse. Later, the customary image of

the centaur shows a human figure down to the loins only, rising from the forequarters of a horse, so that all four legs are equine.

The bronze centaur is a fairly remote descendant of the wise and cultured Chiron, for he, too, is a musician. He is playing a rebec, a medieval three-stringed fiddle, and he appears to be tapping out a lively rhythm with one foot. Like the ancient Greek centaur on the Sophilos vase, he has a complete human body and horse hindparts. He was made in Germany in the thirteenth century AD, and was not solely for decoration, since he functioned as a candlestick.

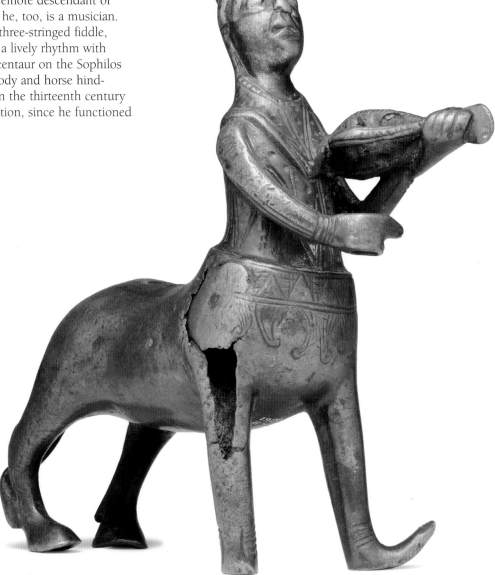

OPPOSITE
The centaur Chiron in a wedding procession, from a black-figure *dinos* by Sophilos.
Greek, *c*. 580 BC.
THIS PAGE
Bronze candlestick in the form of a centaur.
German, 13th century AD.
Felixstowe, Suffolk.

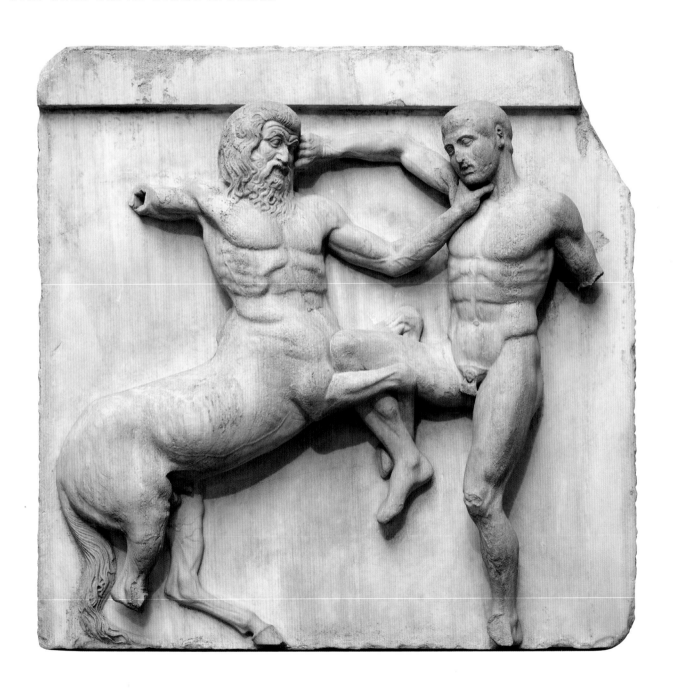

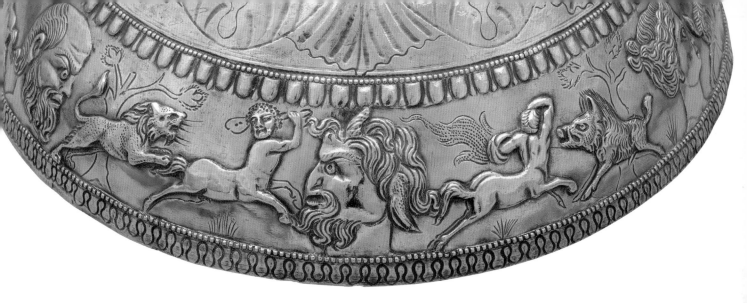

THE standard centaur of the Graeco-Roman world was a magnificent creature, a powerful and muscular man down to the hips and a graceful, well-proportioned horse beyond that point. Most centaurs depicted in antiquity are male, but centauresses also existed, and are occasionally to be seen in Roman art.

The sculptural decoration of the Parthenon, the temple of the goddess Athena at Athens, built in the fifth century BC, is one of the enduring achievements of Western art. A series of panels or metopes on the building depict mythical battles, and these include the unedifying tale of the fight between the centaurs and the Lapiths, a Greek tribe. The king of the Lapiths, Peirithoos, had invited centaurs to his wedding feast, but they drank too much wine and disgraced themselves by attempting to abduct and rape the

women guests and even the royal bride herself. Naturally a brawl ensued, and in the metope shown here from the south side of the temple, we see a Lapith and a centaur locked in combat. The Lapiths eventually won.

Centaurs were often to be found later in the lively entourage of the wine-god Bacchus, and those on the lid of a silver bowl from the Mildenhall Treasure, a collection of Roman table vessels of the fourth century AD, are typical. Bacchic decoration was very popular on domestic decorative art, especially on items connected with dining. In the frieze that encircles the lid of this elegant late Roman tureen, centaurs confront and defend themselves against wild animals – boars, a lion or tiger, and a leopard – using clubs and the large boulders that they were wont to hurl at enemies.

MYTHS AND MONSTERS

ANIMAL fables occur in the folk-tales and literature of all societies. They are used to explain and illustrate sayings, proverbs and facts of nature, and to wrap up the moral education of the young in a palatable and entertaining form. Many fables are very widespread and long-lived, forming part of a virtually universal storytelling tradition.

The Mughal emperor Akbar (r.1556–1605) was said to have enjoyed such tales and approved of their use for teaching purposes, and to have commissioned illustrated collections of fables. This gorgeous page is from a book dating from a period late in his reign, around 1590–1600, and has been attributed to Miskin, a Hindu artist working in Mughal court circles. The scene is from a story about the enmity between crows and owls, provoked by the crow's warning to all other animals against electing an owl as their leader. The crow (its grey-and-black coloration suggests that it is a crow rather than a raven) is seen perched at the top of a steep, craggy peak, haranguing an amazing gathering of animals – mammals, reptiles, fishes, amphibians, birds and even mythical beasts; there is a dragon and a simurgh, the ancient and omniscient bird of Persian legend, with its dog-like head and lion's claws. The picture has a wonderfully intense and vibrant atmosphere, as the creatures all crowd

around and reach up to hear what the crow has to say.

There are no fewer than five horses present and, apart from the elephant entering at the bottom right, they are the only domestic animals. One brown horse has reached up further than any of the other wingless animals, and a group of four stands towards the bottom of the picture, where a stream runs and fish emerge to listen to the crow alongside other water-loving animals. The four horses create a dynamic triangular composition reflecting the shape of the rock itself, and their colours, white, white-spotted brown, dappled golden-dun and dappled blue-grey, attract the eye amongst the rich mixtures of green, gold and intense blue.

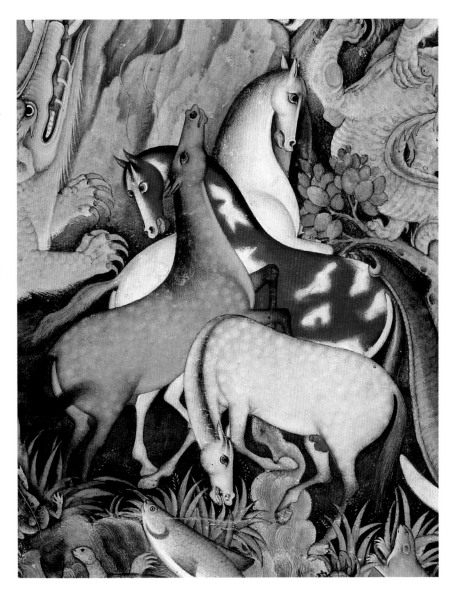

The crow addressing the animals. Painting attributed to Miskin. Mughal India, *c.* AD 1590.

FURTHER READING

The bibliographies on zoological and cultural aspects of horses, on horsemanship and wheeled vehicles, and on special subjects such as the history of racing, are vast. So are those on the history, art and archaeology of all the numerous cultures represented here. I make no apology for listing here only five books that I have found especially interesting and enlightening.

Stephen Budiansky, *The Nature of Horses*, London 1998
Charles Chenevix Trench, *A History of Horsemanship*, London 1970
Juliet Clutton-Brock, *Horse Power*, London 1992
Ann Hyland, *Equus: the Horse in the Roman World*, London 1990
Ann Hyland, *The Horse in the Ancient World*, Stroud 2003

The website of the International Museum of the Horse, Lexington, Kentucky, USA, is also a useful reference:
http://www.imh.org/imh/imhmain.html

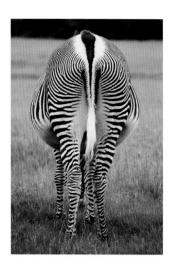

ILLUSTRATION REFERENCES

All photographs are British Museum copyright unless otherwise stated. References are British Museum registration numbers. Photography of British Museum objects by British Museum Photography and Imaging.

INDEX